GROUNDS OF DISPUTE

Grounds of Dispute

Art History, Cultural Politics and the
Discursive Field

JOHN TAGG

University of Minnesota Press
Minneapolis

Published by the University of Minnesota Press
2037 University Avenue Southeast, Minneapolis, MN 55414

Published in Great Britain by
Macmillan Education Ltd

Printed in Hong Kong

Library of Congress Cataloging-in-Publication Data
Tagg, John.
 Grounds of dispute : art history, cultural politics and the
discursive field / John Tagg.
 p. cm.
 Includes bibliographical references and index.
 ISBN 0–8166–2131–4. — ISBN 0–8166–2132–2 (pbk.)
 1. Aesthetics. I. Title.
BH39.T26 1992
701'.18—dc20

Library of Congress Cataloging-in-Publication Number

91–29124

ISBN 0–8166–2131–4 (hardcover)
 0–8166–2132–2 (paperback)

To the memory of my grandmother, Lilly McKenzie

Contents

Acknowledgements

The essays in this volume are, in a pointed sense, occasional pieces. They span a period of six years, a distance of several thousand miles, and a series of highly local yet inseparable contexts. The first was written as a parting gift for the students of my 'Theories and Methods' seminar at Leeds University; and the last as a collaboration with my friend and colleague Marcos Sanchez, as a contribution to a major retrospective of Chicano Art and cultural politics at UCLA and to a conference promoting 'Cultural Studies' at the University of Illinois, Urbana-Champaign. In between came lectures, symposia, debates, polemics, many flights, and the transplanting of my life to another continent. In all this, I incurred more than the usual debts to friends, students, and co-workers. In response, I can only thank Wendy Botting Tagg, Barbara Abou-El-Haj, Philip Armstrong, Rudolf Baranik, Holly Barnet-Sanchez, Victor Burgin, Tim Clark, Sande Cohen, Harry Gamboa, Jeremy Gilbert-Rolfe, Lorraine Kenny, Anthony King, Elaine Koenig, David Kunzle, Maureen Lea, Joanne Lukitsh, Teresa McKenna, José Montoya, Elsie Ritchie, Marcos Sanchez-Tranquilino, Tom Steele, Janet Wolff, the editors of *Block* and *New Formations*, The Mekons, The Three Johns, students and colleagues at Leeds University, the University of California at Los Angeles and the State University of New York at Binghamton, as well as at Newcastle Polytechnic, the University of Rochester, the School of the Art Institute of Chicago, Southern Illinois University at Carbondale, SUNY College at Cortland, Syracuse University, the University of Illinois at Urbana-Champaign, and the University of Victoria, BC. My thanks also go to the staffs of the International Center for Photography, the List Visual Arts Center, MIT, the Whitney Museum, the Wight Art Gallery, UCLA, and the University Manuscript Center, SUNY Binghamton. As is evident from the text, work on this book was completed during my tenure as

Ailsa Mellon Bruce Senior Fellow at the Center for Advanced
Study in the Visual Arts at the National Gallery of Art, Washington, DC. I am especially grateful to the Deans, Staff and
Members of the Center for their assistance, and to the National
Gallery of Art and the State University of New York at Binghamton for their support at this time.

The original texts are presented without the security of hindsight,
unrevised except for minor corrections, even where this entails
repetition. Their arrangement corresponds roughly to the terms of
the subtitle, though not in the same sequence: the problematising of
art history as an institutional practice leads on to questions of
discursive formations and the material production and circulation
of meanings, and to the conditions of contemporary cultural
politics. 'Art History and Difference', 'Postmodernism and the
Born-Again Avant-Garde', and 'Occupied Territories' were first
published in *Block*, no. 10, 1985, pp. 45–7; no. 11, 1985/86, pp.
3–7; and no. 14, 1988, pp. 61–4. 'Should Art Historians Know Their
Place?' appeared in *New Formations*, no. 1, Spring 1987, pp. 95–101;
and in *Journal: A Contemporary Art Magazine*, Los Angeles
Institute of Contemporary Art, no. 46, vol. 6, Winter 1987, pp.
30–3. 'Practising Theories' and 'The Proof of the Picture' were first
published in *Afterimage*, vol. 15, no. 6, January 1988, pp. 6–10 and
11–13. 'Totalled Machines' was published in *New Formations*, no. 7,
Spring 1989, pp. 21–34. 'The Discontinuous City' appeared in
Strategies: A Journal of Theory, Culture and Politics, no. 3, 1990,
pp. 138–58. 'The Pachuco's Flayed Hide' was written for the
catalogue, *Chicano Art: Resistance and Affirmation*, Wight Art
Gallery, UCLA, Los Angeles, 1991. I am grateful for the permission of the publishers and my collaborators to include these essays
here.

JOHN TAGG

Introduction/Opening

the preface is ruled out but it must be written.

Jacques Derrida[1]

Introduction: a beginning, a preparatory training, an exchange of names, an interpellation, a meeting of the reader and the text through the letters of introduction of the writer; an act, therefore, of politeness and decorum, yet also an intrusion, an entrance (via the vestibule we know to be part of the structure and not),[2] an arrival on stage, an insinuation, an insertion, an incision. Thus, a coming together that is also a separation, along the line of a cut, marking an *opening*: another beginning, an overture, an initial sequence of moves, the first pair to the crease, the start of a show, the burlesque part of a pantomime; at the same time, a vacancy that is both an opportunity, even a job, and an empty space, something drawn apart or disclosed to view, a clearing, a gap, a hole, an aperture, a window, a door, a passage. An insertion, and now an orifice – in the body of the work, in the body (already insistent, already differed by the politics of pregnability; 'the body' – write *my* body here, as Adrienne Rich insists,[3] though I had hoped to keep myself out of it or, at least, control my appearances) – but also an extrusion: an action of the bowels, the issue of the *proto-kollon* and the 'excrement of philosophical essentiality',[4] to add to 'the preface, as *semen*':

> the word of a father assisting and admiring his work,
> answering for his son, losing his breath in sustaining,
> retaining, idealizing, reinternalizing, and mastering his
> seed.[5]

(Opening – the engendering of language and the body again.) All this, or simply two facing pages of a book.

1

> *the retrospective is never anything but a category of bad*
> *faith. Writing must go hand in hand with silence . . .*
> Roland Barthes[6]

The literature of post-structuralist theory is well-supplied with
texts that, in beginning, seem to wish they had already begun and
were already in place.[7] Yet this wish is not just the trace of conceit
or long-windedness or, as Condillac wrote, of the abusive art of
'fattening a book to bore one's reader':

> talking of one's work, of one's sleepless nights, of the obstacles
> that had to be overcome; sharing with the public all the ideas one
> has had; not contenting oneself with a first preface but adding
> another to every book, to every chapter; giving the story of all the
> attempts made without success; indicating numerous means of
> resolving each question, when there is only one which can and
> will be used.[8]

To such arguments for textual 'pruning', for cutting the opening,
Derrida has responded that:

> if dissemination also *cuts* into the text, it is rather to produce
> forms which would often *resemble* those which Condillac – and
> all of the rhetoric and philosophy that he represents here – wishes
> to cut back so severely.[9]

Like the discursive constraint that divides text from commentary,
the law of the Preface closes the text of the book as that which has
been written, remains written, yet remains to be written. And if it
permits the opening of a new and variable discourse, it does so only
on condition that it be only repetition or completion; that it 'say, for
the first time, what has already been said, and repeat tirelessly what
was, nevertheless, never said'.[10] The effects of dissemination
continually debase this economy. Its excesses mark the disturbance
of the Introduction as belated point of departure, duplicitous
moment in time, metalinguistic boundary, unmannable border of
'inside' and 'outside', forgetful beginning of all that henceforth will
be or could be written, imposing assumption of the author's voice,
precipitous guide to the progress of meaning and unity of what is
said to follow. But these excesses also vitiate the unadorned text

that, in the view for which Condillac stands, should remain, pruned of its surplus, of all that does not properly belong in the proof, that is not essential and indispensable to the book itself.

Introductions are always out of order. They warp the text and are warped by their place in the text, the place of the text and the place that is the text: by their status as passages in the *space* of the text. It is, indeed, this space of the text that is put at issue.

> *The preface does not expose the frontal, preambulatory façade of a certain space.*
>
> Jacques Derrida[11]

Wherever we stand, this book has already begun, though, as we know, it did not begin with the word 'Introduction'. In any event, it has begun and, already, textuality, paging, the words of others, bodiliness, work, training, desire and, insistently, *space* are in play. The book is held in their field. And from text to text, spatial metaphors (position, place, site, space, ground, field, territory, terrain, map) are multiplied.

Yet we might wish we could leave this metaphoricity, like the preface, behind and go to some other place.

> *All this theoretical nonsense, which seeks refuge in bad etymology.*
>
> Marx and Engels[12]

For Marx and Engels – working the early shift, before the break – the *ideological* error of the Young Hegelians was precisely their improper reduction of political economy to the play of language and 'the sphere of synonymy'.[13] Synonymy served:

> to transform empirical relations into speculative relations, by using in its speculative meaning a word that occurs both in practical life and in philosophical speculation, uttering a few phrases about this speculative meaning and then making out that [one] has thereby also criticised the actual relations which this word denotes as well.[14]

An insistent language intervenes here, in the reassuringly solid opposition of 'empirical' and 'speculative', 'practical life' and 'philosophical speculation', 'actual relations' and 'speculative meaning'. The mutual exclusion and mutual reflection of the terms of this opposition create a space for thinking (the metaphor again) and a movement. It is a space from whose vantage the language of tropes must necessarily be seen as belonging to a pre-scientific phase of knowledge superseded by science proper in its passage from *metaphor* to *concept*.

> *Meta-philosophy does not prolong philosophy's*
> *metaphors. On the contrary, it denounces them.*
> Henri Lefebvre[15]

This insistence on moving into the rigorous reality of a language *beyond* metaphor is a persistent trope in scientistic and sociologistic Marxist thought. It is at work again when Louis Althusser reasserts the scientificity of Marx's 'mature' and non-ideological works. Once more, the issue is the space of metaphor and the metaphor of space. For all that his structuralist vocabulary was built on spatial terms, Althusser was set on arriving at a rigorous, *scientific* text in which these terms would be erased. In *Reading Capital*, he worries, in a footnote, that:

> The recourse made in this text to spatial metaphors (field, terrain, space, site, situation, position, etc.) poses a theoretical problem: the problem of the validity of its *claim* to existence in a discourse with scientific pretensions.[16]

A *scientific* discourse, he proposes, must move beyond metaphoricity, even as a recourse for the development of 'practical' concepts, towards the rigorous formation of a philosophically cleansed set of 'theoretical' concepts, adequate to their object and yielding the required 'knowledge effect':

> If Marx proposes a *new object*, he must necessarily provide a corresponding new conceptual terminology.[17]

It is even possible to see the number one task of every new discipline as that of *thinking* the specific difference of the new object, which it *discovers*, distinguishing it rigorously from the old object and constructing the peculiar concepts required to think it.[18]

This is the very reverse, Althusser declares, of *ideological* discourse, which operates in a 'closed space' of recognition, generating objects adequate to the justification of already existing concepts imposed by 'extra-theoretical instances and exigencies', that is *external* 'interests'.[19]

As in the passage by Marx and Engels, the symmetry is striking and significant. It describes two mutually exclusive spaces: one that is open yet lucid, and its opposite that is closed yet ultimately incoherent. The one is, however, also the reverse of the other: its mirrored double. And, if this were not puzzling enough, a third space keeps insinuating itself, unsettling the convincing symmetry by its uncertain play.

Althusser is emphatic that the 'object' to which he refers, whether the object of science or ideology, must be defined as an 'object of knowledge' constituted by a specific problematic and distinct from the object in the 'real'. Yet, there remains, for him, a productive ambiguity in the *locus* both of the object of science, to which theoretical concepts must be adequate, and of the ideological 'interests' these rigorous concepts must eschew. What is the space of the object? What is the space of such 'interests'? (Is the adequacy of scientific discourse to its object a question of the structural consistency of theoretical concepts *internal* to a problematic, or is it that of a realist theory of correspondence with its silencing appeal to the voice of the state of things? Are the interests that corrupt ideological discourse themselves defined *outside* the discursive field, though known to science, or are they defined in the calculations of counterposed problematics that contest the ideology's discursive effects?) What is the space of the real that insinuates itself? And what is the space of the subject of 'external' interests or of the 'knowledge effect' of science?

It is this series of ambiguities alone that saves Althusser from the empiricism he decries, while sustaining his contrast of scientific discourse with the 'closed space' of ideology and suspending any accusation of formalism against his otherwise 'closed' criteria of

scientificity. Rigorous or not, this ambiguity – this unresolved play of terms – works for him and against him. It keeps his argument afloat, at the price of sinking its claims.

There is, moreover, a further ambivalence in what it is that is at stake in Althusser's suspicion of, and complaint against, metaphor. In the course of an argument about the precise character and effects of the economic instance in Marx's mature conception of the social formation, he remarks that:

> the seductive metaphors of the terrain, the horizon and hence the limits of a visible field defined by a given problematic threaten to induce a false idea of the nature of this field, if we think this field literally according to the spatial metaphor as a space limited by *another space outside it.*[20]

Is the complaint, then, against a mistaken, too *literal*, reading of the metaphors? Is it against the effects of desire the metaphors excite? Or is it against the limited utility of the metaphors as such? Does he propose a *change* of language in order to counter certain undesirable discursive effects? Or does he propose a change of *language*, abandoning the temporary supports of metaphor for the new terrain (the metaphor, once more) of a rigorously defined theoretical language, 'corresponding' to the newly 'discovered' (not constituted) object? In any case, like Poe's one-eyed black cat, the metaphors walled up in theory will not be buried alive. 'Let us abandon this spatial metaphor', Althusser pleads, in order 'to define economic phenomena by their concept.' But four pages earlier, he has already articulated for us, with the utmost rigour, that:

> To construct the concept of the economic is to define it rigorously as a level, instance or region of the structure of a mode of production: it is therefore to define its peculiar *site*, its *extension*, and its *limits* within that structure.[21]

As Derrida asks:

> Is rectification henceforth the rectification of a metaphor by a concept? Are not all metaphors, strictly speaking, concepts, and is there *any sense* in setting metaphor against concept? Does not a scientific critique's rectification rather proceed from an inefficient

tropic-concept that is poorly constructed, to an operative tropic-concept that is more refined and more powerful in a given field and at a determined phase of the scientific process?[22]

The policing of metaphoric activity in theoretical discourse leads only to 'the multiplication of antagonistic metaphors in order better to control or neutralize their effect'.[23] Ironically, for Marxism, in the insistence on the purging of language in the name of 'actual relations' and a teleology of scientific concepts, it is the *history* of metaphoric constructions, rectifications, importations, exporta-tions, exclusions and disseminations that has been erased.[24]

> *It may be that universal history is the history of a handful of metaphors.*
>
> Jorge Luis Borges[25]

It is a paradox, too, that the consuming of the economy of language by the doctrinal system of the science of the economy has mimicked the consumption of everyday life in the hegemony of capital. Against this, Lyotard has bluntly argued, the legitimations of tradition and myth – 'the resistance of communities banded around their names and their narratives'[26] – are no defence:

> The only insurmountable obstacle that the hegemony of the economic genre comes up against is the heterogeneity of phrase regimens and of genres of discourse.[27]

That is why, he has insisted, it is crucial to recognise 'the differend' and distinguish between phrase regimens, and this comes down to 'limiting the competence of a given tribunal to a given kind of phrase'.[28] The dismissal of 'theoretical nonsense' and the imposi-tions of metalanguage are, by contrast, disciplinary ploys meant to appropriate competence and hegemonise the field of discourse. Against this, Lyotard sets not the refuge of some other space, but the delimiting of language games: the politics of *located* knowledge. (We shall return to this point but, meanwhile, let us note we are back at the metaphoric intersection of *space* and *theory*.)

> *The present epoch will perhaps be above all the epoch of*
> *space.*
>
> Michel Foucault[29]

Much has recently been made of 'the spatialization of critical theory'.[30] However, a number of levels need to be distinguished in what is at stake. Without minimising the importance of the articulation of intellectual practices within the global and regional geography of modernisation and the uneven production of space in capitalist development, it is not solely a matter of the theorising of space or of the spatial dispersion of professionalised theorising, nor even of the discursive régime of space. What marks the conjunction of space and theory, from the diagrams of structuralism to the active fields of *différance* and power/knowledge, is the displacement of the axis of temporal explanation, unfolding from origin to fulfilment, by the model of a distribution of positions and intersections in a spatial network.

In a lecture delivered in 1967, at a time when he still seemed to accept the term 'Structuralism, or at least that which is grouped under this slightly too general name', Michel Foucault argued that structuralist analysis was characterised by:

> the effort to establish, between elements that could have been connected on a temporal axis, an ensemble of relations that makes them appear as juxtaposed, set off against one another, implicated by each other – that makes them appear, in short, as a sort of configuration.[31]

This does not entail the denial of time, but is rather a way of reconstituting our manner of dealing with time and with what we call the historical. The erasure of time is the erasure of continuity and coherence by discontinuity and absolute heterogeneity. Our time, our history, the exhaustion of our lives, are lived less as a temporal succession, than as a displacement across a grid of space. This is not, however, the space of a void, waiting to be occupied by individuals and things, but rather that of a network of points defined by relations, series, intersections and patterns of distribution. It is a space constituted in the relations of delineated *sites* that

are 'irreducible to one another and absolutely not superimposable on one another'.[32]

> *Our epoch is one in which space takes for us the form of relations among sites.*
>
> Michel Foucault[33]

A year later, writing the 'Introduction' to *The Archaeology of Knowledge*, Foucault was to describe this same theoretical shift, from time to space, from the continuous to the discontinuous, in different and, for art history, troublingly familiar terms that seemed to displace in advance the very possibility of a radical social history of art, such as was then re-emerging in Britain and the USA. While Foucault now rejected the notion of 'a structuralism of history' and the relevance of the structure/development opposition, he argued that history had undergone a yet to be completed 'epistemological mutation'.[34] This might be summed up in the altered relation to the *document* and the *monument*:

> To be brief, then, let us say that history, in its traditional form, undertook to 'memorize' the *monuments* of the past, transform them into *documents*, and lend speech to those traces which, in themselves, are often not verbal, or which say in silence something other than what they actually say; in our time, history is that which transforms *documents* into *monuments*.[35]

The *interpretation* of the document – the piercing of the opacity of the sign to reach its hidden depths, the deciphering of a voice reduced to silence, the recovery of its identity in the exchange of author and *oeuvre*, the reconstitution of a past in which this voice spoke and from which it emanated – gives place to work on and within the mass of material documentation itself. For this work, the document is not a means to reconstitute lost events in which we will always recognise ourselves; the document is, in itself, an event, belonging to a different series from our own. Work *on* the territory of the document does not, then, listen for history to speak from the

grave; it stakes out the plot, dividing up the mass of documentary material, distributing its elements in series, unities, regularities, relations and (still, at this time) totalities.[36] By this means it begins to map the limits of the enunciative field and trace the figure of a specific regularity: 'that which, outside ourselves, delimits us';[37] the practice that causes a multiplicity of statements to emerge as so many regular events; the law of what can be said. This limit is the system of the *archive* as the horizon of discourse.

The archive is not, therefore, an echoing vaulted space, a musty, hollow place of collection and preservation, a mausoleum of memories set against time. It is a sedimented site and, hence, the ground for an *archaeology* – a term that does not imply the excavation of lost beginnings, but designates a systematic description:

> Archaeology describes discourses as practices specified in the element of the archive.[38]

And this returns us to the surveying of the monument:

> There was a time when archaeology, as a discipline devoted to silent monuments, inert traces, objects without context, and things left by the past, aspired to the condition of history, and attained meaning only through the restitution of a historical discourse; it might be said, to play on words a little, that in our time history aspires to the condition of archaeology, to the intrinsic description of the monument.[39]

The archaeology of knowledge describes the monument – the obdurate volumes of discourse left by the past – as a specific structure in a specific space. Such a spatialisation of the territory of the history of ideas opens up the possibility of mapping the discursive limits of fields and formations of knowledge. It still retains, however, the traces of an epochal conception of discursive totalities as simultaneously present, outside the play of difference and discontinuity, which is consigned to their borders. To say this is not to oppose the immobility of structures and their necessary synchrony to 'the living openness of history'.[40] Nor is it to forget Foucault's riposte to the '*agoraphobics* of history and time',[41] who neutralise the continuous by treating it as a pervasive primary law to which everything must be related. Against them, Foucault argues

that continuities and repetitions, like ruptures or breaks, are always defined at particular levels and governed by specific rules of formation and he is therefore insistent that:

> Archaeology does not set out to treat as simultaneous what is given as successive.[42]

He also denies:

> that a system of positivity is a synchronic figure that one can perceive only by suspending the whole diachronic process.[43]

Yet, this does not sit well with the goal of his analysis as the isolation of a general formation or *episteme* as:

> the total set of relations that unite, at a given period, the discursive practices that give rise to epistemological figures, sciences, and possibly formalized systems.[44]

Or, again, as:

> the totality of relations that can be discovered, for a given period, between the sciences when one analyses them at the level of discursive regularities.[45]

For all the emphasis on their open, mobile and practical character, it is difficult to see how such epistemic totalities effectively escape the duality of structure and development. What is the relation of the '*enveloping theory*'[46] of the episteme to a discourse on discourse that seeks 'to operate a decentring that leaves no privilege to any centre';[47] to an archaeology whose 'aim is not to overcome differences, but to analyse them, to say what exactly they consist of, to *differentiate* them';[48] whose 'task is to make differences: to constitute them as objects, to analyse them, and to define their concept'?[49] 'We are difference', Foucault declares.[50] But the play of difference within and across the episteme would evade the completion of Foucault's archaeological floor plan and, as he himself foresees, would deconstruct the opposition of structure and development, paradigm and syntagm.[51] In spatialising theory, difference marks not a static topography but, as Derrida puts it, a process that is both 'temporizing' and 'spacing':

An interval must separate the present from what it is not in order
for the present to be itself, but this interval that constitutes it as
present must, by the same token, divide the present in and of
itself, thereby also dividing, along with the present, everything
that is thought on the basis of the present, that is, in our
metaphysical language, every being, and singularly substance or
the subject. In constituting itself, in dividing itself dynamically,
this interval is what might be called *spacing*, the becoming-space
of time or the becoming-time of space (*temporization*). And it is
this constitution of the present, as an 'originary' and irreducibly
nonsimple (and, therefore, *stricto sensu* nonoriginary) synthesis of
marks, or traces of retentions and protentions (to reproduce
analogically and provisionally a phenomenological and transcen-
dental language that soon will reveal itself to be inadequate), that
I propose to call archi-writing, archi-trace, or *différance*. Which
(is) (simultaneously) spacing (and) temporization.[52]

(We find ourselves in the sphere of Borges's Library of Babel,
whose centre is everywhere and whose circumference is nowhere.
The Library is an indefinite, perhaps infinite, network of book-lined
galleries, joined by narrow hallways also catering to bodily necessi-
ties, and separated by vast airshafts that punctuate the entire
structure and are the wells of death. Like the structuralist para-
digm, the Library is conjectured to be total and to contain all
possible verbal structures – all possible, but no impermissible,
combinations of the twenty-five basic orthographic elements: the
comma, the full stop, the space and twenty-two lower-case letters of
the alphabet. And, if this is so, the Library must logically, therefore,
include a 'total book': 'a book which is the formula and perfect
compendium *of all the rest*'.[53] The book, however, can never be
found. It is lost amidst uncountable, imperfect variations, in the
immensity of the Library's linguistic permutations, in the enormity
of its galleries and floors. If there is an end to this architecture, it
can never be known and no journeying will bring its limits nearer.
This is the space of dissemination. By contrast, the 'cyberspace' of
William Gibson, which pictures simulated data banks and informa-
tion networks as a neon version of the Ideal City, can never be more
than a latter-day Albertian dream, made over for the video
arcade.)[54]

The space of language today is not defined by Rhetoric,
but by the Library: by the ranging to infinity of
fragmentary languages, substituting for the double chain
of Rhetoric the simple, continuous, and monotonous line
of language left to its own devices, a language fated to be
infinite because it can no longer support itself upon the
speech of infinity.

Michel Foucault[55]

For Foucault, too, the illusion of architectural perfection in Alberti's utopic construction could not be a metaphor for the space of discourse. In Foucault's elaboration of his concept of discursive formations, it was to become clear that we are dealing not with the paradigmatic space of an epistemic system, least of all with a space centred on a subject, but rather with a space that is a network of active relations: a field of *power/knowledge*. The pivotal text in the articulation of this crucial theme may be 'The Discourse on Language',[56] Foucault's inaugural lecture at the Collège de France in 1970, written in the period following the publication of *L'archéologie du savoir*[57] and at the beginning of the project that would lead to *Surveiller et punir*.[58] Here, he plots the field of discourse as a field of material acts. 'Violent, discontinuous, querulous, disordered even and perilous',[59] it is a field that emerges under a set of incitements and constraints that operate to control, select, organise and redistribute the production of discourse and 'to evade its ponderous, awesome materiality'.[60]

Foucault divides these incitements and constraints between the categories of 'exterior' and 'internal' rules:[61] on the one hand, rules of exclusion, prohibition, division and rejection, governing the hazards of the appearance of discourse; on the other hand, rules of identity, typology, origin and disciplinary formation, and rules of employment and subjection, distributing speakers among discourses and discourses to subjects. Foucault's stress on 'exteriority' and 'external conditions of existence',[62] as fundamental principles of the genealogy of discursive formations, may seem problematic here, reiterating a division he rejects in the traditional history of ideas. In effect, it functions as a rhetorical counter to concepts of 'signification'[63] as the determinant effect of a deep and exhaustive structure, and it takes him into a territory that he now defies his critics to call 'structuralism'.[64] As in Derrida's analysis of the frame

or parergon,[65] it no longer has any meaning to ask whether the structures Foucault enumerates are 'inside' or 'outside': they *institute* discourse and their location eludes both an internalising formalism and a sociologism of the external.

What is crucial is the emerging theme that the production of discourse is inseparable from the action and generation of power effects. And, already, Foucault's conception of this relation of power and sense is not focused only on negation – on cutting out, rarefaction and the prohibition of certain objects, practices and performances of discourse. Equally, it seeks to follow the ways in which the operations of power on and in discourse are productive: productive of reason and truth; productive of textual hierarchies, unifying principles, and orders of discourse; productive of subjects and fellowships of discourse. Not only is the formation of a field of sense an effective formation of control, but control is effective as a formation of sense. It is a violence that is done to us and that we do to things.[66] But it is a field of violence that takes effect as an incessant, scattered and discontinuous production of discourse that would evade 'its character as an event'[67] or series of 'events' that always 'have their place'.[68]

> *The spatialising description of discursive realities gives on to the analysis of related effects of power.*
>
> Michel Foucault[69]

Power and place: the terms of the analysis have begun to pass from the rules of formation of statements, what governs them and the ways they govern each other, to a politics of sense; to an analysis of the 'discursive régime',[70] which can no longer be confused with a formal paradigm and for which the appropriate model is not the linguistic system, but war and battle: 'relations of power, not relations of meaning'.[71]

It was, moreover, precisely through the insistent exploration of spatial metaphors, for which he had been reproached, that Foucault came to what he had been looking for – 'the relations that are possible between power and knowledge':[72]

Metaphorising the transformation of discourse in a vocabulary of time necessarily leads to the utilisation of the model of individual consciousness with its intrinsic temporality. Endeavouring on the other hand to decipher discourse through the use of spatial, strategic metaphors enables one to grasp precisely the points at which discourses are transformed in, through and on the basis of relations of power.[73]

What interest him now are the inscriptions of power in and on forms of discourse, material grounds, and the body itself: power as a configuration; power as the field of operation of a definite set of practices, discourses, techniques and technologies; power as producer of knowledges, domains of objects, pleasures, desires, and forms of subjection; power that can, therefore, as in the genealogy of discourse, be accounted for without reference to a transcendent or constitutive subject 'in its empty sameness throughout the course of history'.[74]

Where this leads is into a new engagement with the body in space, as a site of intersection, a force field, cut across by the trajectories of technologies of sense, sensibility, selfhood and power. It is an engagement that marks out decisive historical discontinuities: shifts in the economy and political disposition of the body and space, which have to be grasped in their historically specific and plural forms:

A whole history remains to be written of *spaces* – which would at the same time be the history of *powers* (both these terms in the plural) . . .[75]

This is the history of that pervasive yet 'thoroughly heterogeneous ensemble'[76] of discourses, institutions, architectural forms, regulatory practices, techniques of training, laws, administrative measures, scientific observations, philanthropic propositions, moral exhortations and professional specialisms of space that constitute the disciplinary apparatus, condensed in the metaphor and utopic model of Bentham's Panopticon. But it is equally the history of bodily pleasures and techniques of self-regulation, of other places, other pleasures, other bodies, other than constituted in the specific spaces of disciplinary knowledge.[77]

It is also the history of resistances, of the counter-politics of bodies and spaces that mark the disputed grounds of the everyday.

For the disciplinary field is never realised, never closed. Discipline, like exchange, is never the systematic structure it is willed to be and even the strategic reappropriation of its 'failures' cannot retrieve it as a totality by sealing each and every breach.[78] Discipline begins in local tactics and its institutionalisation is never complete, resolved or uncontested. It is, moreover, compromised by the desire it would repress from its dream of power, of the machinery of an unreturnable gaze. Likewise exchange, as the perfection of a structure of equivalence, is exceeded by the needs and desires it would reduce to functional drives. These needs and desires return to incite the disruptions of sign values, but also to spread anarchy through the dour utopia of rational use values. (In the twilight of commodification, not all coats are grey.)

Against the effects of the globalisation of cultural technologies and discourses, of commodification and disciplinarity, one must, therefore, also stress the necessary processes of negotiation and location and the irreducibility of systems of difference. This is not to negate the moment of economic, technological and discursive globalisation, but to emphasise the heterogeneity, incompleteness, historical unevenness and necessarily negotiated nature of cultural régimes, as a result of which they are never achieved, coherent or hermetic and the dominance of a single discursive regimen is never unbounded. This opens spaces for disruption, deviation and resistance, for hybridisation and 'border crossing'. Splitting, displacement and multiplication, never being habituated, never being at home, never being *proper*, become the empowering articulations of a place within the structure that is irreducible to it.

(I was born in the marches of Northumberland, in the Border Country between England and Scotland, north of the medieval Palatinate of Durham that marked the defensible ground, in North Shields, not far east of Wallsend: once the place of shipbuilding and once the end of Hadrian's Wall, that massive and regular line of stone drawn across the landscape, marking the extremity of what was known and owned, the ultimate military limit, for all but a short time, of the Roman Empire. The River Tyne, at whose mouth Wallsend and North Shields lie, has always been both a barrier and a conduit. Yet, the present border lies fifty miles north, over the Cheviot Hills and along the Tweed. But, like so many others, I was always confused about the place of this dividing line and which side we were on. Where did we fall? *La frontera*: we seemed to be on it,

not beside it; in the path of its violence; no place to be. And, if we belonged to the Border, to whom did the border belong?)

> *space is a practised place.*
> Michel de Certeau[79]

What of the subjects of this crossed-over space of the system? Consumers are also 'poachers', as Michel de Certeau has said.[80] They are not solely passive or docile, but are animated by purposes and frames of reference entirely foreign to the system they have no choice but to inhabit:

> To a rationalised, expansionist and at the same time centralised, clamorous, and spectacular production corresponds *another* production, called 'consumption'. The latter is devious, it is dispersed, but it insinuates itself everywhere, silently and almost invisibly, because it does not manifest itself through its own products, but rather through its *ways of using* the products imposed by a dominant economic order.[81]

The economic system may be 'indifferent' to use, as Marx insists, but it cannot prevent the manipulations of unforeseen practices, which are composed in the vocabularies of established languages and subordinated to prescribed syntactical forms, yet which trace out figures, rhythms and desires neither determined by nor captive to the 'literalness' of the systems in which they develop. Like metaphors, like the 'wandering figures' of utopic practice in Louis Marin's terms, such modes of consumption 'stage the discourse' in which they emerge, opening incongruous spaces by their play of difference within the totalising structure.[82]

> *To walk is to lack a site.*
> Michel de Certeau[83]

In a parallel way, de Certeau argues, if it is true that the silent and silencing processes of the disciplinary grid are becoming ever more

pervasive and fixed, then it is all the more urgent to discover those correspondingly 'minuscule' everyday practices by which the population manipulates and evades the mechanisms of social discipline and thus prevents the reduction of society to panoptic chains. Such tactics of everyday life, like the tactics of the Communards, raise ramshackle barriers to the circuits and flows of disciplinary and economic circulation, while piercing the careful segmentations they create and countering docility and efficiency by mobility and displacement.[84] The syntax of discipline and of the economic system are turned against their literal speech, from within. Without imagining another space, the drive of street cultures is for more speed, more hybridisation, and such 'unsigned, unreadable, and unsymbolised' cultural activity[85] – devoid of legible identity or access – has become, in de Certeau's view, the only possible activity for non-producers in a productivist economy, in which 'marginality is becoming universal'.[86]

> *The place of a tactic belongs to the other.*
> Michel de Certeau[87]

(And yet, one might wonder what form of consumer 'tactics', in de Certeau's sense, can escape, in one place, famine and, in another, dioxin contamination, radiation, cancer and, everywhere, the effects of pollution, deforestation and global warming? Why must tactics begin by silently conceding the limits of choice on the supermarket or the library shelf, on the register of medical practitioners or the ballot paper, on the Job Centre boards or the housing roster? Is the listless television viewer effectively empowered as a counter-author, writing a new script with the remote control? What consolation is there in such a narrative of everyday practices, and for whom? Who can read the tragic inventiveness of the homeless as a form of postmodern counter-planning? And what tricks and manipulations of 'antidiscipline' can break out of the local isolation of specific régimes of meaning and practice within a discursive field whose very tenacity may be a function of its discontinuity and non-coherence?)

The celebration of resistance, transgression and evasion evokes its own difficulties where it leads to the underestimation of disciplinarity and commodification, whose crushing pressure – whether they work well or not – can seem to be felt on our lives at every point. It is difficult to see such systems as the problems of a superseded theoretical or political agenda when their histories, their structures and the levels at which they have been articulated have still been little studied or understood. This is not to say that there do not remain uncrossable limits to discipline and commodification, despite the familiar terrors of their inventiveness. But we are dealing here not only with the limit of what will not yield – in Lyotard's phrase – to the 'gaining of time' in life,[88] but also with bodily and ecological limits, which – in the end – may be the limit of death and the limit of carbon and its excess.

If we want to stop the systems which rule us short of these limits, resistance to their projections of limitlessness must still be made. We cannot depend on the margins of error in the proliferation of systems. Yet neither can we look to the reinvocation of the great closures of history and identity: the terrors of fundamentalist communities closing around their names and their narratives. As Lyotard says, the way beyond capital's hegemony and the 'bloody impasses' of the great doctrinal systems lies not in legitimation through tradition or myth, which in the end amount to the same thing.[89] It comes:

> when human beings who thought they could use language as an instrument of communication learn through the feeling of pain which accompanies silence (and of pleasure which accompanies the invention of a new idiom), that they are summoned by language, not to augment to their profit the quantity of information communicable through existing idioms, but to recognise that what remains to be phrased exceeds what they can presently phrase, and that they must be allowed to institute idioms which do not yet exist.[90]

This is, then, more than resistance as negation. It is more than the oppositional assertion of an irreducible metaphoric movement against the fixed channels of the great systems. It is more than the melancholy thematic of constraint and loss. It is the verso of what Derrida calls 'the saddened, *negative*, nostalgic, guilty, Rousseauistic side of the thinking of play'. It is:

the Nietzschean *affirmation*, that is the joyous affirmation of the play of the world and of the innocence of becoming, the affirmation of a world of signs without fault, without truth, and without origin which is offered to an active interpretation. *This affirmation then determines the noncenter otherwise than as a loss of center.*[91]

Unwounded by loss, without reserve, this affirmation is the burden of inadequacy lived as the exhilaration of incompletion; the pain of silence turned into the exuberance of speech. It is the movement of pleasure and the pleasure of movement. It opens a space in the fixed grid and, by this parting, brings the conditionality of the grid's régime into play. Its double commitment to the heterogeneity of discourse and to the delimiting of all regimens is, at once, an acceptance of our mixed identity and an acceptance of responsibility. It is, in one gesture, a refusal of all hierarchies of space and a demonstrative staging of power and place.

> *there is no space in general, and everything brings its space with it; a place takes place by itself.*
> Jean-François Lyotard[92]

It was in 1984 that Adrienne Rich called for such a 'politics of location',[93] beginning with 'the geography closest in – the body',[94] more exactly, *my* body: my place to see from (and be seen), my place to ask my questions (and to listen), my point of multiple perspectives (and my part in the problem), my place for comparing, beginning to discern patterns, undoing bonds and building alliances. But if my body is a locus, it is not the centre of a discourse; and if it is located, it is at once 'a place in history'[95] and a site of 'more than one identity'.[96] In this sense, my body is never one place: it is always elsewhere, dispersed in meaning and differentiation, given over to the unequal exchanges of discipline and desire. In the same sense, it is not mine – though this is not a justification for the evasions and abstractions Rich contests.

(Where am I now? A body that wants to sleep. With my pale, white, northern English skin. In a shirt and tie and well-creased pants. In an executive armchair. In an office closed to 'the public'.

In an acclaimed building by I. M. Pei – designed by him that is, or his company office, but built by other hands with no known bodies and no known names. In a senior position, in an institution founded 'to promote the study of history, theory, and criticism of art, architecture, and urbanism through the formation of a community of scholars'.[97] To my left, a wall of glass and the prospect of the Capitol, with the figure of Freedom, cast by slave labour, facing the other way. To my right, at least when I wrote this by hand, the glass screen of a 'personal' computer, blocking my view of the door. In front of me, a wall, this paper, a pile of xeroxes and a telephone. Carpet under my feet. Food in my stomach.

Must this description stop at the point of the pencil with which I am writing? At the depression of the key that my finger will touch to make its mark of light behind the screen? Where is the space of my thinking? Where is the space of my speech? Where is the space of its meaning? And where are you? Where is the book that you hold in your hands but that does not yet exist? Where is the argument and how does it travel between our two presents? Is it getting through? *Arrive-t-il?* as Lyotard says.[98] And what will its come-back be?)

> *Feminist objectivity means quite simply* situated knowledges.
> Donna Haraway[99]

Adrienne Rich's challenge has not been ignored. It has been taken up again, for example, by Donna Haraway, in an argument not only for situating limited, local, embodied and technologically 'enhanced' knowledges, but also for contesting unlocatable and therefore 'irresponsible' knowledge claims.[100] Only discourses of dominance present themselves as unmarked, disembodied, self-identical and transcendent. Positioning, Haraway argues, undoes such transcendence and entails responsibility for our enabling practices. Thus:

> The issue in politically engaged attacks on various empiricisms, reductionisms, or other versions of scientific authority should not be relativism – but location.[101]

Located knowledge is answerable for what it can or cannot see, whereas unsituated knowledges cannot be called into account. Such accountability is, however, the only basis for defensible exchange and a precondition of objectivity and of being heard to make rational knowledge claims. It follows, therefore, that:

> politics and ethics ground struggles for and contests over what may count as rational knowledge.[102]

(The weakness of current defences of the Robert Mapplethorpe exhibition or of 2 Live Crew in terms of 'artistic freedom' or 'freedom of expression' is the way these defences end dispute by referring judgement to another place: to the finality of a proper discourse, on Art or on the Constitution, and thence to the authority of the professional masters of those universes. By their exclusion of those positioned as laity from these reserved and hallowed spaces, such defences give over the field of accountability to a rightwing rhetoric of the People; a rhetoric whose own finalities live on the discontents that aestheticism and constitutionalism cannot abide. Accountability and disputability are inseparable and, where they are suppressed, unquestionable authority is left to develop its own unspeakable forms.)

> *An intellectual is someone who helps forget differends, by advocating a given genre, whichever one it may be . . . for the sake of political hegemony.*
>
> Jean-François Lyotard[103]

Far from claiming the transcendence of realism or the finality of a universal discourse, 'objectivity', in Haraway's account, is both positional and a process of 'conversation', – 'decoding and trans-coding plus translation and criticism'[104] – joining specific, partial and halting, but responsible voices. Such a conversation cannot, however, be innocent of the power relations that structure 'conversational' exchange and even, in extreme forms of disciplinary absolutism, enforce a single language as the standard of all communications and translations. As Haraway puts it:

local knowledges have also to be in tension with the productive structurings that force unequal translations and exchanges – material and semiotic – within the webs of knowledge and power.[105]

The very use here of the terms 'knowledge' and 'power', in conjunction, might signal a comparison with Foucault and, in particular, with his much-quoted theory of 'the specific intellectual'.[106] For Foucault, the field of located knowledges is the domain of specific experts with direct and localised relations to specific practices, institutions and sites of knowledge. This relation to knowledge is not at all that of the 'traditional' or 'universal' intellectual: the exemplary bearer of the universal in its conscious form, claiming responsibility – at least, in a literary forum – for adjudicating on the fate of Culture and Humanity. Yet the mobilisation of specific discourses and techniques by new kinds of intellectual expert still has a strategic effect beyond immediate professional and sectoral concerns. These effects do not rest, however, on the authority of some general discourse, but rather arise from the ways specific knowledges and their power effects can be articulated into what Foucault calls the "general politics" of truth'[107] and, therefore, also into the struggles to change the status of truth in society and the political and economic role it plays.

It is evident that, in his description of such a régime or 'general politics' of truth, Foucault is talking about an apparatus, in the fullest sense he gives that term, and not about some epistemological norm. Yet, the notion of the régime of truth may still sound uncomfortably close to the notion of a general discourse where it is thought of as a pervasive set of rules, techniques or discursive motifs, rather than as the various means of negotiating not only the security but also the separation of discrepant and discontinuous discursive fields of truth. In the latter case, even the question of linkage becomes a question of flexible local tactics, untroubled by consistency or coherence. But, with this qualification, the point to hang on to in Foucault may be that *located* knowledge always implies a *strategic* relationship: the local is only local within a field of power/knowledge.

This is also the direction of Donna Haraway's argument. What is important is that rational knowledge must be both 'power-sensitive' and, at root, a construct of 'comparative knowledge'.[108] But, even

here, it would have to be added that the calculation of power fields and power effects and the negotiation of consensus between positions can only themselves be positional and conditional, grounded on specific means of calculation, mobilised at particular points, within particular perspectives, and directed towards particular chosen ends. This certainly complicates the usage of the term 'objectivity'. Yet, it is clear that objectivity, in Haraway's sense, is no more about 'unproblematic *objects*',[109] than located knowledge is about epistemological parochialism or the discursive equivalent of dialect studies. What is at stake in embodied and situated knowledges is 'the pattern of relationships between and within bodies and languages':[110]

> Feminist embodiment, then, is not about fixed location in a reified body, female or otherwise, but about nodes in fields, inflections in orientations, and responsibility for difference in material-semiotic fields of meaning.[111]

> *Feminism is about a critical vision consequent upon a critical positioning in unhomogeneous gendered social space.*
>
> Donna Haraway[112]

For all her recoil from 'epistemological electroshock therapy'[113] and her desire to see an appeal to 'real' worlds as 'more than a desperate lurch away from cynicism and an act of faith like any other cult's',[114] Haraway's argument, like Foucault's, can be read as a call for positional calculation and exchange, and for a pragmatic politics of knowledge measured by its effects. 'We need the power of modern critical theories of how meanings and bodies get made', she tells us, 'not in order to deny meanings and bodies, but in order to build meanings and bodies that have a chance for life.'[115] For all that her essay retains, at times, the language of 'nuanced theories of mediation'[116] and 'a no-nonsense commitment to faithful accounts of a "real" world',[117] it is clear that its concept of located knowledges could never be reduced to a call for a new positivism of the

particular, just as its conception of feminist objectivity does not depend on a notion of abstract justice or abstract humanity.

It is on these points, however, that Haraway's idea of 'feminist objectivity' as a situational logic would have to be sharply distinguished from Edward Said's conception of critical consciousness as 'a sort of spatial sense, a sort of measuring faculty for locating or situating theory'.[118] To Said, this means being able, somehow, to grasp the 'specific social and historical situation of which an intellectual occasion is a part', but which it does not exhaust.[119] But it also means being aware of 'the resistances to theory',[120] which are drawn from resources of humanity and justice 'beyond the reach of dominating systems'.[121] Spacing is again the focus. But it is difficult to see Said's formulation as more than the return of a sociology of knowledge that wants to ground itself by marking out a series of supradiscursive spaces: a space between the language of situated theories and its own language of situating social analysis; a space between the plane of the social and historical and the plane of theoretical systems, whose inadequacy to their real setting is itself explained by that reality; a space between the enduring human subject and the dominating systems that always fall short of the rights inalienable to that subject's essential humanity.

Perhaps there is now no need to labour the point that these are spaces that have been effectively collapsed by the pressure of the theorisations we have been following, even as this same theoretical work has opened on the spacings and spaces of the discursive field. The territory of the discursive field is not that of a sociology of knowledge. The mapping of located knowledges is not that of a new positivism. It would be a mistake, therefore, to take Said's account of the situation of theory for Haraway's or Foucault's. The limits of theory are not those laid down by an enframing social context over the discourse it determines. What exceeds present possibilities of phrasing is not the fullness of a suppressed but resistant human experience. And if justice sets bounds to the jurisdictions of language, it is not the domain of a court of appeal 'beyond' the pale of conflicting phrase regimens.

These are the negatives of a theoretical practice that denies the externality of a sociology of knowledge, precisely to take the limits of discourse seriously. These limits do not mark the boundary between an interiority and an exteriority of discourse:

at the invisible limit [as Derrida puts it] to (between) the
interiority of meaning (put under shelter by the whole hermeneu-
ticist, semioticist, phenomenologist, and formalist tradition) and
(to) all the empiricisms of the extrinsic which, knowing neither
how to see nor to read, are beside the point.[122]

(Such a separation, Derrida has shown, always hangs on the frame
that rules it out.) The limits at issue trace the terms of difference and
the grounds of dispute – the 'differends' – between genres of
discourse. To situate discourses is to insist on these limits, but not
from some supradiscursive space. There is no genre of genres in
which the differences these limits mark may be resolved. Sociology
cannot be the final frame of theory. As Lyotard has made clear, the
idea of a supreme genre, triumphing over all others and encompass-
ing everything that is at stake has no sense, since it must always
except what is at stake in itself. The social is already presupposed in
the phrases of sociology: it is already there as addressor and
addressee, as genre of discourse and the stakes to which it is tied.

Yet, if this collapses both Said's separation of theory and social
context and the privilege he accords to sociological 'measurement',
it simultaneously opens the space of cultural politics, which the
sociology of knowledge has to deny since, in the last instance, it
must depoliticise language in claiming to be the absolute language
of political calculation. Again, as Lyotard has written:

Were politics a genre and were that genre to pretend to that
supreme status, its vanity would be quickly revealed. Politics,
however, is the threat of the differend. It is not a genre, it is the
multiplicity of genres, the diversity of ends, and par excellence the
question of linkage.[123]

*The social is implicated in the universe of a phrase and the
political in its mode of linking.*
 Jean-François Lyotard[124]

But we should not leave Said so soon. There is a movement in his
influential argument that persists: his sense that the location of

practices of knowledge also implies the possibility, and even the necessity, of their *dislocation*. In transmission, translation, reception and consumption, the products of knowledge travel – now, ever faster, at the speed of the electronic exchange of information. For Said, situated knowledge – precisely because it does not exhaust its situation and is not exhausted by it – is also 'travelling theory', caught up in the great movements of traffic across global space, of tourism, migration, exile and colonisation.

> *To theorise, one leaves home.*
> James Clifford[125]

This is unsettling. Yet, if theory in the West – at least until certain recent departures – has closed on defining the proper, its roots, as James Clifford remarks, have been in a history of travel, observation and interpretation.[126] 'Theory' derives from a medieval Latin translation of the Greek root *theoreion*, which signified a place for seeing, the viewing and contemplation of a spectacle or ritual and, thence, those who observed and speculated on the sight of such performances, oracles or rites. In one specific usage, it came to designate an embassy sent by the state to perform or witness some religious rite or duty. Then it began another journey. Following an ancient metaphoric path, like so many words meaning 'see' in the history of Indo-European languages at widely scattered times and places, it migrated towards the sense of seeing as *knowing*.[127] At the same time, it lost its memory of changing places, so that location came to stand in contradiction to the claim to theoretical status. Theory demanded a place that was centre and all places. (We are returned once more to the 'fearful sphere' of the Library of Borges.)

The *Lebensraum* of theory – centre and all places – furnished itself with the trappings of destiny and truth, but it was a space of conquest: the dream of an Empire of Signs, extending from the heart of Europe out across the globe. Yet, this dream of Empire circumscribed its own claims to universality and reinscribed space into the project of theory. Like the Great Day of the Spirit, theory has always begun and ended somewhere, and its travels have traced a telling geography.

Now, with the fall of empires, journeys go in many directions and
have many centres. Yet, if we live at the end of the era of great
systems, still in the shadow of the ruins of their monuments, in the
fragmenting geography of their uneven development, we cannot,
James Clifford reminds us, simply reground theory on the local.
Theory – even what counts as theory – may always have to be seen
as marked by the site and conditions of its production and
reception. The claim of theory to a perspective without a viewpoint
may always have to be heard as a strategy of power, foreclosing the
seeing of things from other positions. Nevertheless, theory remains
more than a local act. As Donna Haraway has also argued, theory
makes claims to establishing and grouping comparative phenome-
na. It is a practice of linkage: in Clifford's words, a practice of
travel, establishing 'itineraries', always traced on specific histories of
dwelling, immigration, exile or migration.[128] Travel as such is not
all, however, that is at stake. The local – what is present – is, as we
have seen, always premised on the elsewhere. But this is also,
always, a reversible relation – and this is the reverse that has set
back Eurologocentric theory and opened up a new terrain:

> 'Location', here, is not a matter of finding a stable 'home' or of
> discovering a common experience. Rather it is a matter of being
> aware of the difference that makes a difference in concrete
> situations, of recognising the various inscriptions, 'places', or
> 'histories' that both empower and inhibit the construction of
> theoretical categories like 'Woman', 'Patriarchy', or 'colonisa-
> tion', categories essential to political action as well as to serious
> comparative knowledge. 'Location' is thus, concretely, a *series* of
> locations and encounters, travel within diverse, but limited
> spaces.[129]

The space of theory is not, therefore, the constant and irreversible
space of 'critical distance'. It is not the free-floating space of
disinterestedness. Nor is it the space of Pascal's sphere: the
imaginary space of the authoritative gaze. It is rather a space of
'*betweenness*, a hybridity composed of distinct, historically-connec-
ted postcolonial spaces'.[130] Theory moves in this space. It travels
and arrives, is received and rebuffed. It is constantly translated,
appropriated, adapted, assimilated, passed on and contested. This

very mobility confronts it with relations of power that seek to structure translation, exchange and appropriation, to engender master languages, to describe a centre and a periphery, and to fix the mean time of a uniform temporality in a moment of post-colonial modernisation, globalisation and fragmentation. But the confrontation of theory and power also opens movements of resistance that unseat claims to universality and flush out the unlocated voice that denies its contingency and partiality and speaks, above our heads, to its historyless, raceless, genderless, bodyless listeners.

(I hesitate. Local tactics, even 'travelling' tactics, may be the space of resistance, but the professionalisation and relocation of intellectual practice in the universities and media seem to have all but stripped academic intellectuals of the local knowledges they would need to participate in dissent. Hence their nostalgia not only for the notion of the Universal Intellectual as Foucault describes him [*sic*], but for the lost urban centre of an earlier capitalism as it survives in the consoling metaphor of the avant-garde: the Saint Simonian dream that artists, politicians and other (post)metro-politan intellectuals might someday cease to be situated yet, guided by rational objective method, might come to take up a position that overhauls all others, at the head of society. Nostalgia has a particular relation to the forces of third-stage capitalism and nostalgia for the avant-garde is an index of anxieties about redundancy, competition and market value, as academic intellect-ual work has been assimilated to the modes and means of popular cultural production, not only in terms of its domination by publicity values, corporate career tracks, marketing and a star system, but also in its dispersal. 'Travelling Theory', in this stage of capitalism, may be a necessary concomitant of replication and homogenisation, on the one hand, and of diversification and absorption, on the other. As the apparatus of this tactical variation and strategic consolidation of knowledge, the academic environment is de-centred, devolved, internationalised and suburbanised, yet bereft of relations to locality – even to the locality of the campus, since allegiances are to 'the discipline', embodied in its peer reviews, national committees, annual conferences, juried journals, prizes and special awards. In what sense is such a system dislocated by the dissemination of theory, with all its opportunities for travel?)

> *Emigration is the best school of dialectics.*
> Berthold Brecht[131]

(We are compelled to migrancy by the very relations that punish our vagrancy. In 1967, for some the summer of flower power as I recall, I left Tyneside to go South to the University of Nottingham. At the same time, the working populations of entire pit villages in the Northumberland coalfield were being transported to the 'modernised' mines of Nottinghamshire and Derby. It was this area that would provide the base of a break-away Union and scab on the Miners' Strike of 1984–5, which was still being fought as I left unemployment in Leeds and – following so many forgotten generations of Geordies and Scots – took the train to London, then flew across the Arctic to Los Angeles.

Writing in exile. All these displacements; repeated putting at a distance. But are the pleasure and investment not complete until the *return*; like the game with the wooden bobbin, to which little Ernst was so attached and which, even in the variation his grandfather would have preferred, never bobbed off, floated away, bowled along like a wheel, or flew through the air without any strings?)[132]

> *Every story is a travel story . . . a spatial practice.*
> Michel de Certeau[133]

Arrive-t-il? Across the space of the preface: across the opening as frame. Across the spacings of metaphor: the play in theoretical work. Across the metaphors of space: the spaces of discourse, the spaces of power, the space of the subject. Across the spatial grid of the system, the spatial disruptions of resistance and the spatial locations of situated knowledge. Across borders and across the routes of theoretical travel. Across a spatial play: a theatre of meaning.

It is within this theatre that I am trying to think the staging of cultural politics: the conditions of possibility and the local and strategic effects of the economies and régimes of representation, pleasure and power that seek to saturate the social; but also the practices of diversion, deviance and dissent that trade with these

systems, steal from them, evade them, elude them, or erupt within them. This is not a puppet theatre. It is a theatre without strings, without heavy orchestration, without prompt, without a massive, hidden machinery to engineer the performance. Yet, even as the action follows its course, the metaphor may remind us that we have also to deal with the architecture that supplies the frame, the apron, the curtain, the platform, the props, the seats and the boxes, the place of the viewer or addressee, the programme and the introductions.

In its space of intervention, every cultural practice has to mount a stage – put it into effect, present it, frame it, raise it up, climb onto it and cover it – to mark a spatial difference between the space of the house and the space of the play. But the stage is not an empty platform on which a scripted performance merely takes place. Like the frame, in Derrida's analysis, the stage both belongs to the whole apparatus of presentation and is the condition of what can be presented as the work itself, even, or perhaps especially, where that work overspills and mocks the formal space in which it seemed about to be confined. The stage marks where the difference of theatre and play is put in place, but, at the same time, its status is disturbing to the order of externality and interiority it demarcates and, thus, to the commerce, evaluations, laws, hierarchies and forms of spectacle this order makes possible.

This invisible limit – the stage, the frame – is, as Derrida says, 'the decisive structure of what is at stake'.[134] It is the historical trace of an institution of knowledge, where the object of knowledge takes its place in an architecture of presentation, or places this architecture in question. It is the uncertain edge at which a proper attention – looking, listening, reading – is invoked and engaged, or frustrated. It is the never-settled threshold at which a legitimised discourse is allowed to begin; the discourse of art history, say, mounting its precious or even delinquent objects in the space of the modern museum and bringing to bear the full authority of its gaze. It is, therefore, the point at which a historical deconstruction might operate with effect, on 'the decisive structure' of the institution itself.

This may be an unfamiliar deconstruction, at least to those critics and proponents who have equated the insistence that everything is discourse or text with the unlikely belief that everything happens in books. (Some of the more fruitless stand-offs in recent art historical

debates begin here. But the aim, on all sides, has mostly been a coup in the boardroom and business as usual.) Yet, Derrida has been clear enough that:

> It is because deconstruction interferes with solid structures, 'material' institutions, and not only with discourses or signifying representations, that it is always distinct from an analysis or a 'critique'. And in order to be pertinent, deconstruction works as strictly as possible in that place where the supposedly 'internal' order of the philosophical is articulated by (internal *and* external) necessity with the institutional conditions and forms of teaching. To the point where the concept of institution itself would be subjected to the same deconstructive treatment.[135]

What follows for art history is not a form of conventional institutional history. But neither is it an endless metacommentary, generating a universe of tertiary texts that float in a self-sufficient space without coordinates, detached from the space of the social and political. The very terms of this commonplace accusation merely repeat the action of the frame that is at issue. In their very implied promise of another space of genuinely political critique, they effectively remove the institution from the reach of political judgement. The deconstruction of the oppositions of internal to external, text to commentary, the rhetorical to the literal, texts to action, discourse to politics, theory to practice, transforms the concept of the institution and changes the conceptual space in which the political is thought.[136] It displaces those politics that seek to ground themselves on criteria that cannot themselves be political, because they are presented as the state of things, the literal or the real. It denies that prescriptives can be deduced from descriptive statements claiming to represent an empirical reality. It insists on the necessity of political judgements and strategic choices between differing opinions, not on the basis of a decoding of their representation of social reality, but on the basis of an argued calculation of their rhetorical strategies, their modes of linkage and their discursive effects.

If deconstruction of the institution of art history withdraws from 'social' critique, it does so, therefore, precisely in order to fore-ground the question of political and ethical practice; precisely in order to drive home the stakes of the discipline. But stakes are not

interests. They are not what lies behind, so that this political practice cannot take the form of an unmasking. Nor can it stop at a mapping or traversal of the spaces, boundaries, closures, fractures and linkages of the institutional formation. To question art history's finalities is to open the question of its ends. (What circles are described by this Center? Who is the addressee of the *National* Gallery of Art? What end could there be to the transcendent narratives of pricelessness, timelessness, inexhaustibility and the great continuing tradition of Art?) But when it is open, the question of ends also compels contesting voices to speak to the stakes on which they are banking and to which they would have art history tied.

It is here that the major critical interventions that make up the 'new art history' have themselves often run aground, exhausted and irritated by the constant eruption of new and unpredictable forms of dissent. Yet, without invoking the force of the literal or the grounding of critique on the terror of the real, there is no way to limit what can be disputed or what can be put at stake. Welcome or not, this opens the institution of art history to the great struggles of identity and the great movements of deconstruction of our times.

It goes on. There can be no curtailing of these movements to mark an opening for the introduction of other ends.

Notes

1. Jacques Derrida, 'Outwork, prefacing', in *Dissemination*, trans. Barbara Johnson (The University of Chicago Press, Chicago, 1981) p. 35.
2. See Jacques Derrida, 'Tympan', in *Margins of Philosophy*, trans. Alan Bass (The University of Chicago Press, Chicago, 1982) pp. xvii–xviii, fn. 9.
3. Adrienne Rich, 'Notes Towards a Politics of Location', in *Blood, Bread, and Poetry: Selected Prose 1979–1985* (W. W. Norton & Company, New York & London, 1984) p. 215.
4. Derrida, 'Outwork, prefacing', op. cit., p. 8, fn. 11 and p. 11.
5. Ibid., pp. 44–5.
6. Roland Barthes, 'Preface' to *Critical Essays*, trans. Richard Howard (Northwestern University Press, Evanston, 1972) p. xi.
7. In addition to the texts by Derrida and Barthes already cited, see, for example, Foucault's *inaugural* lecture : 'The Discourse on Language',

in Michel Foucault, *The Archaeology of Knowledge*, trans. A.M. Sheridan Smith (Pantheon Books, New York 1972) pp. 215–37:

> I would really like to have slipped imperceptibly into this lecture . . . I would have preferred to be enveloped in words . . . There would have been no beginnings . . .
>
> A good many people, I imagine, harbour a similar desire to be freed from the obligation to begin, a similar desire to find themselves, right from the outside, on the other side of discourse, without having to stand outside it, pondering its particular, fearsome, and even devilish features. To this all too common feeling, institutions have an ironic reply, for they solemnise beginnings . . .
>
> Yet, maybe this institution and this inclination are but two converse responses to the same anxiety: anxiety as to just what discourse is, when it is manifested materially, as a written or spoken object (pp. 215–16).

8. Etienne Bonnot de Condillac, 'De l'art d'écrire', *Oeuvres complètes* (Lecointe et Durey, Paris, 1821) pp. 446–47; quoted in Derrida, 'Outwork, prefacing', op. cit., p. 45, fn. 41.
9. Derrida, ibid.
10. Foucault, 'The Discourse on Language', op. cit., p. 221.
11. Derrida, 'Outwork, prefacing', op. cit., p. 8, fn 11.
12. Karl Marx and Frederick Engels, *The German Ideology, Collected Works*, vol. 5 (Lawrence & Wishart, London, 1976) p. 229.
13. Ibid., p. 231.
14. Ibid. p. 277.
15. Henri Lefebvre, *La production d'espace* (Editions anthropos, Paris, 1974) p. 466.
16. Louis Althusser and Etienne Balibar, *Reading Capital*, trans. Ben Brewster (NLB, London, 1970) p. 26, fn. 8.
17. Ibid., p. 147.
18. Ibid., p. 157, fn. 35.
19. Ibid., pp. 52–3.
20. Ibid., p. 26.
21. Ibid., p. 178; italics in the original.
22. Jacques Derrida, 'White Mythology: Metaphor in the Text of Philosophy', in *Margins of Philosophy*, op. cit., p. 264.
23. Ibid., p. 214.
24. Cf. Derrida's reference to the 'history' of metaphor and the concept of metaphor: Ibid., p. 264.
25. Jorge Luis Borges, 'The Fearful Sphere of Pascal', in *Labyrinths: Selected Stories and Other Writings*, ed. Donald A. Yates and James E. Irby (Penguin Books, Harmondsworth, 1981) p. 224.
26. Jean-François Lyotard, *The Differend. Phrases in Dispute*, trans. Georges Van Den Abbeele (University of Minnesota Press, Minneapolis, 1988) section 262, p. 181.
27. Ibid., section 263, p. 181.

28. Ibid., section 5, p. 5.
29. Michel Foucault, 'Of Other Spaces', trans. Jay Miskowiec, *diacritics*, vol. 16, no. 1, Spring 1986, p. 22.
30. Edward W. Soja, *Postmodern Geographies. The Reassertion of Space in Critical Social Theory* (Verso, London & New York, 1989) p. 58. See, especially, chapter 2: 'Spatializations: Marxist Geography and Critical Social Theory' – which does not, however, deal with the discursive articulation of space or the spacing integral to the articulations of language.
 In what follows, spatial metaphors are tracked across a particular field of cultural theory in order to access a debate that has tried to find ways of rethinking the grounds of cultural politics within the terms of a conception of the discursive field. The discussion is evidently, therefore, not intended as a survey, nor does it exhaust the deployment of spatial metaphors in the subsequent essays. Most obviously, any survey would have had to include the spatialisation of psychoanalytical concepts, specifically in the spatial terms, diagrams and models of Jacques Lacan. Concise and pertinent discussions of this can be found in: Victor Burgin, 'Geometry and Abjection', in J. Tagg (ed.), *The Cultural Politics of 'Postmodernism'*, Current Debates in Art History: 1 (SUNY at Binghamton, Binghamton, New York, 1989) pp. 13–31; and Kaja Silverman, 'Fassbinder and Lacan: A Reconsideration of Gaze, Look and Image', *camera obscura*, no. 19, January, 1989, pp. 55–84.
31. Foucault, 'Of Other Spaces', op. cit., p. 22.
32. Ibid., p. 23.
33. Ibid.
34. Foucault, *The Archaeology of Knowledge,* op. cit., p. 11.
35. Ibid., p. 7.
36. Ibid., p. 10.
37. Ibid., p. 130.
38. Ibid., p. 131.
39. Ibid., p. 7. Cf. also pp. 138–9:

 Archaeology tries to define not the thoughts, representations, images, themes, preoccupations that are concealed or revealed in discourses; but those discourses themselves, those discourses as practices obeying certain rules. It does not treat discourse as *document*, as a sign of something else, as an element that ought to be transparent, but whose unfortunate opacity must often be pierced if one is to reach at last the depth of the essential in the place in which it is held in reserve; it is concerned with discourse in its own volume, as a *monument*.

40. Ibid., p. 13.
41. Ibid., p. 174; my emphasis.
42. Ibid., p. 169.
43. Ibid.
44. Ibid., p. 191.

45. Ibid.
46. Ibid., p. 207.
47. Ibid., p. 205.
48. Ibid., p. 171.
49. Ibid., p. 205.
50. Ibid., p. 131.
51. Ibid., chapter 5, 'Change and Transformations', pp. 166–77.
52. Jacques Derrida, 'Différance', in *Margins of Philosophy*, op. cit., p. 13.
53. Jorge Luis Borges, 'The Library of Babel', in *Labyrinths*, op. cit., pp. 83–4. Interestingly, Foucault denies that the archive is 'the library of all libraries' (Foucault, *The Archaeology of Knowledge*, op. cit., p. 130). For Foucault's commentary on Borges's essay, see Michel Foucault, 'Language to Infinity', in *Language, Counter-Memory, Practice: Selected Essays and Interviews*, ed. Donald F. Bouchard, trans. Donald F. Bouchard & Sherry Simon (Cornell University Press, Ithaca, New York, 1977) pp. 66–7.
54. See William Gibson, 'Burning Chrome', in *Burning Chrome* (Ace Books, New York, 1986) pp. 168–91; and *Neuromancer* (Ace Books, New York, 1984).
55. Foucault, 'Language to Infinity', op. cit., p. 67.
56. In Foucault, *Archaeology of Knowledge*, op. cit., pp. 215–37. The original French text was published as *L'ordre du discours* (Editions Gallimard, Paris, 1971).
57. Editions Gallimard, Paris, 1969.
58. *Surveiller et punir: Naissance de la prison*, 1975. Translated by A. Sheridan as *Discipline and Punish: Birth of the Prison* (Allen Lane, London, 1977).
59. Foucault, 'The Discourse on Language', op. cit., p. 229.
60. Ibid., p. 216.
61. Ibid., p. 220.
62. Ibid., p. 229.
63. Ibid., p. 230.
64. Ibid., p. 234.
65. Cf. Jacques Derrida, 'Passe-Partout' and 'Parergon', in *The Truth in Painting*, trans. Geoff Bennington & Ian McLeod (University of Chicago Press, Chicago & London, 1987).
66. Foucault, 'The Discourse on Language', op. cit., p. 229.
67. Ibid.
68. Ibid., p. 231.
69. Michel Foucault, 'Questions on Geography', in *Power/Knowledge: Selected Interviews and Other Writings 1972–1977*, ed. Colin Gordon (Harvester Press, Brighton, 1980) pp. 70–1.
70. Michel Foucault, 'Truth and Power', in *Power/Knowledge*, op. cit., p. 113.
71. Ibid., p. 114.
72. Foucault, 'Questions on Geography', op. cit., p. 69.
73. Ibid., pp. 69–70.

74. Foucault, 'Truth and Power', op.cit., p. 117.
75. Michel Foucault, 'The Eye of Power', in *Power/Knowledge*, op. cit., p.149.
76. Michel Foucault, 'The Confessions of the Flesh', in *Power/ Knowledge*, op. cit., p. 194.
77. See Foucault, *Discipline and Punish*, op. cit.; and *The Use of Pleasure*, trans. R. Hurley (Pantheon Books, New York, 1985) and *The Care of the Self*, trans. R. Hurley (Pantheon Books, New York, 1986) volumes II and III of *The History of Sexuality*.
78. For the 'strategic utilisation' of the failure of the prison as a reformatory mechanism, see Michel Foucault, 'Prison Talk', in *Power/Knowledge*, op. cit., p. 40.
79. Michel de Certeau, *The Practice of Everyday Life (Arts de faire)*, trans. Steven F. Rendall (University of California Press, Berkeley, Los Angeles & London, 1984) p. 117.
80. Ibid., p. xii.
81. Ibid., pp. xii–xiii.
82. Louis Marin, *Utopics: Spatial Play*, trans. Robert A. Vollrath (Humanities Press, New Jersey & Macmillan, London, 1984) p. 9. Marin writes:

> the utopic schema (or the signifying practice that stages the discourse) engenders *spaces* in the unity of a same project. It is a plural organization of spatiality. Within this discourse, which has been closed off by the synopsis of a totalizing (or totalitarian) gaze, this multiple production is signified by the incongruity of the produced spaces. This is a spatial play that can be defined as both imaginary (a productive figurative schema) and nonsuperimposable (multiple spaces), all within the most rigid coherence of a totalizing *discourse*. (Ibid., p. xiv.)

Or more briefly:

> Utopia is the systematic figure within discourse of a strategy for spatial play: it is between the text's signifying and signified spaces. (Ibid., p. 198.)

In Michel de Certeau's terms:

> spatial practices also correspond to *manipulations* of the fundamental elements of a constructed order; like rhetorical tropes, they are *divergent* from a kind of 'literal' meaning defined by the urban system. ('Practices of Space', in Marshall Blonsky (ed.), *On Signs* (The Johns Hopkins University Press, Baltimore, Maryland, 1985) p. 136.)

83. De Certeau, 'Practices of Space', op. cit., p. 139.
84. Cᶠ Kristin Ross, *The Emergence of Social Space: Rimbaud and the Paris Commune* (University of Minnesota Press, Minneapolis, 1988).
85. De Certeau, *The Practice of Everyday Life*, op. cit., p. xvii.
86. Ibid.

87. Ibid., p. xix.
88. See Lyotard, *The Differend*, op. cit., pp. xv and 181 (sections 263–4).
89. Ibid., section 262, p. 181.
90. Ibid., section 23, p. 13.
91. Jacques Derrida, 'Structure, Sign, and Play', in *Writing and Difference*, trans. Alan Bass (University of Chicago Press, Chicago, 1978) p. 292.
92. Jean-François Lyotard, *Peregrinations: Law, Form, Event* (Columbia University Press, New York, 1988) p. 5.
93. Rich, 'Notes Towards a Politics of Location', op. cit., p. 215.
94. Ibid., p. 212. Henri Lefebvre had also, ten years earlier, insisted on 'the body with space, in space, as generator (producer) of space'. (Lefebvre, *La production de l'espace*, op. cit., p. 468.) Western philosophy, he argued, had betrayed the body; though it had done so, according to his positivist sociological analysis, by actively contributing 'to the great *metaphorization* which abandons the body' (ibid., p. 467; my italics); by failing to grasp the 'reality' of social and spatial practice, by leaving 'mental space' and following a trajectory 'from the abstract to the concrete' (ibid., p. 477).
95. Rich, 'Notes Towards a Politics of Location', op. cit., p. 212.
96. Ibid., p. 215.
97. *Center 8. Research Reports and Record of Activities*, June 1987–May 1988 (National Gallery of Art, Center for Advanced Study in the Visual Arts, Washington, D.C., 1988) p. 9.
98. Lyotard, *The Differend*, op. cit., pp. xv-xvi, 79 (sections 131–2) and 115–6 (section 172).
99. Donna Haraway, 'Situated Knowledges: The Science Question in Feminism and the Privilege of Partial Perspective', *Feminist Studies*, vol. 14, no. 3, Fall, 1988, p. 581.
100. Ibid., p. 583.
101. Ibid., p. 588.
102. Ibid., p. 587.
103. Lyotard, *The Differend*, op. cit., section 202, p. 142.
104. Haraway, 'Situated Knowledges', op. cit., p. 590.
105. Ibid., p. 588.
106. See Foucault, 'Truth and Power', op. cit., especially pp. 126–33.
107. Ibid., p. 131.
108. Haraway, 'Situated Knowledges', op. cit., pp. 590 and 597, fn. 5.
109. Ibid., p. 597, fn. 5.
110. Ibid.
111. Ibid., p. 588.
112. Ibid., p. 589.
113. Ibid., p. 578.
114. Ibid., p. 577.
115. Ibid., p. 580.
116. Ibid., p. 578.
117. Ibid., p. 579.

118. Edward W. Said, 'Travelling Theory', in *The World, The Text, and the Critic* (Harvard University Press, Cambridge, Massachusetts, 1983) p. 241.
119. Ibid., p. 237.
120. Ibid., p. 242.
121. Ibid., pp. 246–7.
122. Jacques Derrida, 'Parergon', in *La verité en peinture* (Flammarion, Paris, 1978) p. 71; and *The Truth in Painting*, op. cit., p. 61.
123. Lyotard, *The Differend*, op. cit., section 190, p. 138.
124. Ibid., section 198, p. 141.
125. James Clifford, 'Notes on Travel and Theory', in James Clifford and Vivek Dhareshwar (eds), *Travelling Theories, Travelling Theorists*, vol. 5 of *Inscriptions* (University of California at Santa Cruz, Santa Cruz, 1989) p. 177.
126. Ibid. On 'proper' (the literal, correct, usual, individual, particular, belonging, owned), see Derrida, 'White Mythology', op. cit.; and de Certeau, *The Practice of Everyday Life*, op. cit.
127. Cf. George Lakoff and Mark Turner, *More Than Cool Reason* (University of Chicago Press, Chicago & London, 1989) p. 130.
128. Clifford, 'Notes on Travel and Theory', op. cit., p. 185.
129. Ibid., p. 182.
130. Ibid., p. 184. See also Lata Mani, 'Multiple Mediations: Feminist Scholarship in the Age of Multinational Reception', in Clifford and Dhareshwar, *Travelling Theories, Travelling Theorists*, op. cit., pp. 1–23.
131. Bertolt Brecht, *Fluchtlingsgespräche* (Frankfurt, 1961) p. 112; quoted in Martin Jay, *Permanent Exiles: Essays on the Intellectual Migration from Germany to America* (Columbia University Press, New York, 1985) p. 28.
132. For more on this game, see Jacques Derrida, 'Freud's Legacy', Derrida's reading of the second chapter of Freud's *Beyond the Pleasure Principle*, in *The Post Card: From Socrates to Freud and Beyond*, trans. Alan Bass (University of Chicago Press, Chicago & London, 1987).
133. De Certeau, *The Practice of Everyday Life*, op. cit., p. 115.
134. Derrida, 'Parergon', in *The Truth in Painting*, op. cit., p. 61.
135. Ibid., pp. 19–20.
136. Cf. Bill Readings, 'The Deconstruction of Politics', in Lindsay Waters and Wlad Godzich, *Reading De Man Reading* (University of Minnesota Press, Minneapolis, 1989) pp. 223–243.

1

Art History and Difference

I came to Leeds in 1979 when Tim Clark left for Princeton. I came for one year but he did not come back, so I stayed on; five years on one-year contracts without the tenure which would have guaranteed my intellectual freedom and integrity. When I arrived, the MA in the Social History of Art was one year old; in happier days, polymorphous and perverse and not yet cut by the fear of castration. It was then an informal if intense affair centred on the professorial study; a seminar of equals unworried by strictnesses of syllabus or format and untroubled by the real inequalities of educational relationships. By 1984, the course had its syllabus, structure, procedures and precedents. What it lost by this exactness may, I suppose, have to be set against its greater frankness about the need for teaching and its openness to scrutiny. Paradoxically, the open-ended tutorial had often rested on the traditional academic assumptions that the aims and objects of the discipline are given and access to enquiry is available to all. The tighter structure was the means of bringing these assumptions to view and putting them in doubt. From imagined wholeness, it produced, by the imposition of order, a fractured subject.

This chapter originally formed the text of my final seminar for the Leeds University MA in the Social History of Art, in April 1984. It was published in *Block*, no. 10, 1985; and reprinted in *The New Art History: An Anthology*, edited by A. L. Rees and Frances Borzello (Camden Press, London, 1986).

Five to ten years ago, it was possible to imagine a central, unified project, crucially marked by the conjunction of Marxism and art history which had yet to be defined and whose consequences needed to be worked out in theory, practice and pedagogy. But that was a time when it seemed to make sense to talk of an intervention in the discipline. In the forefront were to be questions of method – questions for which, it was suggested, a solution had already been found in the born-again Social History of Art. It was not a matter of debate. Tim Clark wrote:

> I'm not interested in the social history of art as part of a cheerful diversification of the subject, taking its place alongside the other varieties – formalist, 'modernist', sub-Freudian, filmic, feminist, 'radical', all of them hot-foot in pursuit of the New. For diversification, read disintegration.[1]

For Clark in 1974, the Social History of Art was 'the place where the questions have to be asked, and where they cannot be asked in the old way'.[2]

The passage I quote is notorious enough. Yet its notion of a unified method lingers on in the title of the Leeds course and is still evoked in optimistic talk about a 'New Art History'. Of course the refusal to be marginalised within academic definitions of the discipline, the refusal to be accommodated and peacefully coexist as an alternative specialism, a more or less tolerated sideline, was and is correct. The point was to challenge the structuring values of the discipline itself. What does not follow from this, however, is the idea of a single methodological solution to all art history's ills, a privileged critique which will grow into a coherent practice, subsuming all other 'diversifications'. Even from the point of view of Marxist theory alone, the concept of overdetermination must imply (at least, this side of the millennial 'last instance') an accumulation of analyses corresponding to the complexly over-determined nature of cultural production itself. These analyses have different theoretical statuses and different levels of application which cannot be ranked or put into a hierarchy in advance. Their relationships remain to be explored and explained in each historical instance, but cultural history can offer no guarantees of their relative value or compatibility, let alone the reducibility of all the methods to one.

The same theoretical constraints will also frustrate hopes for an easy eclectic solution to methodological problems. Perhaps we have seen the formula 'Marxism-feminism-psychoanalysis' too often to wonder at what it presumes. What strikes me is that it is the hyphens which do all the work. It may be adequate shorthand for a range of challenges within art history, or for the components of a wider debate with which art history has at last been brought into contact. But its repetition has hidden tensions and incompatibilities and too easily implied that different theoretical traditions can be not only reconciled but combined. To signal the scope of converging critiques is one thing, but to underestimate the complexity of the debate or collapse the convergence into an identity is to close down potentially productive problems and impoverish a still scarcely emerging analysis of the function of representational practices. It also means returning, against the direction of the very theoretical traditions invoked, to the metaphysical notion of an homogeneous Reality as the common referent of a number of discourses, from which it may be extrapolated to serve as an index of truth.

These are not the only criticisms to be made of the once-confident expectations of the Social History of Art. Too often its practice has betrayed an assumption that reconstituting art history means reconstituting the history of a given realm of objects – objects already designated both as 'art' and as 'historical': the familiar 'masterpieces' of conventional art history. Any adequate critique of art history must, however, entail a critique of the canon or paradigm of art which it constitutes or articulates, and therefore of the repertoire of legitimate objects with which art histories have engaged. The limits of this repertoire have, in any case, been differently drawn for different periods of study. As Kurt Forster has pointed out:

> Most museums would not, to this day, exhibit in their nineteenth-century section household items, which often represent the bulk of modest collections of Greek and Roman antiquities.[3]

Such differences have usually been settled by the economics of scarcity, but it would be wrong to see the valuations of art history as merely reflecting the judgements of the market-place. Insofar as it operates with and defends a given definition of its object of knowledge, while limiting the permissible methods for constructing

and establishing such knowledge, art history reproduces a dominant paradigm or canon of art and the fundamental values on which it rests. The paradigm appears as given, but is always produced. The introduction of new methods – certain kinds of Marxism, semiotics, or discourse theory – is therefore no measure of whether a radical shift has in fact taken place. As Raymond Williams has argued in relation to the field of literary studies, we have to discriminate between those tendencies which, however strange and unruly, have been compatible or even congruent with the orthodox paradigm, and others which 'necessarily include the paradigm itself as a matter for analysis, rather than as a governing definition of the object of knowledge'.[4]

I should make it clear that this is not to equate art history's object of knowledge with the objects it studies. Adjustments to the latter – admitting say photography, prints, film, or advertisements – mean nothing in themselves. I could go further and say that it would be misleading to suggest that the focus of art history ought to be objects at all, where these are seen as discrete items. And this stricture applies as much against those recent attempts to see art objects as 'texts' whose 'internal' organisation must be linked in some way to certain 'external' relations. The relation of particular cultural products, particular meanings, and particular conditions of existence remains a problem which has to be studied, but particular objects can neither be seen as the expression of their conditions of existence nor be separated from the subtle webs of discourse of which they are part. Without denying the specificity of material practices of representation, we have to see the objects art history studies as one relation in a field of social processes made up of interchanging and mutually inflecting discourses and practices. Within this field, we must also see that the production and circulation of meanings is itself a modality of power, subject to but also generating multiple relations of domination and subordination. The question to ask is not, 'What does it express?' but, 'What does it do?'

This much has been argued before. We cannot, however, leave it here, as a question of methods and objects. (What is extraordinary in Williams's response to the Cambridge University débâcle over Colin MacCabe's tenure is that he seems to accept that we can.)[5] The debate has not just lain in the realm of theory. It has been institutional and it has had a history. On this more radical level, we

are going to have to understand art history as itself a cultural practice and concern ourselves with the more awkward questions of where and when it is done, by whom and for what purposes. The questions apply to ourselves as much as to others. If the moment of the Social History of Art has retreated, then one might say that Situationist Paris is a vastly different site from Harvard in the last year of Reagan's first term, and neither resembles Leeds.

The roots of recent attempts to construct a Social History of Art lay in those critiques of what were called 'bourgeois disciplines' which were so integral a part of student unrest in the expanding and restructured universities and colleges of the late 1960s. For reasons that were not to remain compelling, such counter-course critiques were then entirely bound up with attempts to democratise educational structures and with that wave of diverse political movements which questioned the privileged place of higher education within the military-industrial-state complex. When Perry Anderson wrote his critique of the 'components of national culture' in 1968, he pulled together the elements of a wide-ranging reassessment of academic disciplines in which art history was not ignored.[6] And yet art history never had an authentic counter-course movement. When the critique came, it came late and from teachers, even professors, rather than from students. In a changed situation, this could only heighten the dangers of academic incorporation in a decently diversified syllabus and of the containment of an oppositional discourse in closed reading groups, small circulation professional journals, and specialist post-graduate options. More than this, it shut down debate on the institutional sites of intellectual practice, rendering the new critical 'vanguard' blind to its own position within a more comprehensive system of cultural production.

The methodological debate, the critique of art history's implicit values, and the analysis of art's relation to wider processes of social reproduction went ahead. Much less, if any, attention was given to art history as an institutional practice, outside local academic politics. Few analyses were produced of the institutional sites in which art history is mobilised. Even fewer attempts were made to organise interventions within them or to establish new kinds of linkage. Equally rare were attempts to understand the effects of changing conditions of intellectual production in general: the processes of specialisation, professionalisation and metropolitanisation, selective state investment, and the restructuring of education,

publishing and the media, which concentrated and isolated the practice of art history like all other intellectual practices. You cannot talk of an effective intervention in the discipline which does not engage with these conditions. Yet protagonists of the Social History of Art have not seen this as their task.

Notwithstanding its links to the Left and the Women's Movement, the 'New Art History', outside Germany, has been largely a campus affair and its proponents have been, for the most part, employed academics who have been reluctant or unable to link up with curators, schoolteachers, guides, leisure officers, National Trust administrators, and local officials who occupy different and less privileged spaces in art history's institutional order. The arguments have been kept within the bounds of academic conferences, departmental meetings and learned periodicals and have been, in consequence, entirely vulnerable to a change of climate there. In Benjamin's terms, you might say that the apparatus was supplied with new material, but the relations of art historical production were reproduced untransformed. When the crisis came in the universities, with budget cuts, loss of jobs, wholesale unemployment for graduates, the downgrading of Arts Faculties and increasing talk of 'orthodoxy' and 'leadership', there was no effective base on which a defence of even limited advances could be made.

What followed was a number of hasty departures and domestic retreats, a flurry of accusations, and a culpable silence. The turn of the tide left some encircled and others cut off. On one side, arguments and oppositions solidified into career-tracks and publicity values, closed to all but a few elite new bloods, denigrated by a fashionable new Right, but flattered by novel attentions from older academic institutions and newer media. On the other side, the old heroics returned: accusations of incorporation and selling out; reassertions of the moral vocation of cultural and intellectual work; rallying calls for a new guerrilla avant-garde on the edge of an allegedly disintegrating society. Either way, so-called 'significant culture' was seen to reside once more in the hands of a privileged or an embattled few. It was the same old play. It had been done as tragedy and as farce and had now gone into rep. But if moral denunciations, more Spartan definitions of outsiderness, and grotesque inflations of the role of the intellectual and artist compensated some for marginality, they could not solve problems

which called for political calculation, collective organisation, and institutional resistance.

This is the measure of the present impasse. It cannot be resolved by importing new methodologies, disseminating a concept of 'representation', running a course on modernism or popular culture, or by deleting 'art history' from the calendar and inserting 'cultural production'. What has to be tackled lies on a more profound level which has not yet been confronted. The confidence of ten years ago seems now in need of its own explanatory archaeology. Clark wrote then that we stood in need of a new work of theory and practice. I might say as much now, but it does not seem much help. No singular strategy can do anything but conceal the inherent complexities and necessary diversity of response. What emerges most strongly, however, is the need to grasp the role within the state, in its national and local manifestations, of the cultural practices and institutions of which we are a functional part. Indeed, it only makes sense to talk of cultural intervention and struggle in relation to societies which have developed certain forms of the state and in which governmentality rests, at least in part, on the effect of a range of cultural institutions in securing the social relations on which the social formation depends. I do not wish by this to conjure up again a grand context for art history's trials. The space may be small. But modern governmentality exists in capillary forms and must be met and confronted at a multiplicity of points. Art history must know how it is touched by and touches, in turn, this dispersed structure of governance. But there is no neutral ground on which the attempt may be made. The problem of *where* to practise is as pressing as *how*.

Notes

1. T. J. Clark, 'The Conditions of Artistic Creation', *Times Literary Supplement*, no. 3768, 24 May 1974, p. 562.
2. Ibid.
3. Kurt Forster, 'Critical History of Art, Or Transfiguration of Values?' *New Literary History*, vol. 3, 1972, pp. 462–3.
4. Raymond Williams, 'Marxism, Structuralism and Literary Analysis', *New Left Review*, no. 129, September–October 1981, p. 65.

5. Significantly, Williams's review of new critical methodologies was based on a lecture given in Cambridge University's English Faculty in February 1981, at the time of the refusal of tenure to Colin MacCabe, when structuralist, semiotic, and Marxist approaches to literary studies became the object of public controversy.
6. Perry Anderson, 'Components of National Culture', *New Left Review*, no. 50, 1968.

2

Should Art Historians
Know Their Place?

Reaching for a title some months ago, I committed myself, some-what rashly perhaps, to a blunt enough question whose legacy I cannot now avoid. A direct question seems to demand a direct answer. Should art historians know their place? Well, *no* – and, *yes*.

NO: if it means being deferential, keeping within the bounds of an aesthetic decorum whose organisation and effects certainly need to be studied, but which so much art history serves only to perpetuate; if it means being polite, accepting the definitions of good manners built into the imposing, sacramental institutions which house art history's supposed objects of study, where failure to conform may jeopardise the very access a historian has to the properties of private collections, auction houses, religious institutions, country homes and museums.

This paper was first presented as a contribution to a session on the institutions of art history in *Arts and Histories Reconsidered: A Symposium on Current Debates*, organised by Holly Barnet-Sanchez, Marcos Sanchez-Tranquilino and John Tagg, at the University of California at Los Angeles, in March 1986. It was subsequently published in a special supplement to the Los Angeles Institute of Contemporary Art *Journal*, edited by Marcos Sanchez-Tranquilino (Winter 1987); and in the first issue of *New Formations*, Spring 1987.

YES: if it means recognising how art histories decorate the ways of life of the powerful, creating and validating social occasions for civilised displays of superiority and wealth and, more than that, serving themselves as models of decorum, reproducing manners, generating standards of taste, and laying down protocols for correct behaviour in the presence of Art – which is, in the end, all that aestheticism has been able to specify.

NO: it if means embracing the commodification of culture in the name of monetarist realism, commercial populism or marketing management which see art history's democratic, privatised future in domestic consumption, leisure industries, publicity and tourism, issuing in 'Life Style' magazines, picture-books, block-buster shows, higher-brow theme parks (like the Jorvik Viking Centre in York, England, which literally offers a ride backwards into history), and package tours through which, in Britain, what is called the national heritage has, like the monarchy, become a significant foreign-currency earner. Indeed, selling the connotations of aristocracy and selling the connotation of Art may have come to appear inseparable, as when the alleged treasures, refined ambience and damp air of English country homes came to Washington last year; but the same process may turn around their opposite, as in the current desperate strategies of deindustrialised northern English towns like Liverpool, Bradford, Leeds and Newcastle, which may be summed up in the conception of the Museum of Northern Working Life at Beamish, County Durham, in which redundant equipment and an abandoned pit-head have an after-life as Art.

YES: if it means avoiding élitist distaste (whether of an Elliotic or an Adornic kind) and grappling with what Fredric Jameson optimistically calls 'Late' capitalist contradictions,[1] which threaten to envelop any and every cultural intervention or effort at conservation in the West today; yet which open up new avenues of opportunity in the way certain art histories (though rarely the ones with which academics concern themselves) have a mass audience now in developed capitalist countries and occupy a strategic position, not only in the cultural order but also in a political economy increasingly weighted in favour of finance capital, service industries and consumption.

NO: if it means gratefully occupying those niches in the institutional order readily prepared for some of us; if it means pandering to collectors, jobbing for the salesroom, pimping for the dealers, walking the streets with the artists, flirting with government agencies, or bowing to what we are told is the national interest.

YES: if it means turning attention to the (still largely unwritten) institutional histories of the discipline, to the role art histories play in an economy as much libidinal as it is political; if it means acknowledging that art histories always function institutionally and, even supposing they had the desire, have nowhere to run to, nowhere to hide, no privileged space to which to retreat. (Where would that be? The University as guarantor of scholarly neutrality? Surely Noam Chomsky, in his analyses of the military-industrial-educational complex in the USA, and more recently Régis Debray, in his *Teachers, Writers, Celebrities*, have said enough about that.[2] Where else? The unstable economy of the small independent magazines, which provided the base for dissenting scholarship in the 1970s, as they had in the 1930s? But these too have been all but absorbed by the universities and established publishing houses. Or perhaps we should think more dramatically of the space of the avant-garde intelligentsia in its villages and marginal encampments: a space fantasised as a radically Other place, but a space unthinkable other than within a map of metropolitan encounters, international communications systems and an urban-industrialised economy.)

NO: if it means serving, at a less genteel or publicised level, those processes of colonialist discourse through which Western art histories have not only shored up superioristic states of mind and even self-aggrandised states, but have also contributed, through the articulation of racial difference in normative and Eurovocal conceptions of civilisation and culture, to the subjugation of what is thereby constituted as the negative Other and to the fetishising of the exotic Other as object of Western desire: both component processes of cultural expropriation and even cultural genocide at a national and international level.

YES: if it means urgently attempting to comprehend this economy of domination, this trade in artefacts and representations of cultures, while acknowledging that there are ways Western intellectual traditions, with their roots in the nineteenth century, cannot

speak of it at all but must listen, if they are not to be caught in and reproduce the same relations of imperialist power.

NO: if it means subservience to a normative notion of authentic culture; if it means, as it so often does, not only analysing but effectively defending received rules and codes, or constructing a tradition and finding a place within it; if it means assuming the role of guardians of the Cultural Canon, or even curators of some more mundane conception of the Heritage, as a dictionary of Master-pieces somehow always already designated both as Art and as Historical.

YES: if it means beginning to grasp what is at stake in disciplines like art history, which constitute the object 'culture' and exercise discrimination to *produce* values and exert power effects. As Raymond Williams has argued of literary studies,[3] any adequate critique of the discipline of art history must entail a critique of the canon or paradigm of Art it constitutes, of the repertoire of objects it produces, legitimates, sadistically fractures and fetishistically reassembles, of the methods it validates for constructing and establishing what it defines as knowledge, and of the consequences all this has for social reproduction.

NO: if it means separating art history's objects of knowledge (the objects it constitutes as *historical* and *art*) from the complex of mutually inflecting discourses and practices which make up the field of social processes of which the specific material practices of representation art history chooses to study are part.

YES: if it leads to engagement with the ways visual representations, as part of the production and circulation of meanings, are themselves a modality of pleasure and power, subject to but also generating multiple relations of domination and subordination.

NO: if it means isolating the discipline, autonomising its history and arguments, constructing an identity for it, the better to exclude diversity while bolstering its professional status and maintaining an atavistic hostility to what can then be called 'external' intellectual developments which threaten common-sense categories – like 'social', 'history', and 'art' – that have no need it seems of theory, though they are already burdened with complex histories and theoretical assumptions.

YES: if it means recognising the specificity, conditionality and effectivity of the institutions of art history, the better to challenge that notorious insularity which has elided the discipline's own histories in which different national structures – focused initially, for example, on the private collection and salesroom in England, but on the university and museum in Germany and Austria – have supported diverse but crucially formative relations with other contemporary intellectual practices – not only philosophy, psychology, sociology and literary theory, but also the practice of art. We might also remember that, if one professionally defensive tendency in the current art historical debate has wanted to cut itself off from an unruly contemporary art practice, then this has been to ignore that much of the recent impetus to theoretical work came not from within art history, but from conceptual and post-conceptual practices which also created the conditions for exemplary collaborative interventions in art history itself, such as the production and distribution of an *anti-catalogue* to deconstruct a Whitney Museum bicentennial exhibition, drawn from highly selective Rockefeller collections but represented as a definitive survey of the history of American painting.[4]

NO: if it means digging in on professional status, sand bagging the hierarchies of the discipline, and entrenching its division of labour. *YES:* if it clears the way to linking up with functionaries of all kinds – curators, schoolteachers, tour guides, leisure officers, National Trust officials, and so on – who make up the complex contemporary economy of art history but occupy less privileged places than professional academics whose positioning, by contrast, has often rendered them strategically blind to all but their own field of practice and tactically blind to the new styles and spaces of work we shall have to develop if we are to intervene more effectively in that economy.

NO: if it means declaring a position and raising a flag – to the New Art History or the Social History of Art, for example, as *the* privileged critique that will give rise to a coherent practice; if it means staking out a theoretical site, a place for miracles and healing, a place for pilgrimage, which will also be a place in the sun, a piece of the territory of the discipline for defence and possession. Proffered solutions and career profiles: they have

become so inseparable (what claims am I staking now?) even in the face of wholesale unemployment for graduates, for whom differentiation on the buyers' job-market is fast becoming irrelevant.

YES: if it means not closure, solutions, positions, careers, but engagement; and if this engagement runs to asking when, where and by whom art history is allowed to be done, under what conditions, and to what ends, and how the answers to these questions have been decisively altered by changing conditions of intellectual production: by processes of specialisation, professionalisation, metropolitanisation, selective state investment, the restructuring of education, and the growth of publicity and the media, all of them processes tending to concentrate and isolate intellectual work in an ever more-stratified institutional division of labour. Can any critique of art history claim to be radical which does not struggle with its place in this?

NO: if it means being marginalised within academic definitions of the discipline; if it means being accommodated in a decently diversified syllabus and peacefully coexisting as an alternative specialism, a more or less tolerated sideline: structuralist art history alongside post-structuralist art history, social art history, feminist art history, psychoanalytical art history and, on another level, Scottish art history alongside Chinese art history, ancient art history alongside modern art history, all of them coexisting without contradicting, yet somehow eclectically reconciled in the larger discipline.

YES: if it means insisting, against this repressive pluralism, that there is a strategic debate, at the point of convergence of overdetermined and radically diverse analyses which have different theoretical statuses and different levels of application and whose relationships remain to be explored, but which can no more be held conveniently apart than they can be collapsed into an identity.

NO: if it means repeating the claims of an Anglo-American social history of art which, almost fifteen years ago, drawing strength from renewed theoretical debate on the left and in the Women's Movement, sought to rally dissent in the discipline around new unifying ambitions, rejecting diversifying debate as diversionary and

claiming, in T. J. Clark's words, to be 'the place where the questions have to be asked'.[5]

YES: if it means recognising what that reworking of the social history of art failed to do: not only that theoretical discourses have no common referent and can have no common agenda of question, let alone be subsumed in one problematic; but also that 'the place where the questions have to be asked' was always inscribed within the institutional limits and power relations of art history, which cannot be reduced to methodological positions and whose effective neglect left this version of the social history of art analytically and practically defenceless against a wave of cuts, unemployment and so-called rationalisation which has battered the arts and education in Britain and threatens now to do the same in the USA.

NO: if it means conjuring up another historicist schema – an expressive structure with its teleological principle, whether that of forms, ideas, modes of production or struggling classes – which can only be a syntactic device seeking to secure the position from which the historian speaks and to guarantee meaning to the historical narrative.

YES: if it means engaging with the ways such closure of historio-graphical truth, like its seeming opposite – the proliferation of particularist histories – does not float conditionless. History is both institution and institutionalised. We need not invoke the idea of origins which determine or guarantee meaning in order to insist that the conditions of existence of histories, open or closed, are traced upon them, are inflected by them, certainly, but are always irreducible to them. The conditions of historiographical closure or proliferation are not generated purely within the text, nor are their effects confined there. Analysis of and engagement with these conditions will demand, therefore, more than textual skills. We are back at the places of histories. Will Derridean deconstruction or, more elusively, the Lyotardian Sublime be enough to change them? [6]

NO: if it signals an imaginary return to Real History, to what supposedly sustains both the discourse of art history and the practices it studies, that is, the institutional base seen as already given, as the machinery of already coded and inscribed interests which are then determinant, as an institutional façade which – as in

Hans Haacke's representation of the Metropolitan Museum, New York[7] – conceals another space, behind the banners and entablature, waiting to be unmasked: a determinant space – the space of Capital, perhaps, waiting the last instance, waiting to express itself, waiting to steal modern art, and so on.

YES: if it allows that the relations of institutions, practices, discourse and agents, in art history as in any other domain, are highly complex – that there is no neat division of text and context: that institutions and agents are already textualised; that discourses and practices are already condensations of power effects; that social interests and identities are not given but produced and reproduced across the discursive order and economy of which art histories are part; that to insist on this is very different from positing a determined power and its expressions.

NO: if the question can be taken at its word; if it implies a singular act of knowing, a collective and unified, possessive self, a subject to be reunited with its truth, or one fixed and predictable common place.

YES: if, in the sense Paul Hirst develops in his critique of Althusser's theory of ideology,[8] it calls instead for continual, conditional political calculation; if it generates specific knowledges and representations, analysing their conditions of existence and calculating their specific effects, without being caught either in fetishistic closure or its utopian denial; if it traumatises assumptions that the 'their' of the question has a given and stable referent – the subjects of art history, always already defined and amongst whom we would be privileged to find ourselves; if it explodes and disperses not the 'place' of art history, for that is already multiplied, but the logocentric fantasy that there is or could be one place: the place of an acknowledged presence: the founding subject, source of meaning, and beyond that, the Master Subject: Historical Truth in its various guises.

Without such securities, however, it may seem that the question cannot be answered. Or, more precisely, that there can be no end to answering. Did I hear you sigh? Are we not in danger of losing our place, if you or I have not already done so in this mêlée of answers? Perhaps the point is that there never was such a place, outside the

continual production, exclusion and elision of positions for speaking, within a discursive and institutional régime whose conditions of existence, limits and effects have to be gauged and regauged from perspectives that cannot claim privileged exterior vantage points. In this context, no singular strategy, no separation of methodological issues from institutional analyses, no grand historical narrative can do anything but consolidate the régime of art history, conceal the inherent complexities and obstruct the necessary diversity of response. No recipes for action here. No 'social command', as one-time Marxists used to say. This is not, however, an apology for defeatism, but rather an argument for another kind of *nous*.

Notes

1. Fredric Jameson, 'Postmodernism, or the Cultural Logic of Late Capitalism', *New Left Review*, no. 146, July–August 1984, pp. 53–92; and 'Foreword' to Jean-François Lyotard, *The Postmodern Condition: A Report on Knowledge* (University of Minnesota Press, Minneapolis, 1984) pp. vii–xxv.
2. Noam Chomsky, *American Power and the New Mandarins* (Pantheon Books, New York, 1969); *Problems of Knowledge and Freedom* (Pantheon Books, New York, 1971); and 'Politics', in *Language and Responsibility* (Harvester Press, Sussex, 1979). Régis Debray, *Teachers, Writers, Celebrities: the Intellectuals of Modern France* (New Left Books, London, 1981). See also: Francis Mulhern, '*Teachers, Writers, Celebrities*: Intelligentsias and Their Histories', *New Left Review*, no. 126, March–April 1981, pp. 43–59.
3. Raymond Williams, 'Marxism, Structuralism and Literary Analysis', *New Left Review*, no. 129, September–October 1981, pp. 51–66.
4. The Catalogue Committee, *an anti-catalogue* (New York, 1977).
5. T. J. Clark, 'The Conditions of Artistic Creation', *Times Literary Supplement*, no. 3768, 24 May 1974, p. 562.
6. For an introduction, see Jacques Derrida, *Positions*, trans. Alan Bass (University of Chicago Press, Chicago, 1981); and Lyotard, op. cit.
7. Hans Haacke, *MetroMobiltan*, 1985.
8. Paul Hirst, 'Althusser and the Theory of Ideology', in *On Law and Ideology* (Macmillan, London, 1979) pp. 55–6, 73.

3

Articulating Cultural Politics: Marxism, Feminism and the Canon of Art

I am here, I imagine, to speak *to*, though – for reasons that will become clear – not *for*, the first term of this evening's title: 'Marxism and Feminism: Convergence in Art'. It is a title, we may note, that sets a number of generalising terms in place and constructs a narrative flow from one suggested unity to another. What has to be said is that, after twenty years of renewed radical debate in this area, it is precisely this confident and optimistic flow that has become so difficult to maintain. You will not need me to remind you that this has not been for theoretical reasons alone. Yet, it is a significant fact that, as a result of a number of developments in the field of contemporary theory, each of the nouns of the title has come to be seen less as the name of a coherent position or practice than as the site of a specific set of problems that must also affect our conception of the ways they can be linked together.

The text of this chapter was presented as a contribution to a symposium, organised by Linda Nochlin, on *Marxism and Feminism: Convergence in Art*, in the Sunday Symposia series on 'Issues in Contemporary Art', at the Whitney Museum of American Art, New York, in November 1988.

Let me begin with the term that is marked out for me in advance, and in which I am marked out: the M word, not the F word. For all its currency in populist political rhetoric of various persuasions, and for all the sorry history of attempts at dogmatic closure, the term 'Marxism' does not mark a homogeneous body of doctrine, with its source in a set of texts whose meaning and unity are secure, but rather a number of articulated lines of debate. And if, in the way these debates have been imposed on cultural history over the past hundred years, certain models have insistently put themselves forward, these have certainly never exhausted the theoretical resources we might find in Marx's analyses or in their histories of contentious readings, on which quite different forms of political calculation have been based.

Schematically, we might take for example the conceptualising of 'class', which is clearly of central importance to our concerns here today. In texts by Marx such as *The German Ideology*, the *Communist Manifesto*, and the 1859 'Preface' to *A Contribution to the Critique of Political Economy*, we may find a tendency to conceive of class as a historical structure of fixed positionalities, inscribed at the level of the economic base, whose consequences are then logically unfolded as a set of conflicting forms of life, themselves expressed in social objectives, political forms and ideologies as the necessary superstructural realisation of a struggle of fundamental class interests.[1] Even here, much hangs on the play there is in the usage of the word 'determination' and on the precise application of the terms 'base' and 'superstructure', inextricably complicated today by the growth of cultural and communications industries which, like the material practices of language, find no comfortable place on either side of the theoretical divide. If we turn, however, to works like the *Grundrisse*, *The Eighteenth Brumaire of Louis Bonaparte* or, indeed, the central chapters of *Capital* on the development of the factory system and the transition from absolute to relative surplus value, we find very different models in which to think the constitution of class.[2]

Here, concepts of structure and social transformation turn not on the architectural metaphor of base and superstructure, but on the notion of an interactive structuring of differentiated practices, within which there may be patterns of dominance, but behind which there is no longer any essential and logically determinant process. Crucial to these texts is a concept of representation or

articulation, in relation to which class positions may be thought of as complexly, and not necessarily coherently, *produced* across an array of social practices involving definite modes and means of representation. Understanding class in these terms involves, therefore, not the uncovering of origins, but the situational analysis of the overdetermined, and not necessarily homogeneous, processes of the constitution of classed subjects. What opens up is the prospect of an analysis of the articulated levels of representation at which, given certain definite means and conditions, social identities and differences are culturally, politically and economically produced and precariously fixed.

Drawing on such theoretical resources, we are, then, simply able to sidestep tedious and unproductive theoretical disputes about the most fundamental determinant: class, gender, race or ethnicity, where these terms are conceived as essential, originary forms imposed on cultural and political 'expressions', and where claims for the logical priority of one must conflict with claims for another. If we set out to examine the determinant effects of specific discourses, practices and institutions under definite conditions, it is not logically inconsistent to suggest that they might have diverse and even contradictory outcomes on a number of levels, dependent also on our perspective and mode of analysis. From this point of view, the 'convergence' signalled in the title would have to be stripped of all guarantees. Social identities are only ever precarious and historically contingent articulations of multiple, heterogeneous positionalities. A class or gender formation is, in consequence, never given, but must be actively – politically and discursively – constructed. It would be crucially disabling, therefore, to view the political and theoretical mobilisations that bear the names Marxism and Feminism as necessarily 'progressive' expressions of primal interests that mark out, in advance, the destinies of privileged subjects of historical change.

The loss of such certainty is the price we must pay for escaping the causal chains of essentialist determinism. It is only by this escape, however, that we can formulate and justify an effective notion of cultural politics. I choose my words pointedly because, if we are going to deal with the fluctuating construction and fixing of classed and gendered identities, we must extend our engagements across an entire range of cultural practices, not just those subsumable under 'Art', as in the title. This is not to say we can ignore

institutional divisions and hierarchies of practice, but that we have
to view them as features of a specific discursive formation, having
definite effects on the régime of sense and economy of difference in
our social order. From both feminist and Marxist perspectives,
therefore, the institutional and discursive effects of canons of Art
must be the objects of critical analysis and counter-practice.

But beyond this, attempts to elaborate such analysis and practice
also come up against an increasingly integrated network of regula-
tory and coercive state apparatuses that represent themselves as
standing above social conflict, and a constellation of professiona-
lised social agencies in which new technologies of the body and
instrumental modes of documentation play a pervasive role in
positioning those they make subject. We have, thus, not only to
deal with economies of cultural production or systems and practices
of representation, but also with forms of discipline and bodily
transformation. Challenging these will demand more than a
guerrilla semiotics or theoretical critique. It will mean articulating
new forms of social mobilisation and political practice, not only in
marginal or alternative spaces, but within the domains of the
cultural and political institutions where power is most condensed.

This far recent developments in theory might take us in opening
up a new space for thinking about the articulation of forms of cult-
ural politics with the potential to invade structures of domination
and construct oppositional solidarities. At this very point, however,
the echoes of early-1970s' commitment in the title – seemingly
dispatched by the sophistication of 1980s' theory – return to
challenge us. After the defeats of the Reagan/Thatcher years, we
shall have to work hard to recover some of the organisational
inventiveness and strategic optimism that characterised those years.

Notes

1. Karl Marx and Frederick Engels, 'The German Ideology' (1845), in K.
 Marx and F. Engels, *Collected Works*, vol. 5 (Lawrence & Wishart,
 London, 1976) pp. 19–539; and 'Manifesto of the Communist Party'
 (1848), *Collected Works*, vol. 6 (Lawrence & Wishart, London, 1976,
 pp. 477–519). Karl Marx, *A Contribution to the Critique of Political
 Economy* (1859) (Lawrence & Wishart, London, 1971).

2. Karl Marx, 'The Eighteenth Brumaire of Louis Bonaparte' (1852), in Marx and Engels, *Collected Works*, vol. 11 (Lawrence & Wishart, London, 1979, pp. 99–197); *Grundrisse: Foundations of the Critique of Political Economy (Rough Draft)* (1857–8) (Penguin Books, Harmondsworth, 1973); *Capital: A Critique of Political Economy*, vol. 1 (1867) (Penguin Books, Harmondsworth, 1976) especially chapters 10, 14, and 15.

4

Practising Theories: an Interview with Joanne Lukitsh

Joanne Lukitsh: When questions of theory and practice are raised within college art departments, it is usually done within the art studio but not the art history classroom. What are your observations on this split?

John Tagg: There are ways one can open up the space between theory and practice from the point of view of art historians as well. Art historians are very good at meting out prescriptions to practitioners, but they are not very good at thinking of themselves as practitioners, thinking about the strategies they use, the spaces they work in, their own institutional base, their own implication in power. Art historians, like art critics, are comfortable telling practitioners what to do, how to operate – ticking them off for not connecting with new audiences, finding new spaces for practice – while they go on writing in journals, lecturing, sitting in

The text of this chapter is an expanded version of one first published in *Afterimage*, vol. 15, no. 6, January 1988 and, in altered form, in Carol Squiers (ed.), *The Critical Image: Essays on Contemporary Photography* (Bay Press, Seattle, 1990). The interview took place in May 1987 at the State University of New York at Binghamton.

universities – like me. But this is an area to look at, too. What about art history as a cultural practice? Because it is actually more and more significant economically. Agriculture is New York's biggest industry. The next biggest industry is tourism: which means selling what you and I do – selling 'cultural heritage'.

There have been few enough moments when art historians have tried to confront these issues: the *anti-catalogue*, for example, produced at the time of the Whitney Museum's bicentennial show in 1976.[1] Was it interventionist art? Was it art history? It is uncategorizable. And I would like my students to think about doing something besides writing a thesis – to have much more flexible ideas of what they could do as a historian-critic and what kind of form they could find for their work.

JL: I can appreciate the desire to create a generation of cultural historians, especially since that kind of training is not widely available in art history departments in this country. But in terms of gainful employment, only certain people will end up occupying a very secure institutional space. Most of the BFA students taught by these instructors will face very uncertain employment opportunities. I have been feeling this inequality, feeling somewhat irresponsible, because I am not able to address their problem about how to 'make it in the art world'.

JT: The direction of your question suggests we can still speak from a voice of authority, a voice outside. But can we? There are two responses to your comment: either start worrying about how those students can operate with a BFA, what they can do; or else start challenging the position of art historians to adjudicate on this, making them think about their own practice. This is not, of course, something we might choose to do. In England, before I left, many of my graduate students were going to go on the dole. They were probably doing their course while picking up welfare, and there was going to be no work for them afterwards. Contrary to what you say, they have not been hiring in universities in Britain since 1980. There are no jobs; there will be no jobs.

In the mid-1970s, by contrast, at a moment of relative expansion, debate had been focused on new methods in art history. No one really thought about *where* they practised because it was all going along OK, even if it was often marginal. Then the university cuts

came. They cut right across the interests, security, and habitual concerns of what had then become established as 'the New Art History'. Art history students as well as art students had to ask: where am I going to go with these kind of ideas about 'deconstructive practice', cultural politics, or whatever? And there was nowhere for them to go, unless they found spaces in community arts centres, youth opportunities services, or the kinds of independent galleries and studios that were beginning to set up education programmes. They were not ever going to come back into academe: there was no space for them. They had to think about *where,* as well as *how,* an art historian could practise. They were more likely to find work in the areas of tourism, museums, and galleries. They had to create alternative institutions, set up workspaces, set up a gallery, education programmes, seminars or something like that. It happened in Leeds, Newcastle, Sheffield, Manchester, Liverpool, and so on, as well as in London. It cut against the process of metropolitan concentration.

Such projects are interesting in themselves. But they have also pointed to a whole unchartered area: 95 per cent of the art history that is consumed. What do people do on their day off? They go out and consume art history. They go out and visit a monument; they go to an open-air museum, a country house, a 'national monument', site of 'historical importance', or whatever. And the art history they consume plays a crucial role in the construction of a notion of the National Heritage and of national identity. Yet, it seems that few of the radical art historians of the 1970s ever thought about this as an area of intervention, even though we were the people who were all in favour of interventionist art work, work on the streets, or deconstructive work. But what would it be for art historians to do the same within their own practice? An example, as I have said, would be the *anti-catalogue* committee who sold a counter-catalogue on the steps of the Whitney Museum that rewrote the museum's bicentennial show, from which the committee's concerns and arguments had been excluded. So, if I agree, on one hand, I have got out of art schools with the problems they have, because I want to teach people who have a primary commitment to the area in which I work; on the other hand, against the cop-out, there is the idea of shaking up art history as well, producing new kinds of art historians.

JL: Perhaps it is a dilemma many art historians do not want to face.

JT: It is difficult. It brings up the whole thorny question of 'intervention'. Anything I say is going to seem like bad faith because I have a job and so many people are unemployed. Nonetheless, I think the space between incorporation and intervention is not fixed but constantly negotiated. The mythology of the avant-garde is that there is a centre, which is incorporated, and a middle-ground, which is kitsch or lower-brow culture or whatever the term is they want to use, and then there are the margins, occupied by avant-gardes and other heroes. So it is simple: there is a centre – a dominant culture – and there is a margin. Cross that line and you are incorporated.

In fact, this whole representation of our culture is completely inadequate to understand how it is structured, where its centres are; for it may be subject to colonisation and domination, at a number of different levels, but not be a centred structure. Power does not operate in one way, through the 'usual channels', or in a simple descending manner, however much we might have to calculate the effects of the emergence of certain forms of the modern, centralised state. For example, contrary to one kind of argument that often surfaces here, there is no such thing as a unified market culture, because there are whole areas that are highly capitalised and fully absorbed into commodity production, that are areas of great profit, that use the latest technological means of cultural reproduction and are very powerful in some senses, yet are excluded from cultural privilege, where they are not, sporadically, repressed. Think only of the publishing, film, video, and tourist industries connected to pornography, for example. On the other hand, we have residual activities that would have died out long ago if it had been left to market pressures, yet which carry all the weight of cultural prestige: monumental sculpture, for example, or ballet, or opera with its 80 per cent state funding, or military bands, which in Britain receive a bigger subsidy than all the other 'arts' put together. Dominant culture is not homogeneous, nor is domination a single kind of process, let alone a question of economic determinacy.

This is not to say that I think there is any space outside our cultural order, but I do not think this order is a circle with a voracious centre and a vulnerable periphery or margin. Thus the

question of incorporation is not one that is decided in advance, say, by where somebody is working – whether they are showing in a gallery or working on the streets, lecturing in the lecture hall or speaking from a soapbox, publishing books or producing pamplets. It is a matter not of stark moral choices – a kind of Truman Doctrine of cultural practice – but of continual and provisional institutional calculation. So, there is no question of grand strategies either. I mean, along with the unified image of our culture as a series of concentric and involuting circles goes the whole avant-gardist fantasy of a grand strategy; a way to strike at the centre from an uncontaminated space outside the circle, to effect a total revolution. The political resonances, here, are clear enough but, against the ambitions of totalising theory, Michel Foucault's ideas of micropolitics make us think much more about how practices engage with specific kinds of institutional relations, power relations, ways of speaking, ways of prohibiting. I guess the whole 1970s' radical fantasy of the big push, the answer, the strategy, is gone.

This is supposed to be the index of my own despair, and I suppose it is from some points of view, because we have no longer got the compensations, the self-heroisation; we have seemingly just got little, shuffling kinds of interventions that have no way of getting a bird's-eye view of the field from which to judge every action against some grand map. There is no doubt this has created a kind of vertigo: where is the grand plan? For example, a book came out in the late 1970s in England with the title *Beyond the Fragments*,[2] which suggested the hope that eventually this fragmentary activity would all add up: we would all be shown to be in the same column, headed by the same vanguard. But it was a false and, I think, unnecessary hope. These struggles do not add up; they actually do not add up. There is no way you can make the struggle over washing-up the same as the struggle in the classroom, or the struggle over deindustrialisation. Acknowledging this is deflating but I do not think disabling.

JL: I agree with that analysis very much, but I keep on thinking about the notion of audience, in the sense that, if you are building up a community of academics, the problem remains how to communicate with students and the audience outside the academic community – which goes back to my question about art students.

JT: That is a very specific question. The question of audience usually comes up with a capital 'A' : *the* Audience, like *the* Public. I have a habit of pluralising things, which does not really escape the difficulties, but it is a gesture, a gesture toward the fact that we'd have to talk about specific audiences.

Beyond that, the problems you raise also have to do with the professionalisation of intellectual life; but that is affecting artists as well. And these problems cannot be got round, for example by the wishful strategy of the Community Arts movement in Britain in the 1970s, which, for all its radical profile, was often little better than a kind of cultural philanthrophy. The very words 'Community' and 'Arts' point to the problems. The notion that there is a community is, for me, a nostalgia, a fantasy, and it is a fantasy which precisely elides what I regard as crucial: the structures of difference – between men and women, black and white, working class and middle class, manual and mental workers, able-bodied and disabled, young and old, and so on – which are as productive as they are damaging, in the way they work against homogeneity, centralisation, monodoxy. And the other word, 'Arts', capital 'A': inoculating working people with High Culture in order to elevate their lives. It is interesting for example that, in its last years, which were years of political experimentation, the Greater London Council (GLC) Arts and Leisure Committee tended to avoid such groups. And by contrast with community artists' disdain for what they regarded as aloof and élitist theory, Alan Tompkins, who was in charge of the GLC's arts and leisure programme, specifically said that it was an issue of *Screen Education* on 'The Politics of "Representation"' that provided the rationale for his attempt to invert the power relations of culture.[3] He was not interested in community arts. He was interested in getting black artists to organise themselves, or the Irish population to articulate its identity culturally, or Indian-British women to organise photography darkrooms, or whatever it would be. The great irony was that community artists complained because, they said, Community Arts was an area of professional competence. So, for all the arguments that theoretical debates had been élitist, it was these so-called Community Arts groups that came back and defended professionalisation. Having counterposed theory to direct experience, they were hardly in a position to grasp the institutionalisation of their own practice or the fact that professionalisation was precisely the problem, not only for university

professors, but also for community artists who had their own
training and had virtually the same relation to the working-class
areas they worked in as professionalised experts' in the areas of
medicine, teaching, health care, sanitation or social work. Com-
munity Arts was a prime strategy of enculturation. The romanticism
of its self-justifications was a way of avoiding the problems.

This is not, of course, to say that art historians, critics and artists
are not equally beset by the problems of professionalisation and
academicisation. Most artists, for example, are state employees,
working for the education system. When the Works Progress
Administration (WPA) in the United States was eradicated in
1943, nobody wanted to listen to the Artists' Union demand for
state employment of artists, and yet it has come back in a peculiar
way. If artists thought about themselves as professionalised intel-
lectuals, cultural executives, and stopped romanticising the notion
of a creativity which supposedly sets them outside all institutional
spaces, and if academics started thinking about their own implica-
tions in these spaces, then they might actually have a basis to work
together, rather than just having critics write advertising copy. It
would be more a question of exploring the common institutional
and discursive conditions that govern their practice.

JL: Do you want to elaborate upon that?

JT: Well, it is what I have been saying. I would want to look at
the conditions of my own practice, my own relationship to writing
and representation, speaking and silence, and see if – as in the case
of the *anti-catalogue* – there is a way of working which intersects
with interventionist art practice. This would be something quite
different from art history or criticism representing that practice or
explaining it in a supposedly privileged metalanguage. There are
already examples: *Photography/Politics: One* was another instance
of artists and theoreticians working together; people like Jo Spence
or Victor Burgin who are both/and or neither/nor practitioners and
theoreticans.[4]

As far as students go, I would not expect studio students to come
into the theory seminar that I do for art-history graduates. In their
case, I'd start from the other end, as I have done in a course called
'Looking Aloud'. Behind this lies the recognition that, in any studio
programme, I am never the only one teaching theory. There are all

the people who teach about form, perception, a belief in beauty, a notion of creativity; who inculcate an idea of the artist; who presuppose a repertoire of supposedly appropriate practices and objects; who do not think it is problematic to organise a class around the systematic scrutiny of a solitary naked women, who do not seem to think that is an odd thing to be doing, one with a particular history involving specific kinds of power relations, something that would be worth worrying about; who load the students up with all this theory and call it the obvious, and then denigrate attempts to dig out what they have buried and call them destructive, obstructive, overcomplicated, incomprehensible. So, far from bringing 'Theory' to the studio, I would want to get students first to speak the theories they already have.

In many ways, they have already struggled to acquire complex vocabularies. They come with vocabularies – not necessarily from a history of studio theorising but, as likely, from pop music, from mending cars, from sport, or from wherever it is that they have acquired sets of terms to describe distinctions that are important to them. So we could start there, with the languages they have got, which would mean starting immediately with the implication of seeing in speaking. Hence the phrase, 'looking aloud': speaking one's sight, rejecting the idea of pure vision or just looking. It picks up the idea of just looking and tries to show how implicated in language looking is, and then asks about the ways students already articulate discriminations in looking; building out from there. Their ways of speaking have histories, which might take you back to the history of sport or fashion as much as to Clive Bell, Roger Fry, or Clement Greenberg.

There is, of course, something profoundly disturbing here for embedded notions of art training: to be told your voice is not your own, your eyes are not your own, goes against its grain. As Art & Language argued long ago, most studio teaching is based upon a notion of possessive subjectivity in which the artist is the paradigm of the possessing subject, the self-possessing subject. For art students – or any other kinds of students – to be told they are merely a flickering across a field of institutional spaces is an assault on their selfhood. But I think that is crucial. We lose our Selves, capital 'S'; but, in doing that, our selfhood becomes a space for work, transformation, intervention, rather than being a fixed and given nature.

JL: Is that a course you plan to teach here?

JT: I have done it elsewhere: in Leeds and at Goldsmiths' College, where my first job was actually on the studio floor (the very use of that phrase suggests there is a kind of class distinction between studio teachers and art-history teachers) working as a theoretician within the studio space. Because I was not trained solely in academic art-history establishments; at that time, you simply could not study art theory anywhere. There was art history, which meant the Courtauld Institute of London University, and if you wanted to do something else – for example, to look at the traditions of art historiography, at Marxism, linguistics, phenomenology, or even at the relation of German art history and German philosophical theory – then you had a problem. So, I took advantage of a space that opened up with changes in studio curricula, to do work on theory as a student at the Royal College.

It is worth stressing that, when you think of the late 1960s, it was in such spaces that those debates were going on, that those arguments came out in the first place. With one or two exceptions, it was much later that such work began to come out of academic art-history departments, and I do not think anyone – bar Roger Scruton – has come into this debate from the tradition of academic aesthetics, which has always remained a highly specialised kind of practice on campuses.

JL: Where would you go to school now?

JT: I wonder about that. The lecture hall is a truly archaic technology: I get up behind a wooden box and the students write down what I say. In an age of word processors and video disks this really is an extraordinary atavism.

So where else would one speak? I am still struggling to find my map of route-ways in the States, but we talked earlier about the new kinds of institutions that have grown up in Britain, often with Arts Council funding. In Newcastle upon Tyne, for example, a place such as the Side Gallery has a production base as well: they have a film company called Amber Films, photography darkrooms, galleries, an education programme, and they have been beginning to work with video, too. In fact, before I left, I worked on a video with Sarah McCarthy, who also graduated from the Royal College in the early 1970s and got into this area as a way of dealing with the difficulties of photo-textual narrative work in the gallery context.

She had also worked on the representation of 'deviancy', in an area that is theoretically close to my interests. The Side commissioned her to make a video to accompany an exhibition of photographs by John Davies, whose earlier work in Ireland had been very much involved with the relationship of weather and landscape, but who went to Sheffield and began to look at the city as a geological topography. I wrote a short piece about his work in *Art Monthly*, because I was interested.[5] What the Side did was to pay him to go and work in a particular area in Durham, during the last miners' strike. Then, in turn, they commissioned Sarah McCarthy to make a video to go with the show and she asked me to do the talking-head critic thing. Yet, what was potential was that these institutional divisions might begin to break down, because there was a more complex relationship between John Davies the photographer, Sarah McCarthy the video-maker, and myself.

We are back to your question of *where* might a critic work and how might a critic or historian work with people who produce in other ways. Where would I go? I think the whole area of video would be interesting because of its potential for constructing new audiences. But this would mean little outside an attempt to cut across the institutionalised division of labour, the relations of cultural production, as well as the régimes of meaning that constrain and constitute the historian's as much as the photographer's work. This is what has been exemplary about the projects of people like Martha Rosler, Allan Sekula, Jo Spence, Mary Kelly, Victor Burgin, Marie Yates, Sarah McCarthy, and a number of others.

JL: I noticed that you co-curated several exhibitions in England, most recently *Let Us Now Praise Famous Women*, at the National Museum of Photography, Film and Television in Bradford, and also *Photographers in Support of the Miners*, at the Crucible Theatre, Sheffield, and the Royal Festival Hall in London.
JT: Right. That was during the strike. Paul Wombell and I wanted to do an auction to raise money. It was a disaster, financially. But if you hang somebody's pictures in such a show, they are making a commitment beyond that of giving you a print to auction for the strike fund. It was distressing how little money we raised, because it was an extraordinary show of British photography. I recall that when I did *Three Perspectives on Photography* at

the Hayward Gallery in London in 1979, there were three selectors:
Paul Hill, Angela Kelly and myself.[6] And people immediately read
Paul Hill's selection as representing the 'Right' and the rest as the
'Left'. Unfortunately, his section was in one space and Angela
Kelly's and mine were in another, so it was even more marked. It
was something of a lesson that, when it came to *Photographers in
Support of the Miners*, Paul Hill not only gave work but he also got
on the phone to all of those maligned guys who do Minor-White-
type, dark forest pictures and persuaded them to cough up prints.
Of course people like Conrad Atkinson and Victor Burgin and
groups like Network also gave us work. But it was striking, if
obvious, that, at certain levels, one cannot read off politics from
images; whereas the reception of *Three Perspectives* was, I think,
premised on the idea that one could. In hanging their pictures in
that show, a number of surprising photographers made a statement
and implicated themselves, though the show was not of 'radical
photography'; it was a total mixed-bag.

JL: Why were you involved?
JT: Because I was on the dole. Yet, I was also still chairperson of
Yorkshire Arts' Photography Panel and I wanted to do something
for the strike that used my own specific skills and knowledge. I, too,
had found myself 'redundant' and the Association of University
Teachers certainly had not fought for my job. I wanted to be active
in support of a union which was really committed to a struggle that
not only concerned de-industrialisation, but was also a cultural
struggle. The strike was very much written in North–South terms:
London and the South-east versus Wales, Scotland and the North.
It was a cultural struggle over who could control where and how
one lived, brought to a focus around the still relatively integrated
cultural base of the mining towns and valleys, which constituted a
persistent space of resistance to deindustrialisation and which the
Conservative government was hell-bent on smashing in the name of
modernisation and Victorian values. I am not suggesting mining
villages as a romanticised model for a socialised society; their
cultural structure is actually a residue of a much older formation,
deeply implicated in its own, highly patriarchal, power relations;
though these relations were broken down during the strike, because
the women in the mining families were central to the organisation of
the action and, as a consequence, began to question the internal

relations of their communities. So this was more than an industrial action. It was a fundamental cultural struggle and we are seeing now how crucial it was: a real watershed. A lot of people rallied to it because it was a space for declaring resistance against the kind of rapid transformation of Britain into a mobile, service economy that the Conservatives wanted.

JL: So the photographers were declaring a resistance; they were speaking for the miners?
JT: They came out in support: they gave their work; they gave their name; they associated themselves with something that was very unpopular in the press, though very popular on the ground. It was not just 'we support the miners'. I think it was a recognition that a certain kind of struggle was going on through the miners' action. The mine-workers and their families were carrying the load for a certain kind of resistance to the Conservative vision of a future Britain – a de-industrialised Britain dependent on a service economy – and what that would mean: a wealthy South-east, with highly paid and corrupt professionalised, high-tech, legal, financial and academic service industries, and a less-than-minimally-paid low-tech service sector at the bottom. 'Service industry', here, means pushing broom. It means being 'in service'. It means socialised domestic work for women, just as in this country: minimum wages for McDonald's workers and fat fees for lawyers, stockbrokers, and savings and loan executives. It also meant a whole geographic redistribution of the population not condemned as surplus, compelling workers to be migratory. The Conservative government talked about social values, about The Family, about embedded traditions, and yet they smashed them, because they also want a highly mobile, highly vulnerable, unorganised, malleable work force, at all levels. So there was clearly a stake here, a cultural stake, a regional stake.

Perhaps this ameliorates the sorry fact that the show was financially disastrous: the work went for nothing. We were more than a little naive: you cannot unleash 500 pictures on the market at one time. Prints were going for the equivalent of $10 and $25 each. Three or four dealers came and picked up what they wanted.

JL: So the goal was not to show the work, but to raise money.
JT: Right, to sell it. It was shown in Sheffield and London as a gesture of solidarity, then it was auctioned. However, we made sure

we had a catalogue and sent it to the Tate Gallery and the British Museum, which may sound like solidifying the approved archive, but we wanted a trace there, we wanted the record to remember. Try to dig up material from the 1930s concerned with the Artists' International Association or the Workers' Photography Movement; it is odd that it is now in the official archives but, on the other hand, it is a trace: a trace of a kind of activity that, however much it was implicated in nostalgic notions of the expression of a given working-class identity, was an attempt to construct a cultural politics. So we wanted a comparable trace to be left.

I think these things are crucial. For example, teachers still deal with *Three Perspectives*, even though it critically bombed at the time and the Arts Council subsequently made sure that nothing of its kind would happen again.

JL: What happened?
JT: *Three Perspectives on Photography: Recent British Photography* was supposed to be the first biennial British photography show. Art had its annual at the Hayward, so photography, being only half as important, was going to be given a national show every other year. The Arts Council officials took one look at the show and the complaints from conservatives and, mysteriously, it has never happened again. It was not just the photography. The Hackney Flashers, for example, who effectively broke up over contributing to the show, had argued pointedly that they would be politically implicated by going into such a gallery space. One of the things I did in response was to organise an event that was not a photography event at all; it was a rally concerned with child-care in South London. We just used the facilities of the Hayward and the focus of the Hackney Flashers' work to draw attention to the lack of child care. There was a panel of speakers, a feminist rock band, children's theatre, and a baby-carriage protest. Now, I do not doubt there was also trouble over the photographs – especially Report's piece on unemployment – but, on the other hand, I made the simple request for a créche during the show and that was the kind of thing that really upset the administration. That is why they will never do it again.

Griselda Pollock wrote a very sympathetic and theoretically informed review in *Screen Education*, but nobody mentioned the child-care event – it was seen as having nothing to do with

photography.⁷ Of course there were other panels properly con-
cerned with photography and the politics of photographic practice,
and those things do get remembered. I also think that the show had
a more persistent influence on photographic education.

JL: Since you moved to the United States in 1985, it seems that
you have been less involved with activities dealing specifically with
photography than you were in the 1970s in England.
JT: Am I resisting talking about it? I have certainly never wanted
to be a historian of photography as such. I have always tried to pose
the issues more widely as those of visual culture, histories of
representation, representational practices. It is true, however, that
it was possible to talk about things in the area of photography it
was not possible to talk about in the area of art history. But it is
impossible to teach the history of photography as a discrete and
coherent field or discipline. The history of photography cannot be
assimilated to a medium or a cultural canon, though attempts are
made to accommodate it or sanitise it in this way. I mean, how
could one teach the history of photography without talking about
family photography, without talking about the photographic
industry, advertising, pornography, surveillance, documentary re-
cords, documentation, instrumental photography – whole areas of
production in which there is no common denominator? There is no
such thing as photography as such, a common medium. There are
differentiated areas of production, differently institutionalised
practices, different discourses.
 One could, of course, raise the same issues in relation to
literature, but radical literature departments invariably go on
laudering the same canon, rereading the same texts: a new reading
of Milton's *Paradise Lost*, another reading of Joseph Conrad, and
so on. A course is offered, say, on 'Writing and the Body'; but it
turns out to be a Lacanian or Derridian resurrection of Surrealism.
'Writing and the Body': would not that mean looking at medical
reports; would it not mean reading criminological tracts and
parliamentary records on public health; would it not mean tracing
the emergence of new forms of technical writing? Where is the body
written? For so many literary critics, the body of Literature is too
precious to be given up for this kind of inquiry. You could say the
same about art history: it too thinks it knows where its objects are –

because they are all in museums. But it is the historical emergence of this canonised archive in relation to others of a more lowly sort that constitutes the real problem.

These are the sorts of issues that could be opened up through the history of photography, so that, now, if I was to look at the history of drawing, I would have to ask: where is the history of mechanical drawings or 'working drawings', as opposed to 'idle drawings' or 'art' drawings? Where is the history of blueprints? Where is the history of cartography? (And cartography and photography have a crucial relation.) I would have to ask a wholly different set of questions. There would be no assurance of knowing in advance where the archive was or, indeed, what drawing was. Just as, in the case of literature, one would be committed to tracing histories of *writing* as opposed to a history of literature; one would have to look at a number of differentiated practices of writing: report writing, memo writing, diary writing, letter writing, evidence writing, not just certain kinds of literary writing. This is a line of questioning that has been pursued above all in the area of the history of photography; something which has not even been the case with film history and theory, where most have taken the 'corpus' as given.

Perhaps, that is why so many people in the mid-1970s gravitated towards work in photography. I think a number of people did so precisely because it was not caught in the canon. And I think a related point at the level of practice is that it has not been successfully appropriated to a hierarchy of metropolitan institutions. In Britain, photography is a thoroughly devolved practice: you cannot learn about British photography in London. It goes on in provincial towns and cities, in all kinds of galleries and workshops and evening classes, and so on, in devolved organisations – it is not London based. I think, therefore, that a number of people went into this area of practice and theory because there was a space: it was not caught in the same institutional structure, or in the same paradigm, as Art. But then, having done that, and having made an intervention through this space, I do not want to get caught in it, because then I would be solidifying the very thing that I have sought to challenge: I would be occupying and institutionalising a contained space as a historian of photography who, paradoxically, writes all the time that there is no such thing as photography and so on.

JL: In the United States, you are strongly identified with the two 'Power and Photography' articles – which are often cited.[8] By publishing these articles again in *The Burden of Representation*,[9] is it going to confirm that? In general, what do you try to accomplish in the book?

JT: It is related to what we have been talking about, because what we have been talking about is, actually, how I could take the arguments of these articles and apply them to my own practice? So it folds back. If I am going to ask questions about the relationship between power and representation, questions about institutional spaces, power relations and their implication in ways of speaking and ways of silencing, then I have to ask them in relation to the way I work as well as in relation to the things I look at.

OK, it is a book. Perhaps, the best I can say about that is that it is a contribution to a series on cultural theory and cultural history; so it is a particular space. All of the articles it includes were written with a project in mind and it was useful to pull them together, though they do not add up. I mean, it was useful to see them together in an order that is not the order in which they were written, and then see how the project did not add up at all.

I think the articles were each always speaking to a number of contexts, saying different things in a number of different contexts. For example, the original 'Power and Photography' piece was given as a talk at the Institute for Contemporary Arts in London in February 1979, where it was deliberately couched to follow a lecture by a photographer who taught at the Royal College of Art, in the photography department, but who was volubly committed to street photography, to the idea that Reality is out there on the streets and you have got to get out there, that is the radical thing to do. There is the Real, out there; it can be possessed and brought back, and the truth will blow apart ideology. I wanted not only to have a go at this theoretical conception of the Real-out-there and the conception of ideology that goes along with it, but also to suggest that surveilling the streets or getting on the road in search of the Truth were activities implicated in a sorry history and saturated in relations of power. This precipitated me into looking at other kinds of archives, other kinds of materials. But, at one level, the impetus was an argument about contemporary left photography; something that takes us back to *Three Perspectives on Photography*,

because my selection there, the 'socialist perspective on photogra-
phy', deliberately refused to present a stylistic position but argued
instead for a mapping of specific practices. It showed quite different
kinds of activity, even including street realism or social realism,
because what interested me about the groups like the photo agency
Report – whose organisation goes back to the 1920s in Germany –
or the feminist collective, the Hackney Flashers, was that they were
much more inventive and resourceful in the way they organised
themselves than photographers intervening in art institutions tended
to be.

So there was an argument in the book with current practice, but
there was also an argument with photo history, pointing to archives
that had not been engaged with. And there was a further argument
with art history; for example, with Tim Clark's seminal work on
realism which, for him, focused on a study of Courbet.[10] What I
wanted to suggest was that, if there is a crucial connection between
debates about realism and an emergent social order, perhaps the
significant debates on realism, on representations claiming the
status of the real, do not go on in art criticism alone. Perhaps
there are other levels of debate and negotiation which might take
you to very different spaces: to manuals on police photography or
psychiatric photography; to parliamentary legislation allowing a
kind of photography to be used as evidence; to arguments about
copyright law – about which image is real and therefore in the
public domain, and which image is creative and therefore private
property. In another sense, then, those two articles on power and
photography specifically engaged with Tim Clark's work by seeking
to ask where else one might look to trace the emergence of new
realist discourses and how else one might think through their
relation to power.

Another area on which the articles focused was that of theories of
the state and their relation to theories of representation. The first
piece appeared in an issue of *Screen Education* that was subtitled
'The Politics of "Representation"'. I was on the board of *Screen
Education* and was very much aware that the journal had an idea of
cultural history and cultural theory that was, by then, much broader
than the journal *Screen*'s idea of finding a methodology and a text
to apply it to – a can-opener to open the text. The board of *Screen
Education* had tried to develop a notion of cultural politics that
carried over into the journal's specific involvement with teaching

and pedagogy. This was an intervention of which the articles became a part. We talked earlier about Alan Tompkins and the GLC's efforts to think out the operation of a radicalising cultural policy, and about the way these notions of the politics of representation then came into play.

So I think these essays, like any others, have spoken a number of times and, when you say they fix me (though they are theoretically unfixed and incoherent in ways we could talk about), my reply would be that you are pulling these texts into a particular context but, beyond that, they require their own archaeology because their multiple and un-unifiable concerns already seem elusive and strange.

JL: Is this kind of discussion of the implications of changing the context of publication raised in the book?

JT: Yes, in the introduction. It seems to me now that these articles are both theoretically and historiographically incoherent in ways that are, perhaps, instructive. They also had their own contexts to which I wanted to point. These things run together: the kinds of context they came out of had to do with debates about cultural politics that were bringing together practitioners and theorists in new ways, that were not necessarily going on in academic spaces, and that were engaged in trying to think of new options for political change as well. This is a context that has come to seem so remote now – and, of course, in another country it seems even more remote – that it needed some explanation.

Part and parcel of this were certain marked theoretical ambitions, so that one could talk about the articles in another way: talk about the kind of political intervention being theorised, but also about the way the theoretical basis created excessive hopes for that intervention. Central to all the essays was the work of Louis Althusser and Michel Foucault.[11] And there is clearly an attempt to read their theoretical programmes as continuous: to argue that we could take Althusser's idea of the state and Ideological State Apparatuses and that would explain where photography worked, why it was politically important, what political investment there was in it, how power operated in the representations and institutions of photography, and how they could be viewed as part of the state in this expanded form; and then, you could plug Foucault's account of specific

institutions, discursive formations, and their power relations right into this model. And that would provide an alibi . . .

JL: An alibi?

JT: An alibi for cultural activism. Althusser's theory made a cultural politics possible because it said: cultural apparatuses are actually extended apparatuses of the state, invested with power relations that reflect relations of class domination in the society. It therefore became as valid to be working in a cultural arena as in a parliamentary or an industrial arena, or whatever. One could say, look, there is the Althusserian argument, which explains that the way power works in a developed capitalist society resides in a whole network of cultural institutions that somehow secure social relations of production. That validated one's work. But at the same time, it invalidated it. Because, according to the theory, if cultural institutions were Ideological State Apparatuses, on the one hand, they were valid areas of intervention; on the other hand, if those interventions did not go beyond the cultural institutions themselves, ultimately to take on the state, then they were merely reformist. Cultural institutions were seen as extended arms of the complex modern state so, unless challenges went beyond them to engage in the supposed common struggle against the state, wherever it was found, they could be accused of merely collapsing back into reformism.

On one hand, Althusser's seminal contribution, as it was debated in Britain, opened up the area of cultural politics for analysis and for practice and created an alibi: we could have good political credentials for working on specific cultural institutions. On the other hand, at the same moment, it took the ground away from beneath us, because it was a view that was still implicated in a reductive idea of power as economically constituted class power, 'expressed' in the entire range of cultural institutions, which could then be viewed as apparatuses of the state. It still maintained an idea that cultural 'apparatuses' reflected or represented power relations that were really and properly set in place elsewhere, in *production*. So we were given something on the one hand, only to have it taken away on the other.

If we take the articles in the book in the order in which they were written, beginning with 'The Currency of the Photograph',[12] we can clearly see the ambition to try to build up from the Althusserian

account of the state, to understand representational practices in the terms of that model, then to slot in Foucault's analyses of power/ knowledge relations merely as a development or extension of Althusser. This would then be a way of analysing the micro-level of photographic documentation, to blow apart the 1930s' idea of radical documentary, to talk about the power relations involved in practice, and yet to maintain a claim to being engaged in a thoroughly politicised activity. This became a problem, because the idea that institutions reflected power that came from elsewhere ran against the very grain of the theory of power and discourse being invoked. Once one said that the kinds of power effects generated in cultural institutions or cultural practices are not representations or reflections, are not simply referable to a power given in advance, elsewhere – if, in fact, the power effects of cultural practices and institutions are not reducible to the replication of power relations created at the point of production – then, of course, the whole centralised model of the state begins to be decentred, begins to fall apart. We can retain an idea of cultural politics, by insisting on the power effects of cultural practices and institutions in themselves, only at the price of abandoning the idea of a necessary structural connection between these activities and some larger desire to overthrow the whole totality.

The worrying path trod by the articles is the loss of that sense of social totality. If they insistently hang onto an idea of cultural politics, it is only to see any notion of the pre-given place of cultural practices within a total structure receding fast. Hence the critique in the introduction of the notion of totality that is there in the first essays: the conception of society as a structure involving a number of functionally necessary levels of practice that interlock in certain ways, so that cultural practices can be seen to be as crucial as economic and political practices, though in the last analysis they do not have the same determinant weight. Because of the ways this model of the social totality has come under attack, it seems that we now have no clear way of siting the activities we are involved in as practitioners (theory practitioners, history practitioners, academic practitioners) or have studied (photographic practices, representational practices) within a pregiven structure or model of society.

This is what comes to be questioned in the articles in the book. Their ambitions are unfulfilled and unfulfillable. The ambition of the first articles was to elaborate a model of the social totality in

which social practices would all lock together in this way, and in which we could then begin to understand cultural apparatuses and how they work to reproduce the relations of production. Having put together a book and tried to make it coherent only to find myself working against the grain of the very ideas being invoked, I am now trying to argue that its incoherences are actually useful, productive or interesting.

In the introduction, I have tried to make an argument about the relation that is there to be explored between the development of forms of social governance and administration and practices of representation. This is crucial: the implication of photography in new forms of social administration in the nineteenth century. A number of the articles look at documentation, record-keeping, and practices of surveillance in the nineteenth century and go on to ask about the relationship between these models and 'documentary' practices, which constitute a quite different kind of discourse: a popular rhetoric addressed to a particular sector of the populace, speaking of an Other. This is quite different from nineteenth-century documentation, and the two cannot be run together. We have, rather, to map the moments in which these discourses were formulated, the currencies they had, the power effects they generated. But the relationship between instrumental representations and new forms of social administrations cannot be seen in the way imagined at the start: in terms of a model of the state in the Althusserian sense.

So I have tried to bring out both the historical argument, about nineteenth-century documentation and 1930s documentary practices, and the theoretical argument, whose direction points again to what we discussed earlier in relation to seeing academics as 'specific' intellectuals. Here, too, what comes out is an insistence upon analysis of specific structures and specific practices; not an analysis premised upon a global model into which the particular is then fitted. This is deeply problematic if you have been working out of a Marxist tradition that has insistently revolved around a particular kind of topography of society in order to understand the cultural and its place in the overall social order.

JL: Would you like to elaborate on that?

JT: Marxisms have constantly negotiated around the idea of cultural practices as a superstructure, somehow linked to the other

superstructural and structural levels of society – the political and economic. For such theories to abandon the notion of social totality is fraught with problems. How could we then pose the relationship between one practice and another? Yet I think we can pose the relationship between one practice and another without having to be dependent on a pregiven model into which they can be slotted. We do not have to have this architectural model in which everything is fixed on the right floor, no matter how many mediatory staircases and elevators are built. We may be told that we have to choose between totality and chaos but, in fact, thinking about specific structures, specific institutions, specific discourses does not shut us off from exploring specific relations between practices or between the conditions of existence of a particular practice and its effects. We simply do not have to choose between a global explanation – a notion of totality – and a chaotic conception of everything as simply being itself.

JL: Is the chapter about doing research in an archive, 'God's Sanitary Law: Slum Clearance and Photography in Late Nineteenth-Century Leeds', an answer to that criticism?
JT: It is an essay precisely caught in the problems of the ambitions I am describing. It concerns an archive opened up to me by a local historian in Leeds, Janet Douglas, who used to conduct architectural walks in which she taught her classes a kind of literacy: how to read the streets. (Not just 'high' architecture, though Leeds has a wonderful Victorian town hall and Corn Exchange. We would walk around back-to-back housing and learn how to read the political–geographic formation of this town.) It was Janet Douglas who pointed out that historians of housing used these albums of photographs as illustrations allegedly showing us what nineteenth-century housing was like. None of these historians, however, seemed to have asked about the photographs themselves as a historical practice. As historians, they were caught in the notion of the photograph as evidence, which was precisely the notion these photographs tried to establish in their currency.

Having found these photographs of slum housing in this way, I began to work on them, but I still had in mind that this would again slot into a particular conception of the local state: that one could look at this archive as an instrumentality of state power. The photographs were certainly part of a strategy in which the east

end of the town, the literal environment and, of course, its
occupants, were to be brought under control, spoken for, posi-
tioned, defined as Other. Within this strategy, photography opera-
ted as a means of surveillance – intruding, looking, searching out –
but also a means of evidence or incrimination. The interesting point
is that these photographs were produced in Leeds to be shown in
Parliament in London, as part of the official case for an enabling
bill allowing this area of Leeds to be knocked down. The photo-
graphs claimed, therefore, to speak the truth of an area that
Members of Parliament had never visited. Of course, there are
minutes of the parliamentary committees, but in these we do not
hear the photographs speaking for themselves. We rather find that
the very readability of these pictures had to be negotiated.

Here, then, we have photography as an instrumentality of power,
mobilised by the local Medical Officer of Health and the local
engineer as a means of intruding into, of fixing, knowing, and
controlling a no-go area, a working-class, largely Irish and Jewish,
slum. The very fact of medical officers and their photographers
having intruded into the area was a trace of a kind of power – but
it was not, however, entirely successful: the photographers never got
into anyone's house, for example. The photographs were then to
be used to gain the power literally to knock the area down, to
unhouse the inhabitants. To do that, however, the photographs had
to be established as real; they did not already possess an evidential
value.

In *Camera Lucida*, Roland Barthes argues that the photograph's
value as evidence is seared into it by its indexical nature.[13] I wanted
to argue that its evidential value was something that was contestable
and, in fact, contested. It was something that was institutionally and
historically produced; it had to be argued for. Otherwise, the
photographs were just bits of chemically discoloured paper or,
more to the point in this case, just a bunch of postcards. Seeing a
photograph as somehow having the clout of truth was something
that had to be produced, argued for, institutionalised. And, given
the fact that there were minutes covering the Select Committees that
were shown these photographs, we could follow, here, the trace of a
historical gaze; uncover, perhaps, the way that gaze was engineered
and institutionally sanctioned, so that looking became caught up in
the idea of the truth of the photograph and its evidential weight.

The investigation of how these pictures were used and looked at

was, therefore, a way of developing arguments previously made, for example, in 'The Currency of the Photograph', which rested on the view that we cannot understand photographic meaning as an abstract system, as a *langue*, but only as a social practice involving specific institutional currencies, determining the way photographs circulate as social discourse. It was a chance actually to look at the historical negotiation of the idea that photographs are self-evident.

In fact, the minutes trace the photographs' disputability. It is largely the Medical Officer of Health who takes them to London, to do a number of things. He wants to build up his own credentials and the professional weight of his account of the area proposed for demolition. He has then to build up the professional status of his reading of the photographs. He therefore has to contest the idea that photography is an entertainment, something associated with Sundays on the local common. He has to insist that photography is a specialised technology, like a surveyor's theodolite, and that its images, like blueprints and maps, are materials that require professional scrutiny and interpretation. So he builds up his own credentials at the same time as he builds up the credentials of photography. This is what the minutes trace to a degree, though still not as one might wish, because even the minutes do not record how the committees, which might have thought they were being shown a postcard album, were schooled in the protocols of handling photographs as evidence. A similar question could be asked about the maps or architect's drawings which were on the table as well, and which the committees seemed to be much happier about accepting. Clearly, we are dealing here with specific representational conventions that are very much professionally controlled and have to be taught and learned, and not only by those who make the maps, because the enabling bill would never have been passed if the committee had not accepted those conventions and their reading. I was looking for a trace of how such literacy was engineered for photography. But it was not entirely graspable, because it was not even minuted. It had rather to do, one suspects, with the way the photographs were handled and handed round the room, the way they caught the gaze of the committee members and 'spoke for themselves' wordlessly. What is recorded is the work that had to be done by the Medical Officer of Health to make them speak in this way, by a legally sanctioned ventriloquy, by his insistently helpful translation of what they had already supposedly spoken.

JL: Given what we have already discussed, what would you add to your comments on 'Power and Photography'? And also, do you anticipate becoming as involved in arts administration in the United States as you were in England?

JT: We were talking about the way this article tries to telescope a number of things: Foucault into Althusser, semiotics into discourse theory, the theory of positionality into a general theory of the social formation. There is an idea that, somehow, Marxism, feminism, psychoanalysis and semiotics revolve around a theory of social subjectivity. And we discussed why those ambitions for an eclectic but unified theory have fallen apart. You could look at a whole range of journals from the late 1970s, not only *Screen* but *Screen Education*, *m/f*, *Working Papers in Cultural Studies*, or *Block*, and find this momentary belief that these theoretical discourses could be sewn together. And it was not only a theoretical project.

But that was another moment: pre-1979; before Thatcher's first election victory. It was another context. Not that it was a simple matter of taking theory onto 'the streets', but there seemed to be enough connections, through involvement with arts administration, workshops, galleries, publications, and local politics, to make it seem that it was not isolated.

The major problem here in the United States is the corporate structure of cultural institutions and the much more developed professionalisation and thus greater isolation of intellectuals. It is more than just being stuck out on a campus shaped like a brain, whose spinal cord is a post-urban parkway, with no connection to a (dead) town centre. This is the most obvious part. But I am so far from understanding the economic, cultural, political processes that make this place. I cannot just 'intervene'. The whole theory of intervention is not a paradoxical general theory for landing anywhere, parachuting theory in. Perhaps an important part of what I am saying is that I simply have not done enough mapping to understand the cultural and institutional networks. I do not know enough to say what are the languages, institutions, spaces, or conditions here.

What is different on the academic front is that a lot of what I am doing is retrospective, informing people of debates that have gone on in Britain over the last ten years. Because it seems that American campuses have characteristically skipped a beat in the way humanities departments have come, recently, under the influence of a

particular reading of Derridean desconstruction, in which Derrida is taken away from the way in which he was interrogated in France or Britain. There is little familiarity with the kind of questions associated with journals such as *Formations* or *Screen Education*, for example. To be coming out of certain traditions of French theory means something very different here. But I still think that there are crucial things going on in this tradition – its attack on authorship, or its attack on the closing of the text, for example – that can be brought into relationship with other areas of debate that are not read here. For instance, with the work of Raymond Williams on the organisation of cultural production, the technologies of cultural production, and the relations in which cultural production goes on. These are issues, like those of cultural practice, that tend not to be talked about here in theory departments dominated by a particular conception of deconstruction.

JL: Would it be premature to talk about the kind of programme you would want to work out here?

JT: On a general level, it is crucial that there is a real potential on certain campuses, like this one, for cross-disciplinary work on cultural history, theory and practice – and this could include a cinema and a studio programme, whose very presence *ought* to upset the academic order, ought to sit uncomfortably within the 'University', whose very name implies an ordering of a universal knowledge. The more difficult issues are the ones we have talked about: reaching other audiences, making this institution shift its place. For a campus like this, it might simply be done by opening a downtown evening-class centre, tapping into a wholly different set of students and concerns.

The other area you talked about earlier was the question of why go on lecturing or writing articles and books, when there are other spaces. Should we be trying to make television programmes? On the most obvious level, we have already talked about the idea of using video with shows to open up the exhibition material in new ways: instead of a catalogue, you make a video. There are other, larger questions here.

At the risk of digressing, perhaps we might think again about the late GLC and the two levels of its cultural strategy. One was directed towards the dominant high culture which, after all, is

made up of practices which largely could not survive in the market. In the Royal Opera House, the cheapest seat may be sixty bucks, but that seat is 80 per cent subsidised; so we are talking about a $300 seat very few could afford. How, then, is that practice to be sustained? A problem for the dominant culture: in the face of market forces, how is a privileged culture in which social values are more visibly articulated and defended, to be kept alive? The answer has been massive subsidy: a disproportionately high amount of spending on the arts in Britain, other than that spent on military bands, goes to the Royal Opera, the Royal Shakespeare Company and to the National Theatre. On the one hand, we clearly have to intervene in this, to demand a presence for other voices, to demand the spaces for other things to be said, within the area of subsidised high culture. It is obviously important to insist both that the grants are redistributed and that the granting bodies are transformed in their structure in the direction of greater accountability. We have to look at the way the government actually controls the overall funding but sets up an indirect link, via a number of supposedly independent 'experts' who defend a level of professionalised control over the area, and hands out the money through these conduits, these quasi-autonomous, national government organisations. It is crucial that we intervene to redistribute the funding but also transform these funding bodies, and this is what the GLC did: they *devolved* the money.

The arts committees agreed to set up subcommittees which would contain 'non-experts' or those with a different notion of expertise that was not institutionally privileged. The official committees literally handed over the budget. And that was essential. Money was under the control of the communities and workers directly involved in the development of black arts workshops, or gay and lesbian film-making cooperatives, or documentary centres working with trade unions, and so on. However, the problem is that, even with these changes, such institutions remain grant dependent; they cannot become independent because they are all but totally reliant on public sources of funding and are, therefore, constantly vulnerable, because as soon as you get a political change or economic cuts then the carpet is pulled from underneath them. One can insist that they should become economically viable, but they are never going to be able to fund themselves other than through public subsidy – and, anyway, it is important that we recognise that the dominant high

culture is also maintained by post-market relations of public sponsorship in which we have a right to intervene.

On the other hand, the GLC also developed a policy that was not administered through the Arts and Leisure Committee, with its attempt to develop alternative notions of what could constitute a cultural event, what a cultural organisation was, and who should get funding for what. The Industry Committee had also to become involved because, as the core imperialist countries typically begin to switch over to service economies, we have to look at the role that cultural industries now play. In London, for example, a sizeable percentage of the work force is now employed in cultural industries such as television, newspaper production, advertising, tourism. So here is another kind of space for intervention, directly involved in the market. Instead of having an Arts Council hand out deficit-funding once a year, we actually move into trying to set up alternative businesses that can then sustain themselves in the market. But this might be an area where academic critiques and intellectual competences would not have the same status.

Now, moving into the area of television and video, they are clearly practices which occupy both these spaces. We might be talking about deconstructing the narrative strategies of the evening's viewing, or we might be asking how we can break up monopolies, how we can set up devolved and diversified businesses which can sustain themselves, find their own markets, actually use the mechanism of the market to create new means, rather than remain dependent on subsidy. This may sound like incorporation in the market, but it is what alternative music has had to risk. No one has ever given Arts Council grants to post-punk bands like the Mekons. They find their own audiences. Or we could look at publishing houses like Women's Press or Comedia which also try to survive in the market-place. And clearly we need to think of video in this way.

Why do I go on lecturing, amidst this pre-medieval technology for transmitting information by voice and writing? Why do I have this article on my desk that I will probably type out and scribble on and cut up with scissors and type out again? I wonder about my use of my time. In answer to your original question – what would I do now? – I think that I ought not to have been so contained in this state-funded, professionalised academic area. I wonder what we will do, now that the role of the literary intellectual has not only been

blown apart theoretically, but that we are also losing our mode of production. It will breed nostalgia. As you said earlier, in terms of the photo-historian's research material being available only on video disk, that will, of course, produce a longing for the authentic. For all that recent photo-criticism has laughed the authentic object out of court, I can see that we will all be complaining that they will not let us into the archives to see the object.

JL: Desktop publishing would seem to offer possibilities for circulating ideas and information outside existing communication structures.
JT: It is interesting, but it will certainly be uneven. It will make us dependent on the people who produce the software and the hardware in ways that will bolster corporate growth; but it will also create space for alternative practice, as Xerox machines did for fanzines, or as photography did.

Was the development of amateur photography a 'democratic advance'? It is hardly a simple question of putting cameras in people's hands. What was put in people's hands? Knowledge certainly was not. The means of production were not. Of course, the immediate means of production were, but this was the very process by which photography underwent its second industrial revolution in the 1890s, producing massive monopolies like Eastman Kodak. So on the one hand, the means of production were certainly not democratised: handing things over, as with personal computers, meant yet greater concentration of ownership of the means of production and a more deeply entrenched division of knowledge. Amateurs did not know how to take a camera to bits if it went wrong, or how to make their own film, or even how to print. Such knowledges were yet more concentrated, invested and professionalised. And knowledge about picture-making has become equally specialised and professionalised: you go to an art school to acquire that.

From one perspective, one could view the development of amateur photography as just a means of solidifying another stage of capital concentration and corporate growth, but this is not enough. Because the same development did put cameras in people's hands, even though this means of representation was then locked into the relations of power of the family, contained not only institutionally but discursively. Who pictures whom in family

photography? Why do people not photograph family arguments, illness, failure, even just work? These are questions that, above all, Jo Spence has asked, in her attempt to undo the model of the family album; but we have yet to trace how, historically, these discursive and institutional limitations were produced and imposed. Yet, having said that handing over the camera hardly constitutes breaking the structures of production or institutionalised discourse, there is still space for resistance.

Sitting here in a town dominated by IBM's manufacturing base, I am thinking again about the way in which these arguments fold back onto my practice. My reluctance is no doubt due to the fact that academics are rooted in residual practices. I think that is to do with the tension in the university between its being a place of production, a place which produces skills and knowledges for production, and its being a place where a residual culture is defended. There is a duality here. The university has a double function: it has to train technicians, executives, and managers in professionalised knowledges, but is also has to defend and oversee a dominant culture. And these do not match up. The dominant culture is not an expression of the dominant relations of production: there is a decided asymmetry between the two. The problem with so much of the theory of commoditised culture is that it has not begun to investigate the conflictual connections between cultural production, the market, and the relations of high culture; to grasp and exploit, for example, the drive of the market to produce and circulate commodities, representations, that would actually undermine the dominant relations of high culture. Look at the growth of academic Marxism as an area to which publishers have turned, not out of conviction, but because there is a market for it. The drive of the market is not the same as the drive for social reproduction. There is a continual tension, and the university lives that kind of tension.

This also brings us back to the relationship between alternative art spaces, the dominant culture, and the market; a relationship which has not really been thought through. Alternative art spaces were constituted in the post-market relations of developed capitalist cultures. They were the creations of institutions like the British Arts Council, with their indirect governmental funding. We all know that hedges in what they can do in all sorts of ways, especially with cutbacks affecting the National Endowment for the Arts as well as

the British Arts Council. It is crucial to defend their need for subsidy, but this has too often pushed out all consideration of the problems of intervening in the market as a strategy for transforming culture, because of the danger this poses of being absorbed into the dominant relations of cultural production. The result of this has frequently been that the relations of cultural production have ceased to be an issue for grant subsidised art centres, too; they are happy to occupy their space in the privileged area of post-market institutions.

If you go back to the ideas of the Artists' Union in the USA in the late 1930s, you have a much more radical challenge to the relations of cultural production in what Stuart Davis called a system of 'cultural monopoly'.[14] Davis had a strikingly clear idea about the institutional organisation of culture – the museum-dealer-critic complex – and how the Artists' Union could intervene within it, even if he did not question the privilege of Art or consider the relation of artists to, say, workers in the film or printing industries. What happens when you demand wages for artists? Where are they going to work for those wages? What does it do to their status as artists once they become wage-earning state workers? Who owns the product of their work? What consequences would this have for the cultural economy? Is direct labour to be understood in terms of state patronage? How can state patronage function without implying a consensus taste? All these things caused great and productive confusion in the 1930s and created the space for an Artists' Union. It seems to me that this kind of questioning just disappeared for forty years – at least till the production of the *anti-catalogue*.

JL: In *Photography/Politics: One*, you wrote a diaristic essay that describes the development of your interest in photography from work on American culture in the 1930s. Could you talk about it and its place in your book?

JT: Right, we have not talked about that piece and its embarrassments and difficulties, even though it is very fashionable after Barthes and Baudrillard to be writing diaristically, to be speaking the personal. I should say that, if I find it embarrassing, it is embarrassing in precisely the way that I ought to be embarrassed.

Two things are not being spoken in the rest of the book: the impact of feminism and the impact of psychoanalysis. One can, it is true, read 'Power and Photography' as a kind of response to Laura

Mulvey's article on power and looking, to the great difficulty she has in trying to connect her analysis of a specific historical régime of representation and looking with the undefined temporalities of patriarchy and the Oedipal complex.[15] Foucault's analysis of power and looking suggests that this universalising of the look is inadequate, because looks have more complex histories. So one could regard 'Contacts/Worksheets', like 'Power and Photography', as written in response to certain debates in feminism, psychoanalysis and representation. But it engages more directly, not only with this, but with feminisms of other sorts.

There was an interesting split in Britain between the kind of feminist cultural theory that was close to the theoretical concerns we have been talking about – semiotics, psychoanalysis, deconstruction – and the kinds of feminist art practice they fostered (paradigmatically, Mary Kelly's; though the *Post-Partum Document* is still in a sense a diary of her losses in relation to her child), and other kinds of work that were regarded as theoretically reprehensible and labelled essentialist, but which often challenged relations of representation in other ways. This latter work was frequently much more effective at finding other spaces in which to speak, as in the 'Women's Postal Art Event' or Kate Walker's 'Portrait of the Artist as a Housewife', which sewed up other connections, took itself elsewhere, and did not operate in galleries or even in single spaces. Much of this work was also diaristic, as a means of retrieving subordinated genres and articulating other voices. Whereas that is now acceptable, after Derrida and after Barthes's last writings, it was greeted with much less enthusiasm in Kate Millet's earlier and much less comfortable work, from *Sexual Politics* to *Prostitution Papers*, *Sita* and *Flying*.[16] Hers was a political and not purely textual questioning of the masculinised voice of authorial and academic authority.

The essay in *Photography/Politics: One* was pushed by this into an effort to interrupt that voice, *my* voice, to give it a body, to catch it up in the personal, yet to find the personal not a comforting area of nostalgic truths, an area outside politics, but thoroughly implicated. So, there is a degree of self-implication that, of course, can be misread; and there is irony, which can itself be a mechanism of disavowal. It was also an attempt to unsettle the voice of some of the other essays in that anthology. I am sure what the original editors wanted for their book was another theoretically

brutal attack on left documentary practice, putting it in its place. But that would have been caught in the very problems that I thought I should be looking at: the authority of theory and its relation to my voice, my speaking, my writing. So I decided to do this. But it was not much liked. I think that pointed to a great discomfort on all sides about men speaking, in however academicised a way, about the ways our own activities are implicated in power and sexuality. Perhaps there was also rightful offence at a man stealing the voice and colonising the space of the Other again.

However, I wanted it in *The Burden of Representation* because I regard it as having come out of a difficult period of engagement with certain feminist practices and the women's art movement. But I did not want to write about that; I wanted it to be ingrained across the voice, I wanted it to interrupt my speech. It is striking that what would have been better received would have been exactly the voice of violent authority, heavy theory. That is why I said it was embarrassing: it was meant to be disturbing of my Self, but I think many other people at the time just found it embarrassing.

JL: They were embarrassed for you?

JT: Yes. Which is interesting because, after all, it is 'only writing'. It is a quite conventional article: there is a beginning, no end, but it occupies the pages, stays on the line. What is it? Is it autobiography? Is it confession? Is it a story about a character? Is it theory? It tried to occupy a space that was not criticism and shake up those comfortable and controlled genres. James Agee had already done much more forty years earlier.[17] And, just as much to the point, there were a whole lot of practitioners whose work had problematised categorisation. Are they photographers? Photographers do not think they are. Are they theoreticians? They often find it difficult to get jobs in art-history departments. Jo Spence, Mary Kelly, Marie Yates, Connie Hatch, Martha Rosler: it is intentionally difficult to define the status of what they do. So that was another reason to attempt to do something similar in the space of criticism as well.

I think I have similar thoughts about it now as about being involved in the Pavilion Feminist Photography Centre in Leeds between 1980 and 1984. Perhaps the article wants to be in a space and then is unable to deal with the consequences, in a similar way. But I still like it because it upsets the rest of the book, which is in a very traditional mode of theory. It is a fly in that ointment.

The danger of trying to exhibit something ironically may be that one will replicate it. Yet, I must say, I was also trying to open a space in *Photography/Politics: One*, as in my own work, for kinds of writing that are not there in other parts of the collection, with its very particular kind of theory. This was to be much more oblique.

JL: I found most of the articles in that book prescriptive: people telling us what practice ought to be.
JT: It is true. It was virtually proletcultist in parts. And, in that context, I certainly did not want to be prescriptive, to lay down what photographic practice should be, or a theoretical line. I felt that I was being asked to contribute precisely to do that, to sew it up at the end, to write a theoretical conclusion. It was the same thing I refused to do in the *Three Perspectives on Photography* catalogue. I am sure that, for the editors, it made a very unsatisfactory ending, but that was my satisfaction, that was my point.

JL: Does your current work explore that approach?
JT: I kept up the notebooks from which this piece was drawn for another two years. I might do something with them, but that is not a theory book; it is not an academic book; it is not a photography book; it is something else.

It is very difficult to do something on the self that is not self-serving. It is bound to be – like this interview. Yet, I wonder about Millet: I think she genuinely did. Barthes's undoing of himself in *Barthes by Barthes* is now part of the post-structuralist canon.[18]

Still, we all have to work; we all have to eat.

Notes

1. The Catalogue Committee, *an anti-catalogue* (New York, 1977). A more recent and impressively successful example would be the issue of *October* edited by Douglas Crimp on 'AIDS: Cultural Analysis, Cultural Activism', *October*, no. 43, MIT Press, Winter 1987.
2. Sheila Rowbotham, Lynne Segal, and Hilary Wainwright (eds), *Beyond the Fragments: Feminism and the Making of Socialism* (Alyson Publications, Boston, 1981).

3. *Screen Education*, 'The Politics of "Representation"', no. 36, Autumn 1980.
4. T. Dennett, D. Evans, S. Gohl, and J. Spence (eds), *Photography/Politics: One* (Photography Workshop, London, 1979).
5. 'The Geology of the City', *Art Monthly*, no. 56, May 1982, pp. 14–15.
6. Paul Hill, Angela Kelly and John Tagg, *Three Perspectives on Photography* (Arts Council of Great Britain, London, 1979).
7. Griselda Pollock, 'Three Perspectives on Photography', *Screen Education*, 'Interventions', no. 31, Summer 1979.
8. John Tagg, 'Power and Photography – Part I. A Means of Surveillance: The Photograph as Evidence in Law', *Screen Education*, no. 36, Autumn 1980, pp. 17–55; and 'Power and Photography – Part II. A Legal Reality: The Photograph as Property in Law', *Screen Education*, no. 37, Winter 1981, pp. 17–27.
9. John Tagg, *The Burden of Representation: Essays on Photographies and Histories* (Macmillan, London, and the University of Massachusetts Press, Amherst, 1988).
10. T. J. Clark, *Image of the People: Gustave Courbet and the 1848 Revolution* (Thames & Hudson, London, 1973).
11. Cf. Louis Althusser, *For Marx*, trans. Ben Brewster (Penguin, Harmondsworth, 1969); and *Lenin and Philosophy and Other Essays*, trans. Ben Brewster (New Left Books, London, 1971). Michel Foucault, *Discipline and Punish: Birth of the Prison*, trans. A. Sheridan (Allen Lane, London, 1977); and *Power/Knowledge*, ed. C. Gordon (Harvester, Brighton, 1980).
12. John Tagg, 'The Currency of the Photograph', *Screen Education*, no. 28, Autumn 1978, pp. 45–67.
13. Roland Barthes, *Camera Lucida*, trans. Richard Howard (Hill & Wang, New York, 1981).
14. Stuart Davis, 'Abstract Painting Today', in Francis V. O'Connor (ed.), *Art For the Millions* (New York Graphic Society, Greenwich, Conn., 1973) p. 122.
15. Laura Mulvey, 'Visual Pleasure and Narrative Cinema', *Screen*, vol. 16, no. 3, 1975, pp. 6–18.
16. Kate Millet, *Sexual Politics* (Doubleday, New York, 1970); *Prostitution Papers* (Avon Books, New York, 1975); *Sita* (Farrar, Straus and Giroux, New York, 1977); and *Flying* (Knopf, New York, 1974).
17. James Agee and Walker Evans, *Let Us Now Praise Famous Men* (Houghton & Mifflin, Boston, 1980).
18. *Roland Barthes by Roland Barthes*, trans. Richard Howard (Hill & Wang, New York, 1977).

5

The Proof of the Picture

*With the advent of the first truly revolutionary means of
reproduction, photography, simultaneously with the rise
of socialism, art sensed the approaching crisis which has
become evident a century later.*

<div align="right">Walter Benjamin[1]</div>

Walter Benjamin's prophesy that the development of photography
as a means of mechanical reproduction would spell the end of the
cult status of art is almost too well-known now to need repetition.
What it requires us to accept, however, is a homogenising concept
of art, prior to its multiplication and emancipation by mechanical
reproduction, as a unique yet distanced presence whose contemp-
lation has been hitherto immersed in the rituals of cult. Technical
progress, run together with something evoked as 'the desire of
contemporary masses',[2] has – Benjamin argues – exposed, pene-
trated and dissected this presence, stripping it of its aura of
authority and surgically severing its parasitical connections with
ritual. Like the state, the aura has been destined, it seems, to wither
away, destroying forever the semblance of art's autonomy and
exhibiting it to a new, distracted but specific, mode of reading,

The material for this chapter was first delivered as a lecture at the
International Center for Photography in New York, in November 1986,
and subsequently published in *Afterimage* in January 1988.

apparently more manual than optical. In the process, so the argument runs, cult value has given place to evidential value (exemplified in Eugène Atget's work) as a necessary effect of the development of means of reproduction, which have not only shattered traditional categories but also shown themselves to be ultimately uncontainable within existing property relations and existing relations of artistic production – relations Benjamin confusingly equates with what he calls 'modern man's legitimate claim to being reproduced'.[3]

I shall return later to a rather different reading of the causes and effects of this partial and specific reversal of the political axis of representation. I shall also have a deal to say about the notion of photographic evidence. But what I want to remark for the moment is the striking fact that Benjamin's technicist prediction – that of a guilty connoisseur and collector under pressure from the Third Period leftism of Brecht – did not come true. The dialectical fusion of art and science (which are, in any case, not given poles but functions of a particular discursive economy) did not take place. The cult of Art, itself of recent construction, was not displaced. What emerged instead – and it was not just a question of specialisation at the level of production – was a decentred field of institutions, practices, agencies and discourses in which photographic technologies were so deployed that what pertained to one space might not pertain to the others at all, and yet in which potential contradictions were contained by being held apart. The new means of signification did not therefore constitute a unified medium or contain within themselves an ordained historical function. Already thirty years before Benjamin wrote his analysis, a complex hierarchy of cultural spaces had been set in place in which, contrary to his predictions, a privileged status could not only be retrieved for cultural practices otherwise threatened by the industrialisation of photography, the growth of popular involvement, and the construction of instrumental archives, but could also be extended to selected practices employing the new technologies of cultural production themselves.

In such a context, it is certainly true that, within the photographic field, the excessive connotators of Art characteristic of aspiring amateur and turn-of-the-century Pictorialist strategies were simply redundant and could be largely, and with time, abandoned. But what this shows is neither that a historicist imperative was working

itself out, nor that some inherent truth of the medium – the in-itself
and for-itself of photography – had compelled recognition. What
matters is that the institutional structures which constitute artistic
status – not only the institutions of the art commodity market but
also, and crucially, post-market institutions of patronage, exhibi-
tion, publication and critical representation, and the discursive
structures of photographic criticism – were already in place.[4] For
all the claims of symbolist theory, typified by the institutional
discourse of *Camerawork*, nothing could be guaranteed at the level
of the image, or by ethical assertion. Status and value had to be
produced. And they were not produced in specialist institutions
alone. Certainly, particular promotional structures – salons, galler-
ies and magazines – and novel critical languages worked, as Allan
Sekula and Ulrich Keller have argued, 'to produce an honourific
milieu, [and] to impart status to select participants'.[5] But, outside
this more or less specialised complex, the legislative and juridical
apparatuses, for example, also intervened to divide photography
into copyrightable artistic properties and mechanical products; just
as they claimed the power to constitute certain photographs as
transparent evidence.

It was not, however, just a question of the emergence of a field of
differentiated and mutually defining practices, for the spaces in
which they were inscribed were, at the same time, read as a
qualitative progression allowing the simultaneous separation and
hierarchisation of arenas of representation in which, nevertheless,
no common criteria or purposes could be shown. The professional
and amateur, creative and commercial, expressive and instrumental,
licit and illicit were thus produced in difference and identity so that,
at one point, market forces could operate uncontested; while, at
another point, a special aesthetic value and cultural status might be
secured for certain photographic practices, giving them a peculiar
precedence; and while, at yet another point, photography might be
stripped of all cultural privilege in order that it might exert a
different power – the power of evidence, record and truth.

One cannot assume, therefore, that the historical production and
transformation of value describes a unified field or that there is one
debate on the status of photography, photographic realism or
photographic aesthetics. The artist's proof is not the police
officer's. There is a complex topography of debates and spaces
which we must map out, and historians of photographies – an

unavoidable coinage since the category is indelibly plural – cannot avoid the question of the stratification of photographic practices and its consequences, which cut right across their own institutional practice. It is rather as if critics of Literature were to be forced to engage with the much more complex and diversified field of a history of *writing*. The discursive object Literature, with all its inherent valuations, with its unstated histories of more or less violent exclusions and suppressions, would be effectively displaced. But to displace it in theory would be one thing; dismantling the paradigm of Literature at the institutional level would require other, more difficult, not only discursive but also organisational and political interventions. Contrary to Benjamin's wishful prediction, the work will not be done for us by the dialectic, or by machines. Like the state, the canon of Art will not wither of any teleological necessity. The régimes of sense of which it is part must be taken over, broken, overthrown, pursued beyond inversion, invaded, interrupted, dispersed, again and again.

And yet, how can we do this when we have hardly understood how and at what levels it has been instated? I am not here imagining some synthetic theory or recipe for action. Nor do I want to exaggerate potential repercussions by collapsing the analysis of specific cultural institutions into an overinflated, functionalist model of the state. What I want to propose is an institutional and discursive analysis appropriate to the level of what Foucault termed a 'microphysics of power'; an analysis not of determinate origins and predetermined expressions, but of conditions of existence, means of representation and conjunctural effects; an analysis itself caught in the conditionality of political calculation.[6]

For example – and this is the example I principally want to explore – to understand the conditions of existence and effects of proliferating nineteenth-century archival systems of photographic records, while rejecting readings of them as reflections of a given reality or expressions of an already constituted class power, we have to relocate them within a constellation of apparatuses that emerged in Western Europe and North America, but also in colonised territories, in response to internal and external problems of order and productivity afflicting developed capitalist formations. Deploying new techniques of observation, representation and regulation, such apparatuses – the police, hospitals, schools, asylums, prisons, departments of public health, and so on – bore down literally on the

domestic and alien social body and its environment, constituting the social as object of new supervisory practices and technical discourses and seeking to exert a control over social life in ways which would integrate social regulation in an unprecedented manner. While such emergent institutions cannot be understood as Ideological State Apparatuses in Althusser's functionalist and economistic sense, which would see them only as the reflexes of an already inscribed power, it is still important to grasp that they were subject to novel forms of state intervention and were articulated into new forms of the local and national state.[7] What we have to deal with, therefore, is the attempt to set in place a new mode of governance which aspired to an unmatched systematicity, while representing its incursions into an objectified populace as disinterested, technical and benign.

Construed as impartial, clean, compelling and modern, photographic records spoke this power. Yet, at the same time, the emergence and official recognition of instrumental photographic practices were also bound up with more general and dispersed transformations in society and in ways of describing it, representing it and seeking to act on it. The development of new regulatory and disciplinary institutions was inseparably linked, throughout the nineteenth century, to the development of new 'scientific' discourses and practices – comparative anatomy, anthropology, criminology, medicine, psychiatry, public health, sociology – and their attendant professionalisms. Disdaining the older orders of an established 'common sense', new bodies of experts pressed their claim to a greater authority. Through special kinds of attention to the bodies, environment and material needs of subordinated subjects, they sought to inculcate a habitual docility and bind the dominated in consenting relations of inferiority to and grateful dependence on the benevolent agencies of investigation, regulation and reform.[8] But beyond this, through their control of technicised representations, the new experts also sought to take the power they claimed out of the realm of political dispute and to reconstitute the social as solely the target of professionalised knowledges and technical supervision.

I am not suggesting that direct coercive power was absent from such emergent social formations. Nor do I want to forget the more mundane economic constraints that continued to operate on the lives of dominated and exploited groups. In any case, attempts to

impose new forms of social control were never to pass without resistance, if only by a dogged imperviousness to 'reform' or by a kind of absenteeism from cultural, political and economic structures which causes as many problems for contemporary social and statistical historians as it did for the agents of reform at the time. Such factors as these cut across exaggerated versions of social control which see in local and specific institutions only metaphors for a totalising panoptic or disciplinary régime: the working out of a will to power.

If a general strategy emerged, therefore, its unity was not preordained. It was rather the cumulative effect of specific interventions and struggles through which an administrative and discursive restructuring was negotiated across a range of institutional sites. Of central importance to such a restructuring were – as I have been stressing – new practices and technologies of representation, crucially involving photography, as well as new forms of writing, textual organisation and statistical storage. In the mobilisation of such practices and technologies, the political axis of representation was – within these spaces – emphatically reversed. Though an honorific culture continued, in which it was a privilege to be looked at and pictured, its representations were institutionally and economically separated from instrumental archives in which the production of normative typologies was joined to the tasks of surveillance, record and control. To be pictured here was not an honour but a mark of subjugation: the stigma of an other place; the burden of a class of fetished Others – scrutinised, pathologised and trained, forced to show but not to speak, cut off from the powers and pleasures of producing and possessing meaning, fashioned and consumed in what Homi Bhabha has called a cycle of derision and desire.[9]

Photographies operated in both these realms of representation – the honorific and the instrumental – and the photographs they generated were accorded quite different statuses and explanations; as different as the standing attributed to the agents who produced them, as artists or operators, in the differently evaluated domains. It is into these spaces, therefore, that we must pursue differences of meaning and effectivity. The legitimations of particular photographic practices derive from specific discursive economies that are sited in specific institutions and practices, supported by specific agents, and invested with specific relations of power. Such legitima-

tions are never given in advance but have to be produced and negotiated. The notion of evidence, for example, on which nineteenth-century practices of documentation traded, cannot be taken as already and unproblematically in place. Before what tribunals was photography a natural witness, empowered to exercise the truth of evidence as elsewhere it embodied the Truth of Art? Any adequate answer to this question cannot expect to confine itself to the familiar ground: to already privileged cultural, critical or juridical sites; to the familiar masterpieces and usual sources of a history of art. That limitation is part of the problem. It presupposes a conventional model of culture and power which determines, in turn, a certain ready conception of historicalness. To get beyond these limits, we have to find a way into the small spaces, into what Foucault called 'ignoble archives';[10] that is, if we want to understand the largely unremarked and unresisted powers photographies came to exert, or trace their processes of negotiation.

This is the only claim I make for two albums of captioned photographs produced for Leeds City Council in 1896 and 1901.[11] My purpose is not to suggest that the negatives – wherever they are – should be canonised, printed by Lee Friedlander and published by *Aperture*. Nor do I want to lend them a spurious status as part of a 'concerned documentary tradition', as transparent documents of late nineteenth-century housing conditions, or as telling us anything about a real or imagined working-class experience. With all due deference to Roland Barthes, no amount of pre-Oedipal nostalgia can get beyond the disappointing fact that the photographs do not and could not validate their meanings within themselves.[12] The photographs' compelling weight is not phenomenological but discursive, by which I mean here more than that the individual images are bound into larger photographic narratives, but that they exerted a force only within a much more extensive argument and social intervention in and on public health, housing and urban redevelopment. The argument and intervention constituted the photographs' conditions of existence and infused their production and reading. What we must ask, therefore, is not: What do these photographs authenticate? but: How were they articulated in and how did they articulate an argument? Whose was this argument? How was it validated? Who spoke it? To whom? Under what conditions? To what ends? With what effects? In other words, not: What do these albums re-cord, re-flect, re-present? but: What

did they do? At least, under certain determinate conditions, since they have certainly shown themselves capable, at other times, of doing many things: of servicing an academic discourse on the history of housing, for example, or, more recently, advertising the nostalgic attractions of the 'living heritage museum' a deindustrialised West Yorkshire has threatened to become through Thatcherism. Asking what the photographs did, however, rather than dreaming of another scene, takes us back to their specific contexts of production, presentation and reading: the specific arenas of their truth effects.

The Quarry Hill Insanitary Area albums were made and remade over a period of five years between 1896 and 1901, for presentation to Select Committees of both Houses of Parliament as part of an argument put forward by the local government officials of Leeds City Council for enabling bills to permit a two-stage inner-city clearance scheme. Their effective deployment depended on establishing a notion of their realism and evidential value: their power to make present another space – a space which, though absent, would be accepted as already saturated with the meanings constructed for it in the Council's representations. By this conflation, the photographs would be seen to prove the Council's case.

The idea that photographs could have the power to do so was still a relatively new and vulnerable proposition, at least in the context of legal and parliamentary practice. It had, therefore, to be negotiated for the photographs in the very process of their use and this seemingly simple but elusive transaction is partially traced in the Select Committee minutes which dramatise what might otherwise be lost: an historical process of reading and the institutional advance of a particular politics of photographic literacy. The Real that was thereby called up for the photographs, though represented as inhering in them, was always a complex discursive reality, figured at every level in metaphors which multiplied its meanings, so that, for example, even the denotation of light and dark was always already resonant with the almost conventionally demanded biblical meanings which had structured an affronted middle-class perception of and moralising fascination with slums for half a century.[13]

At the same time, in the way the photographs were offered, the metaphoricity they set in play was disavowed. The camera was called on as a technical instrument, like a theodolite; its own

connotations of precision and modernity bolstering and bolstered by the technical practices and expertise within which it was mobilised. The camera of the Council was not a commercial or recreational toy or a means of journalistic sensation. It was a modern technical device for metering light and measuring space. It was the instrument *par excellence* for Medical Officers of Health and sanitary engineers at the forefront of their disciplines; while, at the same time, it could serve, through the production of lantern slides, as a political instrument to popularise their expert theorisation of the supposed causal relation between light, air, ventilation, and public health.

The camera was thus the scientific means to look squarely and dispassionately at a 'technical' problem. Yet, if the apparatus here was proposed to operate as a controlled extension and aid to the trained and expert *eye*, the photographs it produced functioned as a kind of *mouth*: a mouth that spoke for itself, of course, wordlessly enunciating its incontrovertible evidence; yet a mouth that had to be given a voice by the public health experts who imputed that they alone could read its lips. Through this silent ventriloquy, theirs is the voice that speaks the evidence and opens the Select Committees' eyes. It is not the voice of the inhabitants of what has been designated the Quarry Hill Unhealthy Area. Indeed, it is as indifferent to them as the most hardened structuralist. Its advocacy does not depend on representing their experience. They are an effect of the structure: the structure of closed courts, alleys, ginnels, yards, and the notorious back-to-back houses of Leeds's east end. The inhabitants are mere epiphenomena; what matters is the structural causation. The voice of the photographs goes on, speaking its technical arguments about light, air and ventilation, tolerant of repetition in the patient translation of what ought to be already evident. The minutes record it:

> on the right hand side, that is the back door of the common lodging house – this yard is 25 square yards in area – the photograph is taken from a narrow entry, and the only way into that yard from the other side in that yard is on the right hand side, the window and the back door of the common lodging house, and on the left side two small two-storied buildings let off in furnished apartments, and then in front that wall with the line of light shown upon it is the wall of the 'Yorkshire Hussar', and

the 'Yorkshire Hussar' prevents the only daylight that might possibly get into these buildings on the left hand side from getting into them.[14]

The photograph is before the Select Committee. The Medical Officer of Health, Dr James Spottiswoode Cameron, is explaining what it says. And in the careful redundancy of his utterly professional and technical lecture, the social and political debate over health, housing and class can have no place.

Why, we might want to know, was the clearance of Quarry Hill negotiated through such an argument? Why, indeed, after more than a century, had slum clearance come to be an issue in Leeds? And why and how was photography involved? It was clearly not a question of philanthropy. Even by the *laissez-faire* standards of Victorian England, Leeds had had a deplorable reputation in housing and public health for sixty years. Undoubtedly, this had begun to tarnish the burgerdom's civic pride and, in any case, the reputation for epidemics threatened to harm Leeds's function as a commercial hub and centre for the wholesale trade. There was also fear of contagion and Cameron's predecessor as Medical Officer of Health had been promptly sacked when typhoid spread from the infernal slum to the middle-class suburbs on the hills to the north, 'above the smoke'.[15]

On a different plane, however, housing and urban clearance had become major public issues in the 1880s and 1890s as a result of a heightened political struggle at the local and national levels in which the Conservative Party, out of office for so long, sought the means to challenge the domination of the Liberal Party, and the Liberal Party responded, while the hegemony of both was put under question by an emerging organised labour movement. But the political struggle which 'discovered' the housing of the working classes in the last decades of the nineteenth century cannot be located only at the party political level. The power of those groups which had made up the ruling bloc of Leeds's 'shopocracy' for sixty years was also under pressure both from renewed political activity amongst an older social élite, and from a newly emergent stratum of professional officialdom – Medical Officers of Health, engineers, factory and local government board inspectors – whose position had been greatly strengthened by new legislation and local interventions by central government. Symptomatic of such interventions

was the 1890 *Housing of the Working Classes Act*, under whose powers the Quarry Hill clearance scheme was moved by the Council. But the terms of this new and controversial Act had the paradoxical effect of highly politicising the issues of health and housing, while simultaneously removing them from the level of political debate and representing them as the property of professional technicians: the sanitary engineers and Medical Officers of Health like Dr. Cameron who contrived, organised and presented the photographic evidence for the necessity of demolition, but had no mandate to propose reconstruction, other than widening the roads.

The political meaning of this depoliticisation takes on yet another colour when one considers what was more widely at stake in the periodic concern about housing in Britain's industrial towns and cities. In the context of the defined class zoning and social divisions characteristic of unregulated development in nineteenth-century towns, the inner urban slum had become a dark and other place to a suburbanised middle class and ruling clique. Such separation, outstretching Christian missionary zeal and beyond even the fantasies of a journalistically titivated desire, was a middle-class comfort which turned, however, into a source of anxiety at times of periodic crisis, unemployment, social unrest, immigration, epidemics, and harsh weather. It was just such fear which animated the Leeds clearance scheme – though it is decently repressed in the reasonableness of informed argument. Quarry Hill was a jerry-built, disease-afflicted, racial and working-class ghetto (like Mulberry Bend in New York which Jacob Riis wanted pulled down). Its inhabitants were tied to the area by poverty, lack of alternative housing, lack of transport, and the need of employment in its mills, markets, slaughter-yards, factories and sweated trades. In an increasingly marked isolation, especially amongst the large Irish and Jewish immigrant populations, they had developed the networks, systems of support and diversions of what Gareth Stedman Jones calls, in London, 'a culture of consolation':[16] subordinated, passive, defensive, yet relatively impenetrable to social missionaries, reformers, policemen, teachers, local officials and even radical political activists.

And yet Quarry Hill was also, beyond this, if not on a widespread scale, a space of political resistance perceived by local authorities as beyond the pale of civilised norms. The metaphor is pointed here

since the prime supposed offenders were less the Jewish community, represented as deplorably 'Eastern' and attracting the disorderly attentions of racist rioters, than the Irish: transplanted from 'the wildest parts of Connaught' and allegedly intransigent to education and reform. From this Irish community, the leaders of the Independent Labour Party and local Trade Union movement emerged. But, more fundamentally, the population of emigrants from England's first colony made up a constituency which, unlike its English counterparts, was never subsumed in the imperialist celebration and racialist supremacism of Victorian and Edwardian politics.

A troublesome community to have, then, in an important marginal parliamentary seat, especially at the close of a period of economic depression, industrial and political unrest, agitation for Irish Home Rule, immigration, epidemics, and crisis in the local municipal order. Yet, as the parliamentary committees scrutinise the irrefutable evidence, all this is elided. The inhabitants are – for the camera, as for the clearance – pushed aside. The streets are cleared, except where scale needs to be set. The power of a new kind of agency intervenes. It deploys its instruments and pieces together its pseudo-technical argument: the area must be opened out so that sunlight can kill germs and through ventilation can destroy the conditions of disease. Light, air and space: these are the issues and these are what the camera measures, conjuring up in every image a utopian obverse: the imagination of a clean, ordered and supervised space – an arena of benevolent technical control. It is this argument that the photographs are allowed to speak. They were made under its conception and, though we may not know who the photographer was in the sense of the operator who released the shutter, we may regard them as decisively 'authored' at this as at other levels by the departments of the Medical Officer of Health and the Borough Engineer under whose supervision they were prepared and presented. Under such conditions, the photographs mark the beginning – but only the beginning – of a methodical documentation which has to differentiate itself in a field of urban representations: shunning the picturesque and sensational, disdaining the moralism and humanism of philanthropic reformist photography, affecting a systematicness beyond and above that of commercial stereoscopic and postcard views, relinquishing the privilege of Art for the power of Truth.[17]

Such ambitions may have informed the albums' production; their status and significance, however, still had to be negotiated before the parliamentary Select Committees. Their meanings always potentially remained to be opened, as was shown when, within a year of the final committee decision, they were rebound and presented to Leeds Public Library and a local antiquarian society as a self-congratulatory monument to the Council's work and an evocation of a time gone by. In the context of the parliamentary inquiries, therefore, this openness had to be contained and a specific reading of the albums had to be constructed and imposed. This is the process which can be traced through the minutes, especially through the crucial and carefully drafted contribution of Dr Cameron. By what, in his own terms, ought to have been a redundant and repetitious description, Cameron sought to under-line the scientific status and instrumental realism the photographs embodied for him. Yet even while this claim was insisted upon, there was never any question of the pictures speaking for them-selves. Cameron intervened continually, following a prepared script, patiently enunciating the photographs' message and indexing them to written evidence, maps and architectural plans. He was not about to accept the accusation of rousting people up with 'postcards'. His was a methodical and unambiguous dossier:

> E is the front of it; F is the yard behind it; G is the back of the house taken from that same yard; H is the north end of Riley's Court adjacent to it; I is another view of the same court.[18]

In the framework of this authoritative reading, even the limits of photographic realism could, without acknowledge contradiction, be brought into play – always in the interest of conjuring up a space beyond photography yet knowable through it to the guided eye. In this way, what was not shown was also made to speak: there were alleys and courts so dark and cramped that they could not even be photographed:

> I should like to have shown you a photograph of some of these places but the difficulty is that the yards are not big enough to allow the camera free scope.[19]

For all the insistence on the fullness of meaning and presence of truth in the photographs, it was this absence that proved the Council's case; though the existence of other kinds of contemporary

photographic representations might have made it possible to question this appropriation of silence to meaning. Why are there no interiors in the albums, for example? (They occur, by contrast, in D. B. Foster's Christian Socialist text on *Leeds Slumdom* of 1897.)[20] Would their inclusion have put too riskily to test both the impersonal technicism of the discourse and the actual powers of entry of officials of the Sanitary Department? Cameron allowed no room for such doubts to develop and, when under cross-examination, could even abandon realist rhetoric for a frank recognition of the photograph's construction:

> 'Look at this photograph. Do you repeat your evidence that it is covered in – that is a photograph of the yard as it is now?'
> 'Yes, it is taken at a very wide angle of lens, and makes this part broad; the impression is that you are coming in to a shut-in place'.
> 'I will not discuss with you whether it is covered in or not'.
> 'It is covered in where you see on the photograph. If you take the picture with a wide angle lens you magnify the foreground at the expense of the background; the background is covered in'.[21]

Such a tactic only underlined Cameron's standing as an expert reader. Theoretical consistency was not the goal. What were at stake here were both his expertise and his power to produce and control meaning. In their conjunction, the space of the city was to be transformed.

The justness of Cameron's language gaming might have been called into question from a position outside the political field of his discursive and institutional strategy. The opposition that was heard in parliamentary committee from landlords, publicans and estate agents, however, (unlike that from a handful of Irish MPs in the House) was caught in the snare of the photographic realism Cameron constructed. The content of this might be disputed but not its status. The weight of evidence fell therefore on Cameron's side and he won the case. Subsequent historians of housing who have been familiar with these albums have also tended to fall in with Cameron and the Council, though lamenting the failure to rehouse more than 198 of over 14 000 people displaced by the total clearance scheme. In terms of their own practice, too, these historians have invariably gone along with Cameron's idea of the photographs as evidence, giving it a new currency in their use of the images as

illustrations to their work. From this point of view, they have had no purchase on the historicity and effectivity of the photographs themselves and the discursive strategy of which they were part. They too have been stuck on Cameron's theory of the photographs' self-evidence.

But the proof of the picture was in the reading. The photographs had to have their status as truth produced and institutionally sanctioned. The distinctive gaze of the Council's camera – though a gaze nonetheless – was a complex and specific socio-discursive event. The images it produced – though images nonetheless – caught the eye of the legislators only in the play of a particular régime of power and sense. If this photography seemed to bring to the institutions involved certain powers they sought – the power of a new and intrusive look; the power of a new means and mode of accumulative knowledge; the power to structure belief and recruit consent; the power of conviction and the power to convict – the powers the photography wielded were never its own. They belonged to the agents and agencies which mobilised it and interpreted it, and to the discursive, institutional and political strategies which supported it and validated it.

What was constructed in and through the photographs was, at once, a truth and a discipline: an order of meaning, a system of discursive constraints, bound into the discipline of public health. It was on their appropriation to this discipline that the photographs depended for their status and against its notional primary texts that they were read. The photographs had, in consequence, to be stripped of authorship, this being integral both to their standing as science and to their instrumental realism. For the sacrifice of authorship was asked to accomplish seemingly quite opposite ends, institutionalising control over photographic meaning while presenting the photograph as neutral, transparent and true. The 'super-cession' of this contradiction was a function of the discursive strategy itself, from which its power flowed. On the one hand, the constitution of a purely photographic field of space and light was inseparable from the empowering of an institutional and discursive order which appropriated the productivity of photography to its disciplinary structure. On the other hand, the fixing of truth within the image elided the dangerous materiality of the photograph, its problematic nature as discursive event, and the power and desire which sought to structure it. In this way, a special domain of

technical, instrumental photography was produced, interlocking with special domains of writing and speaking, regulated by prohibitive limits to who might pronounce on what and under what circumstances, and by strict controls over the dissemination of appropriate literacies. The potential field of photographic production was thus both demarcated and divided up in advance into specialised territories of practice and meaning which were congruent one with another only in their exercise of constraints on the proliferation of photographic discourses and in their articulation of a discontinuous field beyond which there was only a declared non-sense. Across this field, the unity, integrity and continuity of photography was, from the beginning, only ever locally and discontinuously invoked.

I have come back to the point from which I began: it is this institutional field of discursive strategies, the relations of power which invest them and the effects of power they produce, that we must study. Analyses premised on the positing of photography as such – whether in order to defend an intrinsicality of meaning, or to declare it abolished by a historicist dialectic – can never theorise this as the historiographical task. Worse than this, and for all Benjamin's intentions, they deprive us at a more crucial level of the means of political and historical calculation we need if we are even to begin to talk about institutional interventions – complex, conditional, specific, and without guarantees, as they must be.

Notes

1. Walter Benjamin, 'The Work of Art in the Age of Mechanical Reproduction', in *Illuminations*, Hannah Arendt (ed.), trans. H. Zohn (Harcourt, Brace & World, New York, 1968) p. 226.
2. Ibid, p. 225.
3. Ibid, p. 234.
4. The term 'postmarket relations' is taken from Raymond Williams, *Culture* (Fontana, Glasgow, 1981) pp. 54–56.
5. See Allan Sekula, 'On the Invention of Photographic Meaning', in V Burgin (ed.), *Thinking Photography* (Macmillan, London, 1982) pp. 84–109; and Ulrich Keller, 'The Myth of Art Photography: A

Sociological Analysis', *History of Photography*, vol. 8, no. 4, October–December 1984, pp. 249–275.

6. For Foucault's notion of a 'microphysics of power', see Michel Foucault, *Discipline and Punish: Birth of the Prison*, trans. A. Sheridan (Allen Lane, London, 1977) pp. 26, 213–14; and Michel Foucault, *Power/Knowledge*, ed. C. Gordon (The Harvester Press, Brighton, 1980) pp. 39, 98–9, 104–6. For the concept of 'political calculation', see Paul Hirst, *On Law and Ideology* (Macmillan, London, 1979) pp. 3–8, 19, 55.

7. Cf. Louis Althusser, 'Ideology and Ideological State Apparatuses (Notes Towards an Investigation)', in *Lenin and Philosophy and Other Essays*, trans. B. Brewster (New Left Books, London, 1971) pp. 121–73.

8. Cf. Michel Foucault, 'Body/Power', and 'The Eye of Power', in *Power/Knowledge*, op. cit., pp. 55–62, 146–65. See also Allan Sekula, 'The Body and the Archive', *October*, no. 39, Winter 1986, pp. 3–64; and my own essay, 'Power and Photography – Part One. A Means of Surveillance: The Photograph as Evidence in Law', *Screen Education*, no. 36, Autumn 1980, pp. 17–55.

9. Homi Bhabha, '"The Other Question" . . . The Stereotype and Colonial Discourse', *Screen*, vol. 24, no. 6, November–December 1983, pp. 18–36.

10. Michel Foucault, *Discipline and Punish*, op. cit., p. 191; *Power/Knowledge*, op. cit., p. 37.

11. The full citations for these albums and other primary sources are given in my essay, 'God's Sanitary Law: Slum Clearance and Photography in Late Nineteenth-Century Leeds', Chapter Five of *The Burden of Representation. Essays on Photographies and Histories* (Macmillan, London, 1988) pp. 117–52.

12. Cf. Roland Barthes, *Camera Lucida. Reflections on Photography*, trans. R. Howard (Jonathan Cape, London, 1982).

13. Cf. Gareth Stedman-Jones, *Outcast London* (Penguin, Harmondsworth, 1984) Part III, p. 237ff; and Raymond Williams, *The Country and the City* (Oxford University Press, Oxford, 1973) ch. 19.

14. *House of Commons Minutes of Proceedings taken before the Select Committee on Private Bills (Group F) on the Local Government Provisional Orders (Housing of the Working Classes) [Leeds Order] Bill*, 15 July 1896, (228), p. 32.

15. See D. Fraser, 'Modern Leeds: A Postscript', in D. Fraser (ed.), *A History of Modern Leeds* (Manchester University Press, Manchester, 1980) pp. 466–70.

16. Gareth Stedman Jones, 'Working-Class Culture and Working-Class Politics in London, 1870–1900: Notes on the Remaking of a Working Class', in *Languages of Class. Studies in English Working-Class History 1832–1982* (Cambridge University Press, Cambridge, 1983) pp. 179–238.

17. Cf. John Tagg, 'Power and Photography', op. cit.

18. *House of Commons Minutes . . . of the Select Committee*, op. cit., 15 July 1896, (236), p. 33.
19. Dr James Spottiswoode Cameron's typescript proof of his evidence before the House of Commons Select Committe of July 1901, in the West Yorkshire Archive, Leeds, LC/TC, Bin 21, Box 2, p. 6.
20. D. B. Foster, *Leeds Slumdom. Illustrated with Photographs of Slum Property by W. Swift*, Leeds, 1897.
21. *House of Commons Select Committee on the Local Government Provisional Orders (Housing of the Working Classes) (No. 2) [Leeds Order] Bill*, 4 July 1901, (812–823), pp. 104–5.

6

Totalled Machines: Criticism, Photography and Technological Change

History has a stutter.
The Mekons

INTRODUCTION

I find myself approaching the more general themes of my subject along a number of tangents. By way of clarification, therefore, I shall say at the outset that the issues that concern me have to do with photographic systems of representation *as*, rather than in relation to, technologies; where the latter term carries not only its usual, but also Foucault's more specialised sense. In other words, I shall want to look at the consequences of the investment of photographic practices in systems of knowledge and power, as well

First published in *New Formations* (Spring 1989), the text of this chapter is based on lectures given at the School of the Art Institute of Chicago and Southern Illinois University at Carbondale, in April 1988, as part of a series *Spectrum of Discourses: Critics on Criticism*; and on a contribution to a symposium on *The Visual Arts and the World of High Tech*, held in conjunction with the exhibition 'Three On Technology' at the List Visual Arts Center, MIT, in May of the same year.

as systems of production. The three machines of the title, however, are mechanisms of another sort, located at another level. They are machines of explanation: technologism, historicism, and criticism. Yet, without understanding their workings, we shall not be able to pose, as a problem, the terms in which we can articulate the effects of developing cultural technologies.

I CRITICISM'S LOSS

My title gestures at an expansive field of problems and it is, perhaps, unease about the generality of what I have to say that makes me begin by anticipating an accusation. In a recent debate with Donald Kuspit, in response to my reading of Rudolf Baranik's work in terms of a conception of interventionist practices engaging the specificities of their own institutional entrapment,[1] Kuspit threw out the not unfamiliar charge that 'You do not look at the art itself.' This proved to be only the first of a series of defensive assertions that traced a marked anxiety, fuelled by an angry sense of loss, symptomatic of the responses not only of a number of other critics, across the established political spectrum, but also of many claiming the status of artist, whose investment in criticism – for all the stock denials – is always great, because it is their constitutive discourse. The alarm that has spread within criticism arises from the perception that, through a series of not always concerted and not only theoretical thefts, it has lost its object, its privileged methods and categories, its institutional security, and even itself.

What has happened is not only that the judgements of criticism have ceased to be enforceable and its field of operations has been socially marginalised. It is the very notion of a codified and professionalised practice of discrimination, whose local impressions and responses are expressible as measures of historical necessity or general standards of taste or sensibility, that has come under threat; as much, I might add, from the pragmatism of contemporary curatorial and investment practices, as from developments in critical theory itself. It is not only 'looking' and 'art', therefore, that Kuspit rises to defend, but criticism itself, in the sense that emerged only in the eighteenth century, of a formation – an 'ism'. What the loss adjusters have to contend with is the prospect that the machine of criticism is its own final write-off. And, in front of the

wreckage, we see that we have been dealing with a machine all along, its high-styled bodywork badly dented now, its mechanics exposed.

These are its workings: Its systems of exclusion governing what may be discoursed on, by whom, under what conditions. Its deceptively final, yet pragmatically inconsistent, divisions of an artistic canon from its variably defined others. Its constructions of truth, in all its supposed particularity and universality, as an alibi for power and desire. Its ever refining disciplinary structure, excluding the speculative, metaphoric and fantastic, in favour of the rigorous formation of objects, methods and theoretical field. Its disciplinary training, of the eye, in the archive, of the voice, in the courts of learning. Its slavish, but less than self-effacing, devotion to another (supposedly more authentic) form of speech, to which it attributes final and prodigious powers of meaning, yet for which it must, in the meantime, always speak. Its elevation of certain privileged producers to the sovereign status of founding author, even as it invokes an authority for its own voice in the non-subjective orders of Truth and Historicity. Its professional rituals and niceties, its cosy fellowships, and its institutional clout. All these mechanisms through which criticism seeks to impose on, organise and control the production of discourse (the discourse it speaks; the discourse of which it claims to speak), thereby averting its disruptive proliferation and dangerous materiality.

Criticism's hypostasising of Art 'in itself', originality and the creative subject entails a final necessary refusal to grasp its objects as conditioned but specific, locatable material events, emerging sporadically and with effect under traceable, intersecting systems of historical constraints. Yet this refusal undermines its defences of itself: what criticism cannot say of its objects returns to interrupt its own conditional, disciplinary speech. In its fear of losing its object, criticism loses itself: it is totalled. Some of the wrecks may be still on the road, but most are headed for the breaker's yard, across which we may pick our way as we look for short-cuts, escape routes or salvageable scrap. While the dump that was criticism is here, we can use it; but it is no longer an occupiable site. (Even investors, curators, art crime specialists and artists on the make have had to adapt to that. In the calculations of such cultural executives, conceptions of social consensus have ceased to play a role; just as neo-conservatives have abandoned notions of consensual politics,

arguing that it is possible for a social order to encompass previously unthinkable percentages of unemployed, homeless, illiterate, sick and poor, and that paramilitary policing can take care of the rest.)

In response to Kuspit's accusation, I might say, then, that there are strategic reasons for averting the eyes, for not being caught in the prepared exchanges of criticism and 'the art itself'. It is not just a question of falling short, and it goes beyond wrecking and recycling. It is rather as in the contradiction between the intellectual and the institutional relation Michel Foucault preserved with the History of Ideas. Texts go on being read, passages worked, chairs occupied, turfs claimed and defended, but the categories, problematics and formations involved are no longer the same. It is no more a matter of tracing influences and continuities, or of delineating a canon, corpus or oeuvre, but rather of calculating the conditions and constraints under which certain productions of meaning can, or cannot, emerge, take effect and have consequences for the overlapping fields of practices and relations across which they erupt. Looking may certainly be involved, but as the locus of specific terms of the problem. Which brings me a little closer to my second point.

II THE OBSOLESCENT EYE

The idea of vision as a distinctive cognitive experience and the related notion of purely visual media, beholden to nothing but the eye, have been central to a mode of criticism intent on legitimising its powers by specialising its skills of attention and isolating a fundamental, defining term of difference for its objects. But this triad of vision, experience and medium has constituted one of the first among the losses to which I alluded earlier. In the writings of Victor Burgin, Norman Bryson and Rosalind Krauss, amongst others, the immediacy and finality of vision and the transcendence of the optical subject have been deconstructed, giving place to a conception of seeing as a site of work, an active process of making sense, dependent on social practice and codes of recognition, and imbricated in structures of address through which viewers, or readers, are invested or denied as subjects.[2] In further critiques, stemming as much from feminist perspectives as from Foucault, this analysis has been extended to encompass the technologies,

techniques and institutional relations of power that structure looking and procure the utility and truth value of visual records, which only thus, by a strange anatomical displacement, come to 'speak for themselves'.[3]

But it is not only the theoretical trashing of opticality that interests me here. Retrospectively, this can be seen to have coincided with a new stage in the development of information technologies themselves. As an example, which introduces photography at last, during the last National Union of Mineworkers' strike in Britain, the police, in their determination to prevent the legitimate movement of organisers, supporters and so-called flying pickets, were found to have fitted computer-linked surveillance cameras to flyovers crossing the main north–south motorway route into Nottinghamshire. As the beneficiaries of Britain's most technically advanced coalfield, Nottinghamshire's mines offered relatively secure, if markedly reduced, employment and, in consequence, had not immediately followed the strike call from Scotland, Wales, and adjoining Yorkshire. It had therefore become exceedingly important to the government to isolate the area from what were now represented as 'outside' influences. Hence the surveillance equipment which, through a process of digitalisation, was not only capable of resolving blurred camera images into readable records of car number-plates, but could also compare them with other licence numbers stored in the computer memory and could thus determine the frequency and direction of specific cars' movements.

There is an interesting change here in the technology of surveillance and archival records that exceeds the metaphor of panopticism. In the first place, the 'image' is not coded in a visually apprehendable form; it is nothing but a series of numbers. But beyond this, it is not only the image but also the viewer that is rendered redundant. It is the computer that manipulates the information. The images are neither visible nor viewed: the eye is doubly obsolescent. As in the Nottinghamshire pits themselves, a new generation of technologies has arrived to discipline, punish, absorb and, finally, replace mere fleshly bodies in new and potentially overwhelming ways.

In saying this, I may already have been drawn down a certain route, along which the machine is represented as a mega-subject: a techno-body in which, as Marx foresaw, human operators 'are

merely conscious organs, coordinated with the unconscious organs of the automaton, and together with the latter subordinated to the central moving force'.[4] Such an automaton confronts the human body as its death: as the exhaustion of its nervous system, the wasting of its musculature, the 'confiscation' of 'every atom of freedom, both in bodily and in intellectual activity';[5] as the apotheosis of capital, 'dead labour, which dominates and soaks up living labour-power';[6] or, in another version, as techno-hysterectomy – in Alice Jardine's words, 'the last desperate attempt, at the stage of nature's final exhaustion, to drain the female body of the "feminine"' and 'liberate men from real women'. From both perspectives, the monstrous body of the megamachine is the direct antagonist of 'real' men and women, or what Marx calls the 'totally developed individual':[8] that given organism, the natural development of whose organs (or 'natural technology')[9] functions both as a methodological model and as a normative horizon against which machinic dehumanisation may be measured.

To this, however, Deleuze and Guattari might reply that it is the organism itself which is the enemy:

> The organism is not at all the body, the BwO [Body without Organs]; rather, it is a stratum on the BwO, in other words, a phenomenon of accumulation, coagulation, and sedimentation that, in order to extract useful labour from the BwO, imposes upon it forms, functions, bonds, dominant and hierarchised organisations, organised transcendences.[10]

The bodily organism cannot therefore be invoked, for the past or the future, as measure of loss or goal. It is already invested. Not an alibi (a guarantee; another place) but the very scene of struggle, as we seek out, on its layers, those momentary points of advantage at which we may experiment, against its order, with the opportunities offered, find potential movements, lines of flight, the flow of conjunctions, new intensities, piece by piece, patiently. In this view, we have to live with the fact that there is no externality, nor any natural grounds on which to base a struggle or motivate resistance with the promise of (human) emancipation.

But back to the well-equipped police in Nottinghamshire, hoping to give miners' leader, Arthur Scargill, one in the eye. The eye: technically obsolescent; theoretically deconstructed. Another temptation might be to collapse these moments together, to see the

theoretical developments as bound up with, or even as the
consequences of, technologically driven changes in the political
economy. A footnote on the second page of the extraordinary
chapter of *Capital* on 'Machinery and Large-Scale Industry'
rehearses the familiar lines of this argument, which ties the subtle
theoretical and documentary analysis that follows to a social
topography it strains to leave behind:

> Technology reveals the active relation of man to nature, the direct
> process of the production of life, and thereby it also lays bare the
> process of the production of the social relations of his life, and of
> the mental conceptions that flow from those relations.[11]

It is the logic of the expressive structure; the same structure on
which Hal Foster relies, in seeking to extend Fredric Jameson's
totalising schema of an unfolding 'cultural logic of capital' to what
Foster revealingly calls the 'historicising' of recent critical theory.[12]

In Foster's argument, the way it comes out is that a field of
theorising, designated 'poststructuralism', has to be read as a
'symptomatic discourse' whose supposed 'fetishism of the signif-
ier' reflects a fetishistic disintegration of the sign in so-called
'postmodernist art' that, in turn, reflects and participates in the
governing dynamic of spectacular reification and commodity
fetishism, inherent to a wishfully 'late' capitalism. The Tinguelyes-
que self-destruction of the machine of criticism is thus connected by
more or less elaborate levers to the smooth running of the 'ultimate
agent', the 'prime mover': the machine of production. The theoreti-
cal work of keeping this explanatory mechanism moving is done, in
part, by a linked series of theoretical collapses: of economic and
symbolic exchange; of use-value and referentiality; of commodifica-
tion and the primacy of the signifier; of Lukács's concept of
reification, Marx's deeply problematic theory of fetishism, and the
notion of semiotic fixity. Beyond these collapses, Foster's argument
rests on the paradox of invoking an explanatory apparatus
dependent on the very reflectionist notion of language and meaning
radically displaced by the theories that are to be thereby 'histor-
icised'. Here, as before, the totalled machine will not work. Lacking
the unities into which to plug its instances, the narrative of
economic or technological determination and total transformation
cannot hold itself together. All the talk of spectacular reification,
obsolescent eyes, technobodies, the end of this and that, and entry

into the 'after'-life comes to sound like sci-fi theory, speed psycho-
sis, the habit-ridden voice of historiographic junk, the heady effects
of the same critical fix. With this, I not only come back to my
remarks on the totalled machine of criticism, but also arrive,
belatedly and obliquely, at the point at which I should have
begun: at the consequences of the kind of positional analysis I
began to sketch earlier for totalising accounts of the effects of
photography as a supposedly unified medium or technology.

III GRESHAM'S LAW OF IMAGES

As in the case of the dissemination of printing and earlier print
media – but in a heightened sense, in the context of the development
of corporate capitalist relations and centralised bureaucracies out of
the looser structures of entrepreneurial capital and the *laissez-faire*
state – the proliferation of photography in the nineteenth century
was caught up, at a whole number of points, in the dynamism and
instability, dispersal and centralisation, freedom and authoritarian-
ism of developing capitalist social and cultural formations. Certain-
ly, the potent brew of technological change, financial speculation
and the restructuring of power seems to have been enough to
intoxicate the critics who first contemplated the advent of the new
technology. What is striking in the earliest articulated responses to
the invention and dissemination of photography is how often the
images it began to pour forth are hailed (or, alternatively de-
nounced) as a totally new currency, not only quantitatively but
qualitatively different from any previous kind of image production.
 In 1839, in a famous address to the French Chamber of Deputies
that first publicised the discoveries of Louis Daguerre, exaggerating
their originality in order to justify their purchase and release by the
state, the left democratic leader, François Arago, imagined the
camera shutter opening on a new world of economic opportunities
and artistic and scientific discoveries. He projected photography as
an immediate and transparent means of representation, free from
constraints of skill and knowledge: a tool for a universal science and
a progressive technology that would provide the means for an
unlimited private appropriation of the world, for unprecedented
leaps in productivity, for the democratisation of art, and for the

creation of a lucid, encyclopaedic archive of knowledge. The limits of the available means of signification and reproduction would simply be burst apart. Thinking back nostalgically to the service a photographically armed art history might have offered the French military expedition to Egypt of 1798, Arago calculates:

> To copy the millions of hieroglyphs which cover even the exterior of the great monuments of Thebes, Memphis, Karnak, and others would require decades of time and legions of draughtsmen. By daguerreotype one person would suffice to accomplish this immense work successfully . . . These designs will excel the work of the most accomplished painters, in fidelity of detail and true reproduction of atmosphere. Since the invention follows the laws of geometry, it will be possible to reestablish with the aid of a small number of given factors the exact size of the highest points of the most inaccessible structures.[13]

Yet, to describe only these imaginable triumphs was not enough:

> when the observer applies a new instrument in the study of nature, his expectations are relatively small in comparison to the succession of discoveries resulting from its use. In a case of this sort, it is surely the unexpected upon which one must especially count.[14]

And to this, Joseph Louis Gay-Lussac, Arago's counterpart in the Chamber of Peers, was to add:

> It is the beginning of a new art in an old civilisation; it means a new era and secures for us a title to glory.[15]

These are not modest assessments and, since Arago's eulogy was to be included in Daguerre's own, rapidly translated and plagiarised, history and instruction manual, such views were to be taken up, paraphrased, parroted and parodied across the industrialised world. Within months, for example, as Allan Sekula has pointed out, the Cincinatti *Daily Chronicle* published a not-very-subtly-derivative report, in which the hieroglyphs of a colonised Egypt, together with the pictograms of Mexico, stand once again for the imagined defeat of older cultures, older modes of representation and language itself, by Western technological inventiveness and the globalised truths of photography:

Its perfection is unapproachable by human hand and its truth raises it above all language, painting or poetry. It is the first universal language addressing itself to all who possess a vision, and in characters alike understood in the courts of civilization and the hut of the savage. The pictorial language of Mexico, the hieroglyphics of Egypt are now superseded by reality.[16]

Perhaps most striking of all amongst these early panegyrics, however, is the rhetorical conceit of Oliver Wendell Holmes, to which Allan Sekula has again drawn attention. Writing in the *Atlantic Monthly*, two decades later, on 'The Stereoscope and the Stereograph', Holmes completed the logic of globalised knowledge and appropriation in terms best understood in an aggressively acquisitive capitalist society, by equating photography as a universal language with photography as a universal equivalent: a universal paper money:

And as a means of facilitating the formation of public and private stereographic collections, there must be arranged a comprehensive system of exchanges, so that there might grow up something like a universal currency of these banknotes, on promises to pay in solid substance, which the sun has engraved for the great Bank of Nature.[17]

Indeed, as with money itself under capitalism, so great is the mystery of this fetishised token of equivalence that 'solid substance' seems poor exchange:

Matter in large masses must always be fixed and dear; form is cheap and transportable. We have got hold of the fruit of creation now, and need not trouble ourselves with the core. Every conceivable object of Nature and Art will soon scale off its surface for us.[18]

Somewhat ahead of Baudrillard, Holmes takes the final rhetorical leap:

Give us a few negatives of a thing worth seeing, taken from different points of view, and that is all we want of it. Pull it down or burn it up, if you please.[19]

Even the irony here is of uncertain substance. The culture of the simulacrum has arrived. With photographic currency – with what

Holmes in a subsequent essay was to call 'the sentimental "green-backs" of civilization'[20] – the West has bought the world and put a large down-payment on global modernity. Photography is to be its first monument, alongside the newspaper, the railway, and chloroform: pictures, publicity, speed and oblivion – seemingly all we need for modern life.

If such vastly inflated rhetoric, in step with the real inflation of image production and the imaginary inflation of the photograph's claim to truth, was to delight some, it filled others with equally exaggerated horror. To them, the inflation of photographic images represented not a speculative triumph, but a fatal collapse of the gold standard of Art. As Lamartine, French Minister of Foreign Affairs and virtual head of the Provisional Government, wrote in 1848:

> It is because of the servility of photography that I am fundament-ally contemptuous of this chance invention which will never be an art but which plagiarises nature by means of optics. Is the reflection of a glass on paper an art? No, it is a sunbeam caught in the instant by a manoeuvre. But where is the choice? In the crystal, perhaps. But, one thing for sure, it is not in Man.
>
> The photographer will never replace the painter, one is a Man, the other a machine. Let us compare them no longer.[21]

Here, the same conception of the photograph as a mechanised, automatic product evokes not futuristic fantasy, but the contempt of a Romantic theory of culture, which sees art as the élite and manly expression of a given human spirit. Yet, the very violence of the language suggests that the assumptions about cultural values are no longer so securely made.

A decade later, the invective has become even more overheated. Writing at the same time as Oliver Wendell Holmes, Charles Baudelaire railed against the soulless modern machine that had so flattered the contemptuous vanity of a novelty-seeking, democratic mob:

> a new industry arose which contributed not a little to confirm stupidity in its faith and to ruin whatever might remain to the divine in the French mind. The idolatrous mob demanded an ideal worthy of itself and appropriate to its nature . . . A revengeful God has given ear to the prayers of this multitude.

Daguerre was his Messiah. And now the faithful says to himself:
'Since Photography gives us every guarantee of exactitude that we
could desire (they really believe that, the mad fools!) then
Photography and Art are the same thing.' From that moment
our squalid society rushed, Narcissus to a man, to gaze at its
trivial image on a scrap of metal.[22]

He goes on:

I am convinced that the ill-applied developments of photography,
like all other purely material developments of progress, have
contributed much to the impoverishment of the French artistic
genius, which is already so scarce.[23]

And he concludes with remarks that leave the division of labour and
class hierarchy of cultural practices in no doubt:

If photography is allowed to supplement art in some of its
functions, it will soon have supplanted or corrupted it altoge-
ther, thanks to the stupidity of the multitude which is its natural
ally. It is time, then, for it to return to its true duty, which is to be
the servant of the sciences and arts – but the very humble servant
. . . let it be the secretary and clerk of whoever needs an absolute
factual exactitude in his profession – up to that point nothing
could be better . . . But if it be allowed to encroach upon the
domain of the impalpable and the imaginary, upon anything
whose value depends solely upon the addition of something of a
man's soul, then it will be so much the worse for us![24]

In texts such as these, photography bears the burden of standing
as a metaphor for a much more extensive pattern of social conflicts
in which the very drive of a cultural production propelled by
mechanisation and market forces is seen as threatening the destruc-
tion of existing social values. As metaphor, photography is inter-
changeable with other derided terms in a series of condensed binary
oppositions: industry and Art, progress and Poetry, the factual and
the Beautiful, universal suffrage and Distinction. 'Industry will kill
art', the Goncourt brothers declare:

Industry and art are two enemies which nothing will reconcile.[25]

And in his essay on 'The Modern Public and Photography', Baudelaire gives back an echo:

> Poetry and progress are like two ambitious men who hate each other. When they meet on the same road, one or the other must give way.[26]

It is a Gresham's Law of Culture: bad currency drives out good. Nothing is able to stop the burgeoning production of photographs or the proliferation of their usages, yet this perplexing diversity is desperately held at bay in the terms of a totalising discourse. In these trenchant rejections, as in the ecstatic praise, a fantasised photographic technology is attributed sweeping powers, for good or bad.

It is not, however, just a matter of critical hyperbole born of nineteenth-century conflicts and struggles. The same mode of argument has continued in this century. In what, for example, is regarded as a key critical text, deferred to by almost all recent commentators on photography, Walter Benjamin offered a belated, 1930s Produktivist version. The invention of photography, he argued, had shattered not so much art itself, as the detached and contemplative mode of apprehension and the uniqueness, on which the cult of Art rested. The potentiality henceforth existed for the overthrow of the oppressive aestheticisation of the world by a mass, revolutionary grasping of factuality, through the new mechanical means of reproduction: photography. The intention is leftist, but the antinomies are the same: photography, mechanisation, multiple reproduction, factuality and mass revolutionary action line up on one side; Art, cult, uniqueness, contemplation, isolation and proto-fascist aestheticisation on the other. Baudelaire is stood on his head, or put back on his feet, whichever is preferred:

> With the advent of the first truly revolutionary means of reproduction, photography, simultaneously with the rise of socialism, art sensed the approaching crisis which has become evident a century later.[27]

The inescapable reply, however, is that, in this century as in the last, neither the dire predictions nor the exaggerated hopes have come to be realised. Perhaps we should stop to wonder why. And this will turn our attention not to some unforeseen quirk in the historical

dialectic but, once again, to recurrent features in the explanatory mechanisms themselves.

All the arguments I have quoted rest on a notion of photography as a unified medium, with its own inherent qualities and consequent potentialities for good or bad. But photography is not a unique technology or an autonomous semiotic system: photographs do not carry their meanings in themselves, nor can a single range of technical devices guarantee the unity of the field of photographic meanings. A technology has no inherent value, outside its mobilisations in specific practices, institutions and relations of power. Images can signify meanings only in more or less defined frameworks of usage and social practice. Their import and status have to be produced and effectively institutionalised, and such institutionalisations do not describe a unified field or the working out of some essence of the medium: they are negotiated locally and discontinuously and are productive of meaning and value.

If, in these terms, we look again at the proliferation of photographic technologies, techniques and practices in the nineteenth century, which aroused so much debate, we can see that what was presented as a struggle for the heart and soul – the essence – of culture, turns out to involve a complex series of negotiations, in which a plurality of photographies were deployed in a whole range of differently directed practices; were institutionalised under markedly different terms; were discussed and evaluated in very different frameworks of reference; and were accorded quite different statuses. The potential field of photographic practices and meanings was divided up, pragmatically, without regard to consistency or uniformity. And across this variegated terrain, the unity, essence and integrity of photography was only ever locally and discontinuously invoked and defined.

For example, while almost 90 per cent of photographic production in the mid-nineteenth century was bound up with a portrait industry governed, like any other arena of capitalist enterprise, by concerns of profitability, market development and cost-effectiveness, this fully commercial field of production was itself layered according to what could be sustained by different consumerships. Acknowledgement of this was, however, overwritten by the attribution of different cultural statuses to the products of the various suppliers. Alphonse Disdéri, the archetypical entrepreneur, might accrue massive sums but no salon medals from his huge turnover in

cheap and quick, multiply produced *carte-de-visite* images. But Nadar, catering to a more highly specialised clientele, could make up in price much of what he lost in quantity, by a painstaking technique that, to sustain his business, had to signal its exclusive quality. This reciprocal definition of levels in the photographic commodity market was, at least, one of the contexts in which distinctions between art and commerce were instigated, though the issue went beyond the strategies of individual entrepreneurs, to engage the need of ever-growing capitalist enterprises in publishing and production to protect their capital investments. From this impetus, frameworks of copyright law were enacted, which proved to be of more consequence than critical discourse for the separation of ownable, exploitable aesthetic properties from mere mechanical products.

To one side of the demands of the market place, certain amateur groupings also laboured at a comparable division. While claiming that their distinction resided in the photographs themselves, they assiduously worked at setting up the institutional structures and frameworks of discourse – independent galleries, salons, journals, forms of patronage, and modes of criticism – which would negotiate the sought for status of Art for their aspiring, individuated work. Yet, what was pertinent to the discussion of work in such new galleries of photographic art did not at all pertain to or impinge upon the equally earnest assessment of photographs in those other late-nineteenth-century galleries – the 'rogues galleries' – which sought to establish as evident the identity and supposed deficiencies of less than fully human subjects in police cells, prisons, hospitals, asylums, schools, factories, slums and colonised territories. And, if the real subject of an emergent art photography was the imaginary force of presence of the creative author, here, in these lowly archives, authorship was less than nothing. To serve as evidence and record, the image had to be said to speak for itself, though only qualified experts could read its lips.

Even this cursory mapping is enough to dislodge the idea that the territory of photography is a unity. There turns out to be no meaning to photography as such. The meaning and value of photographies cannot be adjudicated outside specific language games, whose playing-fields piece out a topography we must trace. Already, fifty years before Walter Benjamin wrote his analysis, a complex hierarchy of cultural spaces had been set in

place in which, contrary to his expectations, a privileged status of
Art was not only retrieved for cultural practices otherwise threa-
tened by market forces, popular access and the construction of
instrumental archives, but was also extended to select practices
employing the new mechanical means of reproduction themselves.

Something further needs to be said here, beyond the obvious fact
that Benjamin's prediction of the death of Art and Oliver Wendell
Holmes's vision of a utopia of universal consumption did not come
to pass. In a wider framework, what is happening with this
institutional subdivision of photography is that attempts are being
made to contain, or even negotiate away, specific tensions and
conflicts within developing capitalist cultures. Thus, while there was
a vast proliferation of image production in industrialised countries,
we cannot assess its effects solely in relation to quantity, replication,
or mechanisation. What is more important (as I argued earlier, in
relation to criticism) is the dissemination of new institutional and
discursive formations, across which the potentiality and productiv-
ity of this outpouring of images is organised and constrained. As a
result, the transformation of cultural structures by mechanical
production and the emergence of mass consumer markets does
not automatically erode the authority of a more or less officially
sanctified Culture, whose increasingly marked institutional isolation
is the condition of its continued privilege to question and affirm
social values. Through the same process, the attribution of exem-
plary status to certain modes and works of photographic Art does
not inhibit a burgeoning photographic industry, nor conflict with
the power of instrumental photographies. And by the same token,
the vastly expanded accessibility of photography to amateurs does
not democratise corporate industrial structures, nor erode the status
of professional artists, technicians, or expert interpreters. An
honorific museum culture coexists with the family album and the
police file.[28]

To return again to broader questions of criticism, analysis and
cultural strategy, such stratification must have consequences for the
modes of political calculation and cultural intervention we can
effectively operate. It suggests we will be making a serious strategic
error if we found our hopes or fears on the notion of an inherent
trend in capitalist formations toward ever greater homogenisation
at the economic, political and discursive levels. The drives of the
market and the quickening pace of commodification do not

encompass the totality of image production. Mass participation does not undo the structures of cultural authority, the control of knowledge, or an adaptive, professionalised division of labour. Panoptic techniques of discipline and surveillance do not entirely displace the power of spectacle and effect a total reversal of the political axis of representation. The deployment of instrumental technologies by the state goes along with its protection of capitalist cultural industries and its support of a privileged post-market cultural arena. The marking-out of these institutional spaces may be defensive or aggressive, negative or assertive. What they stake out, however, is a new and resilient order; though this order must not be confused with the state, even if the state may invest it and be called on to adjudicate upon it. It is an order without coherence, coordination or centre. That is precisely how it functions; how its conflicts are kept from becoming ruptural. We must be sceptical, therefore, of all attempts to treat the cultures of capitalist societies as totalities or unities. If the proliferation of photographic technologies and images explodes anything, it is not Art, Power, or Reality, but this entrenched organicist conception – as dear to a certain critical left as to a certain critical right. Herein, perhaps, lies the wider self-abolishing value of histories of photographies.

Notes

1. See 'Occupied Territories', Chapter 10, below.
2. See, for example, Victor Burgin, 'Looking At Photographs', in V. Burgin (ed.), *Thinking Photography* (Macmillan, London, 1982) pp. 142–153; 'Seeing Sense', in *The End of Art Theory: Criticism and Postmodernity* (Macmillan, London, 1986) pp. 51–70; and 'Geometry and Abjection', in J. Tagg (ed.), *The Cultural Politics of 'Postmodernism'*, Current Debates in Art History: One (SUNY Binghamton, Binghamton, 1989) pp. 13–31. Norman Bryson, *Vision and Painting: The Logic of the Gaze* (Macmillan, London, 1983). Rosalind Krauss, 'Photography's Discursive Spaces: Landscape/View', *Art Journal*, vol. 42, no. 4, Winter 1982; 'Theories of Art after Minimalism and Pop', in Hal Foster (ed.), *Discussions in Contemporary Culture*, Number One (Bay Press, Seattle, 1987) pp. 59–64.
3. See, for example, Laura Mulvey, 'Visual Pleasure and Narrative Cinema', *Screen*, vol. 16, no. 3, Autumn 1975, pp. 6–18. Mary Ann

Doane, 'Film and the Masquerade: Theorising the Female Spectator', *Screen*, vol. 23, nos. 3–4, September/October 1982, pp. 74–87. Michel Foucault, 'The Eye of Power', in *Power/Knowledge*, ed. C. Gordon (Harvester, Brighton, 1980) pp. 146–65. John Tagg, *The Burden of Representation: Essays on Photographies and Histories* (Macmillan, London, 1988).

4. Karl Marx, *Capital*, Volume 1, trans. B. Fowkes (Vintage, New York, 1977) pp. 544–5.

5. Ibid., p. 548.

6. Ibid.

7. Alice Jardine, 'Of Bodies and Technologies', in Foster (ed.), *Discussions in Contemporary Culture*, op. cit., p. 156.

8. Marx, op. cit., p. 618.

9. Ibid., p. 493.

10. Gilles Deleuze and Félix Guattari, *A Thousand Plateaus: Capitalism and Schizophrenia*, trans. B. Massumi (University of Minnesota Press, Minneapolis, 1987). p. 159.

11. Marx, op. cit., p. 493, fn 4.

12. Hal Foster, 'Wild Signs (The Breakup of the Sign in Seventies' Art)', in Tagg (ed.), *The Cultural Politics of 'Postmodernism'*, op. cit., pp. 69–85. See also Fredric Jameson, 'Postmodernism, or The Cultural Logic of Late Capitalism', *New Left Review*, no. 146, July/August 1984, pp. 53–92.

13. François Jean Arago, 'Report of the Commission of the Chamber of Deputies', July 3, 1839, in Josef Maria Eder, *History of Photography*, trans. E. Epstean (Columbia University Press, New York, 1945) pp. 234–235.

14. Ibid., p. 238.

15. Joseph Louis Gay-Lussac, 'Report of the Special Commission to the Chamber of Peers', July 30, 1839, ibid., p. 244.

16. 'The Daguerreolite', *The Daily Chronicle* (Cincinnati), vol. 1, no. 38, January 17, 1840, p. 2; quoted in Allan Sekula, 'The Traffic in Photographs', in *Photography Against the Grain* (The Press of the Nova Scotia College of Art and Design, Halifax, Nova Scotia, 1984) p. 82.

17. Oliver Wendell Holmes, 'The Stereoscope and the Stereograph', *Atlantic Monthly*, vol. III, no. 20, June 1859, p. 748; quoted in Sekula, op. cit., p. 99.

18. Ibid., p. 748.

19. Ibid., p. 747.

20. Oliver Wendell Holmes, 'Doings of a Sunbeam', *Atlantic Monthly*, vol. XIII, no. 49, July 1863, p. 8.

21. Alphonse de Lamartine, *Cours familier de littérature. Entretiens sur Léopold Robert*, vol. VI, 1858, p. 140; quoted in Bernard Edelman, *Ownership of the Image. Elements for a Marxist Theory of Law*, trans. E. Kingdom (Routledge & Kegan Paul, London, 1979) p. 45. After seeing the work of Adam Salomon, Lamartine was to change his mind on the potential of photography to cross over the mutually excluding

divide between soulless mechanical product and the expressive art of the author. The Manichaean categories, however, remained undisturbed. The photographer artist now worked directly with the medium of the sun; the machine remained a transparent means. See, Molly Nesbit, 'What Was an Author?' *Yale French Studies*, no. 73, 1987, pp. 229–57.

22. Charles Baudelaire, 'The Salon of 1859', in *Art in Paris 1845–62*, ed. and trans. J. Mayne (Phaidon Press, London, 1965) pp. 152–3.
23. Ibid., p. 153.
24. Ibid., p. 154.
25. Edmond and Jules de Goncourt, 'The Death of Art in the 19th Century', in Linda Nochlin (ed.), *Realism and Tradition in Art 1848–1900* (Prentice-Hall, Englewood Cliffs, 1966) p. 17.
26. Baudelaire, op. cit., p. 154.
27. Walter Benjamin, 'The Work of Art in the Age of Mechanical Reproduction', in *Illuminations*, ed. H. Arendt, trans. H. Zohn (Harcourt, Brace & World, New York, 1968) p. 226.
28. Cf. 'The Proof of the Picture', Chapter 5, above; see also Allan Sekula, 'The Body and the Archive', *October*, no. 39, Winter 1986 (1987) pp. 3–64.

7

The Discontinuous City: Picturing and the Discursive Field

This essay is concerned with orders of sense, régimes of visual meaning, and the discursive formations and practices of power in which they are constituted. It operates, therefore, at a particular level of specificity and does so with some point. It sets out to map an analysis of one type of formation – the formation of disciplinary knowledge and representations, as it emerges in mid-nineteenth-century Europe and North America – into a wider field; engaging not only recent accounts of representation as bound up with the processes of spectacle and commodification, but also questions of the structures and relations of capitalist cultural production. In placing its emphasis on the effects of the institutionalisation of

This chapter was originally prepared as a lecture on 'Representation: Politics and Histories' for the Ray Smith Symposium Series on *Vision and Textuality*, organised by Stephen Melville and Bill Readings at Syracuse University, in April 1989. It was also presented, at the invitation of Norman Bryson, Michael Holly and Keith Moxey, at the National Endowment for the Humanities Summer Institute for College and University Professors in *Theory and Interpretation in the Visual Arts*, at the University of Rochester, in July. It was first published in *Strategies: A Journal of Theory, Culture and Politics*, in the summer of 1990.

certain systems of discursive constraints, it is relatively silent on the issue of resistance. But, as I make clear, this is not at all to suggest that the fixities of meaning, whose general effects I trace, are ever coherent, accomplished, stable or secured.

Insistence on the return of the openness and indeterminacy of discourse also has consequences for more general questions of theory and methodology in the social history of art that remain implicit, rather than explicit, here. In rehearsing some of the themes that have interested me in my recent work, I shall, however, begin by addressing an important area of exchange between social histories and feminist histories of art. And in conclusion, I shall try to draw out more pointedly what I see as a central theoretical difficulty for such social histories, whether dependent on the expressive model of Marx's German Ideology, *as with Antal, or developing out of the theories of ideology of Althusser and Macherey, as with the approaches that emerged most particularly in Britain in the 1970s.*[1]

I THE CITY OF SPECTACLE

In an essay on 'Modernity and the Spaces of Femininity', in the collection *Vision and Difference*,[2] Griselda Pollock has argued that we cannot grasp those processes of social restructuring which we associate with the construction of modern social orders, or their articulation in notions of *modernity* and new protocols of artistic practice that represent themselves as *modernist*, unless we also see them as centrally involving crucial historical shifts in the political, economic and cultural production of positions for femininity. It is not, however, just a question of adding a feminist account of women's art production to what she sees as the formidable but 'flawed' analyses of social historians of art such as T. J. Clark or Thomas Crow.[3] Rather, modernism and modernity have to be seen as constituted in and through an emergent discursive order, both organising and organised by a new economy of sexual difference. The privileged terrain of this emergence remains, however, the metropolitan city: paradigmatically, Paris in the second half of the nineteenth century.

The presence of this city has saturated the argument and has, in turn, been saturated by its terms. On the one hand, the city's spaces

have provided a way to locate, describe and metaphorise the field of discourse. On the other, the logic of discourse has provided a way of construing the city as a system of closures, overflowed by the fluctuations of difference. The city was ground for modernist representation because, for this analysis, it was already text.[4] Perhaps it would be more accurate to say, it was already a compendium of texts; one construction impacting on another, in a process of accumulation and condensation that replicated the cultural, political and economic concentration on which the power of the modern city was founded.

The connecting links of the argument have become familiar now. At the level of urban planning and the built environment, the productive, commercial, governmental, residential and recreational functions of the nineteenth-century metropolis were systematised and demarcated, in a separation that controlled circulation and traced a pattern of dominance, but also orchestrated sights and opened up vistas that marked out a distinct function of the city as spectacle. Through an immense accumulation of capital, this city took form not only as the site, but also the *object*, of an emphatically visual consumption, articulating and articulated in new subjective experiences of exhilaration and alienation, pleasure and fear, mobility and confinement, expansiveness and fragmentation. And nowhere were these more intense than at those spaces of intersection, especially in places of commercial leisure, where emergent codifications of identity and desire were set in flux, opening the way to new excitements and anxieties that, in the headiest accounts, seemed capable of transcending or rupturing the entire structure.[5]

Such a city was, therefore, both a complex of representations and the place of circulation of representations; the effects of the one always articulating into and reworking the other, and constituting the working material for a range of ambivalent modernisms. What Pollock is insistent upon is that such spaces of representation, logged by a revisionist social history of art, cannot be plotted solely along the axis of consumption, spectacle and class; they have also to be seen as tracing and constructing a difference that is, at once and inseparably, a demarcation of gender. The shift from predominant household production to metropolitan industrialisation involved a transformation of all those arrangements and representations of work, sexuality, parental responsibilities, psycho-

logical life, assigned social traits and internalised emotions through which men and women are positioned in sexual difference. It was a restructuring mapped onto and by the city, so that a passage across its spatial plan was a passage across a geography of gender power, in which men and women were inscribed in relations of asymmetry (and supposed complementarity) that marked out spaces of subjection and, crucially here, structured the subject's relation to desire, pleasure and power in looking.[6]

The effects of this production and fixing of difference are pursued by Pollock across a number of mutually investing spatial planes that overdetermined modernist painting practice in Paris, in the late nineteenth century. At the level of spatial zoning, the city itself – at least, the respectable city of middle-class life – was structured around the differentiation of a feminised private and domestic sphere from a masculinised public domain. It was a division that a woman could cross only at the risk of falling from the elevated social space of 'femininity'. Even in the permissible public spaces of the theatre, the park or the promenade, the lady was seen as dangerously exposed to the predatory public gaze of the male and in consequent peril of confusion with that other, unspeakable, order of womanhood, which entered the public arena only as the brazen object of an exchange and desire that were decently repressed in the closeted spaces of domesticity. So within this divided space was already another: the space of a look, conflated with a gaze: the eroticised, mobile, free and avaricious gaze of the middle-class, male *flâneur*, dandy or blood – that '"I" with an insatiable appetite for the "non-I"', as Baudelaire described him, that 'mirror as vast as the crowd itself'[7] – which was never a habitable space for a woman. Insistent, surreptitious and self-possessed, the assertive presence of this gaze set 'Woman' – 'object of keenest admiration and curiosity'[8] – apart, overruling the hidden, downcast and interiorised look of the 'respectable woman' and the open, searching stare of the woman 'on the town' who was knowingly part of the spectacle of what Baudelaire saw as a City of Women.[9] Finally, we have the space of pictorial representation itself: an active space in which, in modernism, these other spaces of exclusion intersected and were reworked. It was a cultural terrain that proved equally uninhabitable to women; not essentially, but as an effect of the régimes of sense and pleasure in which the feminine was, by definition, excluded from the privileged institutions, locations, languages,

subject-positions and statuses of a modernism for which 'Woman' was the sign but never the speaker.

Across such levels of representation, therefore, we see a new régime of femininity emerging, which served men as a means of regulating and accessing female sexuality, and in which the practices of modernism were implicated. Yet, this order was never monolithic. It was overflowed by the very difference it constructed and, as Pollock points out, by its active rearticulation in the work of artists like Mary Cassatt, which exposed the presumption of the masculine gaze, displaced the look as privileged sense, and affirmed the private sphere as, equally, a 'modern' space.[10] In a sense, this paralleled the way that middle-class women, at the price of accepting the confinements of domesticity, could then exercise from that place a moral authority over the home and even the community. It says nothing, however, about those troublesome working women whose demeanour and very existence as impoverished female workers violated some of the dearest held genteel precepts of 'woman's nature' and 'woman's place'.

As Christine Stansell has brilliantly pointed out,[11] while metropolitan industrialisation strengthened women's economic dependence on men, the very precariousness of this dependency in a casualised labour market compelled women to seek other means of support within an economy to which their labour was increasingly central. Of itself, this both disturbed any settled or complacent notions of the place and control of women, and opened opportunities for working-class women to turn certain conditions of subordination into new initiatives, outrunning the limits of family households and imposing their presence on the wider municipal field of economic, political and cultural conflicts. Already in the 1850s in New York, for example, young working women, whose wage earnings allowed them some degree of distance from familial authority, had played an acknowledged, if ancillary, role in reworking the materials of urban, commercial leisure into the new, and defiantly working-class, subculture of the Bowery Boys and Gals, which flaunted middle-class codes of dress and status, reterritorialised the working-class city, and challenged the dichotomous and patriarchal representations of both a moralising middle-class domesticity and a misogynistic popular culture.[12] What we have here is something quite distinct from the autonomous 'female subculture' Judith Walkowitz claims to have been a distinguishing

feature of nineteenth century prostitution.[13] These Bowery Gals were not ladies, but neither were they fallen women or archetypal victims, caught in a fatalistic structure of bondage, determinism, silence and passivity. As Stansell remarks, 'the dialectic of female vice and female virtue was volatile'; at times, sufficiently so to break apart the binary logic of sexual difference, as 'in the ebb and flow of large oppressions and small freedoms, poor women traced out unforeseen possibilities for their sex'.[14]

II THE CITY OF OTHERS

In this way, perhaps, we might begin to go beyond the difficulty Pollock seems to have in talking about working-class female subjects, other than as the prostitutes and servants they were represented as having to be. It is a silence that might also be linked to another, which follows from her exclusive concentration in this essay on femininity and the city in relation to spectacle, consumption and the fetishising gaze. The modern city was also, at the same time, a place of production, servicing and exchange, dependent on the immigration and congregation of large masses of working people whose very presence and proximity to the core of the spectacle of capital posed real and imagined threats. The conflict was inseparable from the dynamic of the capital city in which the drive to break down every spatial barrier to the 'healthy' circulation of capital and goods simultaneously divorced the city from its imaginary organic past and inflamed the phobia of contagion and pollution at every level of its social life.[15] The containment of this conflict demanded constant efforts of negotiation and propelled the development of new apparatuses and techniques that were codified in proliferating practices of social discipline – policing, education, health, housing and moral welfare – whose effectivity was bound up with their *political strategy of representation.*

The very separation of spheres – which is the structural principle of democratic order, inscribed in condensed and overdetermined patterns of spatial zoning and the very structure of instrumental representation – provided the impetus to new and intrusive forms of social regulation and surveillance. Industrialised production and urban living were geared to the colonisation and development of

techniques of power that were continuous and diffuse, rather than sporadic and exemplary, productive rather than interdictive, internalised rather than spectacular, paternal rather than adversarial, professionalised rather than politicised. Taken over principally from the church, the military and the schools, such techniques entailed new agencies, apparatuses and instruments: new types of expert, new institutional structures, new disciplined forces, new architectural orders, and new languages and technologies of documentation, data storage and information handling. Deploying these new technologies of observation, representation and regulation, modern apparatuses of social control – the police, hospitals, schools, insane asylums, prisons, departments of immigration, public health and sanitation – bore down, literally, on the alien within the social body and its environment. In the process, they not only exerted effects of domination and subordination that integrated social regulation in an unprecedented manner, but also created the conditions for a new disciplinary framework of knowledge in which the social was constituted as the multiple object and target of novel supervisory practices and technical discourses.[16]

What we have to deal with in the nineteenth-century urban, industrial complex, therefore, is the imagination of a new mode of governance that is, at once, a disciplinary régime and a field of science – the field of anthropology, comparative anatomy, criminology, medicine, psychiatry, public health, and sociology. It is a formation that aspires, at all levels, to an unmatched systematicity. Its strategy is to change the ground of struggle over the production and control of meaning, as part of the struggle to dominate and exploit the social body and its space. Yet, it is a strategy that seeks to elide the struggle it wages, gathering power to its expert discourses, while displacing its motivation onto its other and representing its incursions into an objectified space and populace as disinterested, technical and benign.

It is within this dismal landscape that we have to locate that other nineteenth-century textualisation of the city and its inhabitants: the archive of documentation. The very notion of *documentation* was locked into a history of disciplinary practice and knowledge that emerged, piecemeal, across the workings of the apparatuses I have described. It belonged to a paranoid formation for which the social was always dangerously alive with potential pathologies that threatened to overrun the social body, if not constantly monitored,

interpreted and subdued. This was the dream of the social reformatory: that scientific and humane establishment. Surveillance was its apparatus of restraint; the record, its cell; the index, its carceral architecture. It readily appropriated the latest technologies – photography prominent among them – though it was as suspicious of their productivity as it was of the social itself. It sought to make them servile instruments of its compulsive knowledge, driven by a separation, isolation and subjugation of its still troubling object, but eliding the erotic character of its curiosity, denying desire and the exchange of pleasure.

In such knowledge, the intransigent social field was to be dominated by its transformation into a series of 'case studies'. Set at a distance, outside any mutual exchange, such 'cases' were to be stripped of all interiority and scrutinised, without shame, as fields of natural signs: signs of lack, signs of guilt; evident signs that could be read exhaustively; signs that could be transcribed without distortion and fixed in the transparent languages of evidence and documentation. In the fantasy of the subject of this knowledge, the other of this singular and overpowering encounter could be totally and immediately known; reduced to a difference the system of discipline produced, pathologised, desired and controlled. The fixing of this difference constituted the questionable alibi and unstable power of social discipline. It worked – in so far as it did[17] – by arresting the proliferation of frames of differentiation, by reducing difference to duality, and by holding in place a rigid and irreversible polarisation of the positions of subject and object. But it also needed to enforce the immediate presence of that object to that subject, and this was produced by imposing a transparency on experience and representation, as the instruments of an overwhelming truth. The production of knowledge was, at one and the same time, the exertion of power: the appropriation of the social by the fixing of identities in relations of domination and subordination. But this process itself turned on the fixing in place of certain new technologies of representation as purely *instrumental* modes.[18]

III POWERS AND PHOTOGRAPHIES

The separation of subject from object. The fixing of difference. The immediacy of experience. The transparency of representation. The

instrumental mode. What was described here was a discursive space
in which a particular photography could be made to operate and in
which a particularised photography was already prepared, by then,
to find its place. Construed as impartial, objective, clean, compel-
ling and modern, instrumental photography transmitted the power
of the disciplinary structure, but also returned to it powers of its
own: the power of a technology of representation already con-
structed to reproduce the conventional conditions of Western
optical realism; the power of an order of meaning generated by
an already elaborated system of discursive constraints; the power of
a machine of subjection built to recruit identification and structure
pleasure and power in looking. But, if the field of view of this
camera came to coincide with the gaze of disciplinary power, we
must remember that this was not the easy conjunction of eye with
eye. The look of the camera and the look of social surveillance and
science – though looks, nonetheless – were not physiological but
complex discursive events. As such, they had their histories:
histories of institutional negotiation, technical elaboration, and
productive interaction. If the instrumental camera was to operate
as a controlled extension to the expert or supervisory eye, then the
structured possibilities of its representational system had to be
invested in the drives and desires of a constellation of apparatuses
of power. If the photographs such a camera produced were to claim
the status of technical documentation, then they had to be
differentiated from a field of photographic representations. They
had to shun the picturesque and sensational, disdain the moralism
of philanthropic reformism, affect a systematicness beyond com-
mercial views, and relinquish the privilege of Art for the power of
Truth. If these photographic documents were subsequently to
'speak for themselves' and wield the power of proof, then the
meanings supposedly inherent in the images, and even in their
omissions and silences, had to be produced from a most careful
rendition, by restricted agencies whose status, competence and
reading would be institutionally guaranteed.[19]

Instrumental photography was operative, then, when two dis-
cursive structures were coupled and bolted together. The point is
that this could only take place through a process of institutional
negotiation whose history has to be traced. The notion of eviden-
tiality, on which nineteenth-century practices of documentation
traded, could never be taken as already and unproblematically in

place. Photographic documents had to have their status as truth produced and reproduced, and institutionally sanctioned. Their meanings were closed and exerted a force only within the frame of the more extensive arguments and social interventions that constituted the photographs' conditions of existence and infused their production and reading. If photographs seemed to bring to this process certain powers – the power of a new and intrusive look; the power of a new means of representation and mode of accumulation of knowledge; the power to structure belief and recruit consent; the power of conviction and the power to convict – then the powers they wielded were only rhetorically their own. In practice, they belonged to the agents and agencies that mobilised them and interpreted them, and to the discursive, institutional and political strategies that constituted them, supported them, and validated them.

This is not at all to suggest that 'photography' was the transparent reflection of a power outside itself.[20] It is, rather, to insist that the photograph's compelling weight was never phenomenological, but always discursive, and that the power effects of photographic evidence were *produced* by the articulation of two discursive formations. If this is to grant that the photographic always exceeded its colonisation, investment and specification in institutional frameworks of use, it is not to concede any intrinsicness of 'the medium'. It is not to equate a discursive structure with a technology. Nor is it to posit any unity or closure to photography's discursive field. It is precisely in this sense, therefore, that I have denied that photography as such has any identity.

What I was arguing, against any totalising or teleological view, was that the meaning and value of photographic practices could not be adjudicated outside specific, historical language games.[21] Photography is neither a unique technology nor an autonomous semiotic system. Photographs do not carry their meanings in themselves, nor can a single range of technical devices guarantee the unity of the field of photographic meanings. A technology has no inherent value, outside its mobilisations in specific discourses, practices, institutions and relations of power. Images can signify meanings only in more or less defined frameworks of usage and social practice. Their import and status have to be produced and effectively institutionalised, and such institutionalisations do not describe a unified field or the working out of some essence of the

medium. Even where they interlink in more or less extended chains, they are negotiated locally and discontinuously and are productive of meaning and value. The issue, however, is not the imposition of limits as such on the productivity of discourse, for without these the endless play of meaning could never be specified. The question is, rather, that of the specific political effects of particular historical structures of discursive constraints and the histories of struggles to impose or resist them .

If we look, in these terms, at the proliferation of photographic technologies, techniques, and practices in the nineteenth century, we can see that, for all the projections of criticism, the new means of signification did not constitute a closed or unified medium, or contain within themselves a preordained historical function. A plurality of particular photographies was deployed in a whole range of differently directed practices. Their effects and legitimations were not given in advance, but derived from specific discursive economies. They were institutionalised under markedly different terms, discussed and evaluated by different agents, in very different frameworks of reference, and accorded quite different statuses. In this way, the potential field of photographic practices and meanings was divided up, pragmatically, without regard to consistency or uniformity. And across this variegated terrain, the unity, essence and integrity of 'photography' was only ever locally and discontinuously invoked and defined.

For example, while almost 90 per cent of photographic production in the mid-nineteenth century was bound up with a portrait industry governed, like any other arena of capitalist enterprise, by concerns of profitability, market development and cost-effectiveness, this fully commercial field of production was itself layered according to what could be sustained by different consumerships. As the industry developed, it was a point of some heated debate whether a continuous sense of photography could be said to operate across the entire field, or even whether it was bound by a 'family resemblance'. Different pricing mechanisms, different organisations of production, and different styles of promotion supported very different kinds of practice, different expectations, and very different ways of *handling* the image – in every sense of that term. Understanding these differences was integral to the varieties of the ritual, whose social absorption was overwritten by the gradually accepted attribution of different cultural statuses and degrees of commercial

protection to the products of the various suppliers. It was not an undisputed process, but the hierarchical definition of levels in the photographic commodity market was, paradoxically, one of the contexts in which distinctions between a mutually exclusive art and commerce were instigated and deployed to divide one photographic practice from another.

To the side of the demands of the market place (at least, initially), certain committed amateur groups, across Europe and North America, also laboured at a comparable division. Yet, for all the claims of Symbolist theory, nothing could be guaranteed at the level of the image or by ethical assertion alone. Thus, while insisting that their distinction resided in their photographs themselves, such groupings worked assiduously at setting up the institutional structures and frameworks of discourse – independent galleries, salons, journals, forms of patronage, and modes of criticism – capable of negotiating the sought for status of Art for their aspiring, individuated work.[22] Only across such structures could the *difference* of their photography have been produced and secured. Its constitution was, therefore, necessarily located and localised. What was pertinent to the discussion of photographic-ness here in the new galleries of photographic art, did not at all pertain to, or impinge upon, the equally earnest assessment of photographicness in those other late-nineteenth-century galleries – the 'rogues galleries' I earlier located in the discursive formation of the disciplinary system. And, if the real subject of an emergent art photography was the imaginary force of presence of the creative author, in these lowly archives, authorship was less than nothing. To serve as evidence and record, the image – as we saw – had to be *unsigned* and said to speak for itself, though only qualified experts could read its lips.

In each case, then, a special domain of photography, that claimed basis in the ontology of the image itself, had to be produced, in a process interlocking with special domains of writing and speaking and regulated by institutional controls over literacy and practice. In the appropriation of photography to art, as in its appropriation to documentation, we see the same double relation. On the one hand, the constitution of a 'purely photographic space' – whether as art or evidence – was inseparable from the empowering of a discursive and institutional order that annexed the productivity of photography to its structure. On the other hand, the fixing of meaning *in* the image

– whether as expression or index – empowered the speech of that order, by eliding the materiality of the photograph as sign, its problematic nature as discursive event, and the power and desire structured into and by it. In art as in police work, this was not just a matter of overcoming conservative resistance to new technology, but rather of a struggle over new languages and techniques and claims to control them. Yet, as I have said elsewhere, the artist's proof was not the police officer's. There was no general or purely photographic system. And if the *nature* of 'photography' was repeatedly invoked, it was always *local* conditions that determined the production of its 'universal' identity.

As a final example, we may take the emergence of a broadly-based, economically-significant and aesthetically-troubling sphere of amateur practice, following the vast expansion of the photographic economy in the 1880s and the growth of fully corporate dry-plate, camera and photofinishing industries. To acknowledge this industrial momentum is not, however, to grant that we could ever derive the categories, constraints and motivations, or the cultural subordination, of amateur photographies from the technological and economic shifts themselves. To talk about the emergence of amateur photographies is to talk of the tracing out of new levels of meaning and practice, new hierarchies of cultural institutions, and new structures and codes of subjectivity: processes unquestionably bound up with technological innovation and the restructuring of production and marketing, but equally caught in the impetus of a reconstitution of the family, sexuality, consumption and leisure that plots a new economy of desire and domination. And if we can follow this overdetermined development across a radiating cultural geography, it is never as a simple unified, unrolling, economically and technologically driven process. The formation of amateur photographies had always to be negotiated in and across the fields of specific national structures, cultural conventions, languages, practices, constructed traditions and institutions. So far from expressing the necessity of a purely economic or even ideological process, amateur practices constituted a discursive formation in the fullest sense: decentred and differentiated; saturated with relations of power, structuring new effects of pleasure, and generating new forms of subjectivity that have then to be seen as determinant conditions of capitalist growth in themselves.

IV TOTALISATIONS AND THE DISCURSIVE FIELD

There is still, however, a larger question here, that overspills the negotiation of local statuses for specific photographies. In a wider frame, what was happening with this institutional subdivision of photography was that specific tensions and conflicts within capitalist cultures were being contained and even negotiated away. Thus, while photographic technologies promoted a vast proliferation of image production in industrialised countries, their effects were never as total as commentators hoped or feared.[23] Caught up in attempts to define the essential and intrinsic nature of 'the medium', what these commentators failed to grasp was the dissemination of new institutional and discursive formations, across which – I have argued – the potentiality and productivity of this outpouring of images was organised and constrained. As a result, the transformation of cultural structures by mechanical production and the emergence of mass consumer markets did not automatically erode the authority of a more or less officially sanctified Culture, whose increasingly marked institutional isolation was the condition of its continued privilege to question and affirm social values. Through the same process, the attribution of exemplary status to certain modes and works of photographic Art did not inhibit a burgeoning photographic industry, or conflict with the power of instrumental photographies. And by the same token, the vastly expanded accessibility of photography to amateurs did not democratise corporate industrial structures, or erode the status of professional artists, technicians, or expert interpreters. An honorific museum culture coexisted with the family album and the police file.

From the point of view of cultural history and theory, such stratification must have consequences for notions of an inherent trend in capitalist formations toward ever greater homogenisation at the economic, political and discursive levels. The drives of the market and the quickening pace of commodification do not encompass the totality of image production. Mass participation does not undo the structures of cultural authority, the control of knowledge, or an adaptive, professionalised division of labour. Panoptic techniques of discipline and surveillance do not entirely displace the power of spectacle and effect a total reversal of the political axis of representation. The deployment of instrumental

technologies by the state goes along with its protection of capitalist cultural industries and its support of a privileged post-market cultural arena.[24] The marking-out of these discursive and institutional spaces may be defensive or aggressive, negative or assertive. What they stake out, however, is a new and resilient order; though this order must not be confused with the state, even if the state may, in part, annex it, invest it, and be called on to adjudicate upon it. It is an order without coherence, coordination or centre. That is precisely how it functions; how its conflicts are kept from becoming ruptural. We must be sceptical, therefore, of all attempts to treat the cultures of capitalist societies as totalities or unities. If the proliferation of photographic technologies and images exploded anything, it was not art, privilege, or reality, but this entrenched organicist conception – as dear to a certain critical left as to a certain critical right.

This brings us back to what was implicitly at stake in Griselda Pollock's critique of current social historical accounts of modernism, spectacle, the city and sexuality: to questions of representation, identity, class and gender and, specifically, to the tendency in Marxist theorisations of culture to foreclose the issues involved in their relation. A whole territory of debate opens up here, going back to Marx's various treatments of the concept of representation or articulation.[25] It would be beyond my brief, and my time, to pursue this. However, in relation to the project of the Social History of Art, I might underline the following awkward points about the consequences of the kind of discursive analysis I have been developing here.

In the first place, if it is in the material processes of discourse that interests and identities are differentiated and defined, then 'class analysis' cannot survive in the form of a theory of ideology, a return to origins, or a mechanism of expression. There can be no given and essential 'class interests' from which cultural representations can be derived. Indeed, to reverse the terms of the analysis, class identity can only denote the heterogeneous, dispersed and contingent outcome of a play of discourses and articulations, overdetermined by other relations of difference.[26] Second, once one allows an effectivity to discursive practices in constituting meaning and identity and generating effects of power, then there is no longer any way of invoking another, determinant and external tier of 'social' explanation. It becomes a contradiction to conceive of discursive structures

in exteriority to a social domain that they, in effect, contain and define. Yet, conceptions of cultural practices as reflections, expressions, superstructures, ideologies or functional apparatuses of social reproduction have to deny that the discourses, practices and institutions that constitute the cultural can accomplish anything in themselves, other than the *re-presentation* of what is already in place, at some more 'basic' level.[27] Third, and finally, once one confronts the openness and indeterminacy of the relational and differential logic of the discursive field, then the notion of social totality itself has to be radically displaced. As Ernesto Laclau and Chantal Mouffe have argued:

> The incomplete character of every totality necessarily leads us to abandon, as a terrain of analysis, the premise of *'society'* as a sutured and self-defined totality. 'Society' is not a valid object of discourse. There is no single underlying principle fixing – and hence constituting – the whole field of differences.[28]

If the 'social' exists, it is only 'as an effort to construct that impossible object',[29] by a temporary and unstable domination of the field of discursivity, imposing a partial fixity that will be overflowed by the articulation of new differences. There is no end to this history. We find ourselves without the guarantees of an immanent, objective process or a last instance, but analysis and intervention do not need a lost cause. That very lack opens the way to the multiplication of forms of subversion and the imagination of new identities, in which cultural strategies can no longer be contained in a secondary role. In the same play, it invades and transforms the very object, ground and field of possibilities of the social history of art.

Notes

1. Karl Marx and Frederick Engels, 'The German Ideology', *Collected Works*, vol. 5 (Lawrence & Wishart, London, 1976) pp. 19–539, especially vol. I, Section I: 'Feuerbach: Opposition of the Materialist and Idealist Outlooks', pp. 27–93.
 For the concept of an 'expressive' structure, see Louis Althusser, 'From *Capital* to Marx's Philosophy', 'Marxism is not a Historicism',

and 'Marx's Immense Theoretical Revolution', in Louis Althusser and
Etienne Balibar, *Reading Capital*, trans. Ben Brewster (New Left
Books, London, 1970). For the seminal discussion of 'Hegelian' and
'Marxist' concepts of totality, see Louis Althusser, 'Contradiction and
Overdetermination' and 'On the Materialist Dialectic', in *For Marx*,
trans. Ben Brewster (Allen Lane, The Penguin Press, Harmondsworth,
1969). For Althusser's later theory of ideology, see especially 'Ideology
and Ideological State Apparatuses (Notes towards an Investigation)',
in *Lenin and Philosophy and other essays*, trans. Ben Brewster (New
Left Books, London, 1971). See also Pierre Macherey, *A Theory of
Literary Production*, trans. Geoffrey Wall (Routledge & Kegan Paul,
London, 1978).

 Examples of social histories of art structured around a concept of
art as the expression of economically-determined class outlooks might
include, Frederick Antal, *Florentine Painting and Its Social Back-
ground; The Bourgeois Republic Before Cosimo de'Medici's Advent to
Power: XIV and Early XV Centuries* (Routledge & Kegan Paul,
London, 1947); Arnold Hauser, *The Social History of Art*, 2 Vols,
trans. Stanley Godman (Knopf, New York, 1951); Max Raphael,
'Picasso', in *Proudhon, Marx, Picasso: Three Studies in the Sociology
of Art*, John Tagg (ed.), trans. Inge Marcuse (Humanities Press, New
Jersey and Lawrence & Wishart, London, 1980); and Nicos Hadjini-
colaou, *Art History and Class Struggle*, trans. Louise Asmal (Pluto
Press, London, 1978). For approaches to the social history of art
influenced by Althusser's and Macherey's theories of ideology, see
T. J. Clark, *Image of the People: Gustave Courbet and the 1848
Revolution* (Thames & Hudson, London, 1973) and 'The Conditions
of Artistic Creation', *Times Literary Supplement*, no. 3768, 24 May
1974, pp. 561–2; Griselda Pollock, 'Vision, Voice and Power. Feminist
Art History and Marxism', *Block*, no. 6, 1982, pp. 2–21; and John
Tagg, 'The Currency of the Photograph', *Screen Education*, no. 28,
Autumn 1978, pp. 45–67.

2. Griselda Pollock, 'Modernity and the Spaces of Femininity', *Vision
and Difference: Femininity, Feminism and Histories of Art* (Routledge,
London, 1988) pp. 50–90. For a discussion of the representation of
the city in relation to the discourses of discipline, not focusing,
however, on gender difference and not included in the above
collection, see: Griselda Pollock, 'Vicarious Excitements: *London: A
Pilgrimage* by Gustave Doré and Blanchard Jerrold, 1872', *New
Formations*, no. 4, Spring 1988, pp. 25–50.

3. Pollock has in mind, specifically, T. J.Clark, *The Painting of Modern
Life: Paris in the Art of Manet and His Followers* (Alfred A Knopf,
New York, 1984). Her comments might apply equally to Thomas
Crow, 'Modernism and Mass Culture in the Visual Arts', in Benjamin
Buchloh, Serge Guilbaut, and David Solkin (eds), *Modernism and
Modernity* (The Press of the Nova Scotia College of Art and Design,
Halifax, Nova Scotia, 1983); Robert Herbert, *Impressionism: Art,
Leisure and Parisian Society* (Yale University Press, New Haven,

1988); and Theodore Reff, *Manet and Modern Paris* (University of Chicago Press, Chicago, 1982).

4. See for example Clark, *The Painting of Modern Life*, especially 'Introduction' and 'The View from Notre-Dame'; and Pollock, 'Modernity and the Spaces of Femininity'. For other discussions, see: Marshall Berman, *All That Is Solid Melts Into Air: The Experience of Modernity* (Simon and Schuster, New York, 1982); D Harvey, 'Paris, 1850–1870', in *Consciousness and the Urban Experience: Studies in the History and Theory of Capitalist Urbanisation* (Johns Hopkins University Press, Baltimore, 1985) pp. 63–220; and 'The Representation of Urban Life', *Journal of Historical Geography*, vol. 13, no. 3, 1987, pp. 317–321; Kristin Ross, *The Emergence of Social Space: Rimbaud and the Paris Commune* (University of Minnesota Press, Minneapolis, 1988).

5. See the earlier version of 'A Bar at the Folies-Bergère' (ch. 4 of Clark, *The Painting of Modern Life*); 'The Bar at the Folies-Bergère', in Jacques Beauroy, Marc Bertrand, and Edward T. Gargan (eds), *The Wolf and the Lamb: Popular Culture in France, from the Old Regime to the Twentieth Century* (Anma Libri, Saratoga, CA, 1977).

6. Pollock, 'Modernity and the Spaces of Femininity'. See also Abigail Solomon-Godeau, 'The Legs of the Countess', *October*, no. 39, Winter 1986, pp. 65–108; and Janet Wolff, 'The Invisible Flâneuse; Women and the Literature of Modernity', *Theory, Culture and Society*, vol. 2, no. 3, 1985, pp. 37–48.

7. Charles Baudelaire, 'The Painter of Modern Life', in *The Painter of Modern Life and Other Essays*, trans. Jonathan Mayne (Phaidon Press, Oxford, 1964) p. 9.

8. Ibid., p. 30.

9. Cf. sections 'X. Woman', ibid., pp. 29–31, and 'XII. Women and Prostitutes', ibid., pp. 34–38.

10. Pollock, 'Modernity and the Spaces of Femininity', pp. 79–85.

11. Christine Stansell, *City of Women: Sex and Class in New York, 1789–1860* (University of Illinois Press, Urbana and Chicago, 1987).

12. For discussion of the Bowery Boys and Gals, see Stansell, op. cit., pp. 89–101. See also Alvin F. Harlow, *Old Bowery Days: The Chronicles of a Famous Street* (D. Appleton & Co., New York, 1931); and Lloyd Morris, *Incredible New York: High Life and Low Life of the Last Hundred Years* (Random House, New York, 1951). Contemporary accounts and journalism include: George C. Foster, *New York by Gas-Light* (Dewitt & Davenport, New York, 1850); Abram C. Dayton, *Last Days of Knickerbocker Life in New York* (G. W. Harlan, New York, 1882); and George Ellington, *The Women of New York, Or the Underworld of the Great City* (Arno Press, New York, 1869).

 For comparison with the dress of prostitutes in England and the transgressive imitation of middle-class codes, see Judith R. Walkowitz, *Prostitution and Victorian Society: Women, Class, and the State* (Cambridge University Press, Cambridge, 1980) p. 26.

13. Walkowitz uses the term 'female subculture' but does not effectively define it: ibid., pp. 5, 15, 25, 131, 201.

14. Stansell, op. cit., p. 221.

15. See: M. Christine Boyer, *Dreaming the Rational City: The Myth of American City Planning* (MIT Press, Cambridge, Mass., 1983); Didier Gille, 'Maceration and Purification', in *Zone*, nos. 1/2, ed. Michel Feher and Sanford Kwinter (Urzone Inc, New York, n.d.) pp. 227–281; and John Tagg, 'God's Sanitary Law: Slum Clearance and Photography in Late Nineteenth Century Leeds', ch. 5 of *The Burden of Representation: Essays on Photographies and Histories* (Macmillan, London, 1988) pp. 117–52; and 'The Proof of the Picture', *Afterimage*, vol. 15, no. 6, January 1988, pp. 11–13.

16. See Michel Foucault, *Discipline and Punish: The Birth of the Prison*, trans. Alan Sheridan (Allen Lane, The Penguin Press, Harmondsworth, 1977); *Power, Truth, Strategy*, ed. Meaghan Morris and Paul Patton (Feral Publications, Sydney, 1979); *Power/Knowledge*, ed. Colin Gordon (Harvester Press, Brighton, 1980); and *Foucault Live (Interviews, 1966–84)*, ed. Sylvère Lotringer, trans. John Johnston (Semiotext(e) Foreign Agents Series, New York, 1989). Also: Gilles Deleuze, *Foucault*, trans. Seán Hand (University of Minnesota Press, Minneapolis, 1988), especially 'A New Cartographer', pp. 23–44; Jacques Donzelot, *The Policing of Families* (Hutchinson, London, 1979); Michel de Certeau, *Heterologies: Discourse on the Other*, trans. Brian Massumi (University of Minnesota Press, Minneapolis, 1986), especially Chapter 13, 'Micro-techniques and Panoptic Discourse: A Quid pro Quo', pp. 185–92; Pasquale Pasquino, 'The Genealogy of Capital – Police and the State of Prosperity', *Ideology & Consciousness*, no. 4, Autumn 1978; and 'Criminology – The Birth of a Special Savoir', *I & C*, no. 7, Autumn 1980, pp. 17–32; and Giovanna Procacci, 'Social Economy and the Government of Poverty', *Ideology & Consciousness*, no. 4, Autumn 1978.

17. The gaze of spectacle and the gaze of power are visual agencies that, as Kaja Silverman reminds us, can never be owned by anyone's eye, outside all specularity (cf. Kaja Silverman, 'Fassbinder and Lacan: A Reconsideration of Gaze, Look and Image', *camera obscura*, no. 19, January 1989, pp. 55–84). It is only through specific cultural representations that particular looks – here, the look of the flâneur, the look of the policeman, the look of the record photographer – come to be conflated with the authority of the gaze. And it is only in the struggles to impose and institutionalise such cultural representations that these looks, and the practices, protocols and discourses in which they are inscribed, come to be legitimised as distinct and discrete régimes and, simultaneously, assigned the status of 'universal' law: the universality of Art and pleasure, or evidence and truth.

Yet, such legitimations, and the conflations on which they rest, cannot be secured or even long sustained, not only because their institutionalisation is resisted and never finally accomplished, but also because they are internally conflicted. The look of that secular

detective, the flâneur, 'mirror as vast as the crowd itself', which would see everything, from every angle, at once and unseen, is both lost to the lure of its own lonely desire and inescapably part of the intoxicating spectacle it would command. The look of surveillance and discipline cannot erase the desire that implicates it in the lack it disburdens on the other, or the pleasure that scandalously threatens to change the meaning of the power relations of domination and submission it imposes.

What is also put in question, here, is the very separation of looks that the discursive régime instates. The historical forms of this separation described here – the popular catalogue of sights and the professionalised archive of documentation – only come to exclude each other through a constant process of negotiation and struggle. Yet, the institutional closures that give them their pleasurability and force can never be held in place. The images fall out of the catalogue and the archive. The rules of their games are never finalised or clear. They intersect and interplay in hybrid or uncertain spaces: in the Photographic Survey Records of antiquarian societies in metropolitan centres like London and Paris and provincial cities like Manchester; in the homiletic narrative lantern slide sets of 'Slum Life in Our Great Cities Photographed Direct from Life', sold extensively to temperance and missionary groups by individual entrepreneurs and commercial companies such as Banforth's of Holmfirth, West Riding; and in civic collections that appropriated the products of a range of photographic discourses to the constitution of a notion of local or national history and cultural heritage. In 1898, in Paris, for example, Bolestaw Matuszewski, a cinematograph operator in Warsaw, published *Une nouvelle source de l'histoire*, a translation of *Nouwe Zródlo Historii*, in which he proposed the creation of '*un dépôt de cinématographie historique*'. Here, material of a 'documentary interest . . . slices of public and national life . . . the changing face of the cities' would be gathered in a national historical archive capable of furnishing incontrovertible evidence, for use in legal contexts, the arts, medicine, military affairs, science and education. It was in such repositories that the institutional specificity of documentation and the particularism of social reform and antiquarian records began to be reworked into more generalised and emotive discourses. Across the territories of evidence and spectacle, a new Historical Section opens, governed by a social democratic political project of managing consent through the new means of communication, in the context of modernising, rationalising and professionalising the social domain. This was the space of emergence of *documentary* in its historically specific sense.

See Tagg, *The Burden of Representation*, pp. 5–15, 139–142; H. D. Gower, L. S. Fast, and W. W. Topley, *The Camera as Historian: A handbook to photographic record work*, 1916; H. Milligan, 'The Manchester Photographic Survey Record', *The Manchester Review*, vol. VII, Autumn 1958, pp. 193–204; G. H. Martin and David Francis, 'The Camera's Eye', in H. J. Dyos and Michael Wolff (eds),

The Victorian City: Images and Realities, vol. II (Routledge & Kegan Paul, London, 1973) pp. 227–246.

18. This may be the point to comment on a noticeable loss in the passage of the argument from urban spectacle to urban discipline: the loss of the focus of sexual difference. The pathologising and hystericising of female bodies in the discourses of medicine, psychiatry and criminology, like the gendering of urban space, the discursive projection of 'Woman' and the positioning of women in the city as spectacle, were structural to the reorganisation of the economy of masculinity and femininity in the nineteenth century and to a new formation of identity and difference. From this point of view, the emphasis should remain the same: as with the concepts and practices of modernity and modernism, the discourses of disciplinary knowledge were crucially articulated on a new régime of sexual difference. Yet, stress on this strategic centrality carries the danger of re-essentialising difference, not only in the reduction of sexual difference to duality, as we find in Pollock's essay, but in the (spatial) isolation of a centralised sexual difference from the simultaneous field of differentiations.

 The object of disciplinary knowledge – constituted in a relation of engendered otherness – was always, simultaneously, the vanishing point of condensed and conflicting frames of difference, in which multiple differentiations of sexuality, race, class, regionality, age and culture were compounded on the ground of anatomy. Similarly, the economy of spectacle, as it was written across the *internal* and *external* space of the nineteenth-century city, determined not only a political economy of gender difference, or even of gender and class, but also and inseparably a network of divisions of race, ethnicity, regionality and culture, overdetermined by shifts in the division of labour, the distribution of skills and the condition of labour markets. The differences, which are presented as singular and essential, multiply, divide within themselves, and recombine, reimplicating defining term and differed in the discursive fields from which they have emerged, but which cannot provide the last word: gender, race, class . . .

19. For further, though differently theorised, discussions of instrumental photography see: David Green, 'Classified Subjects', *Ten:8*, no. 14, 1984, pp. 30–37; and 'A Map of Depravity', *Ten:8*, no. 18, 1985, pp. 37–43; Roberta McGrath, 'Medical Police', *Ten:8*, no. 14, 1984, pp. 13–18; André Rouillé, *L'Empire de la photographie: Photographie et pouvoir bourgeois 1839–1870* (Le Sycomore, Paris, 1982); and Alan Sekula, 'The Body and the Archive', *October*, no 39, Winter 1986, pp. 3–64.

20. This can also be read as the beginnings of a response to Geoffrey Batchen's critique of *The Burden of Representation* ('Photography, Power, and Representation', *Afterimage*, vol. 16, no. 4, November 1988, pp. 7–9) which – if I may paraphrase – seeks to convict me of holding an instrumental view of writing and photography as passive, inert and compliant 'ideological' tools, entirely external and transparent to the negative power of repressive juridical institutions. Even

allowing for inaccuracies of reading and confusions over significant and recognised differences between articles written across a ten year period and the pointed, but largely ignored, auto-critique that introduces the collection, I find this disconcerting. For whatever purposes, it seems that what has to be attributed to me is, *in every particular*, the view that my writings have from the first set out to dispute.

21. The term 'language games' obviously refers both to Ludwig Wittgenstein, *Philosophical Investigations*, trans. G. E. M. Anscombe (Basil Blackwell, Oxford, 1958); and to its renewed currency in Jean-François Lyotard, *The Postmodern Condition: A Report on Knowledge*, trans. Geoff Bennington and Brian Massumi (University of Minnesota Press, Minneapolis, 1984); *The Differend: Phrases in Dispute*, trans. Georges Van Den Abbeele (University of Minnesota Press, Minneapolis, 1988); and, with Jean-Loup Thébaud, *Just Gaming*, trans. Wlad Godzich (University of Minnesota Press, Minneapolis, 1985).

22. Cf. Ulrich Keller, 'The Myth of Art Photography: A Sociological Analysis', *History of Photography*, vol. 8, no. 4, October–December 1984, pp. 249–75.

23. For a discussion of the critical inflation of the threat or promise of photographic technologies, see: John Tagg, 'Totalled Machines: Criticism, Photography and Technological Change', *New Formations*, no. 7, Spring 1989, pp. 21–34.

24. See: Raymond Williams, *The Sociology of Culture*, Schocken Books, New York, 1982, Chapter 2, 'Institutions', pp. 33–56.

25. The classical points of departure in Marx would be: 'The Eighteenth Brumaire of Louis Bonaparte', in Karl Marx and Frederick Engels, *Collected Works*, vol. 11 (Lawrence & Wishart, London, 1979) pp. 99–197; *Grundrisse: Foundations of the Critique of Political Economy (Rough Draft)*, trans. Martin Nicolaus (Penguin Books, Harmondsworth, 1973); and *Capital*, vol. 1, Chapter 1: 'The Commodity', trans. Ben Fowkes (Vintage Books, New York, 1977) pp. 125–77 .

 For discussion of the problems involved in Marx's uses of the concepts of representation, articulation and fetishism, see Althusser, 'Marx's Immense Theoretical Revolution', in *Reading Capital*; Jean Baudrillard, *The Mirror of Production*, trans. Mark Poster (Telos Press, St Louis, MO, 1975); and *For A Critique of the Political Economy of the Sign*, trans. Charles Levin (Telos Press, St Louis, MO, 1981) especially 'Fetishism and Ideology: The Semiological Reduction', pp. 88–101, and 'Towards a Critique of the Political Economy of the Sign', pp. 143–63; Ben Brewster, 'Fetishism in *Capital* and *Reading Capital*', *Economy and Society*, vol. 5, no. 3, August 1976, pp. 344–51; Norman Geras, 'Marx and the Critique of Political Economy', in Robin Blackburn (ed.), *Ideology in Social Science: Readings in Critical Social Theory* (Fontana/Collins, Glasgow, 1972) pp. 284–305; Stuart Hall, 'Marx's Notes on Method: A Reading of the 1857 *Introduction*', *Working Papers in Cultural Studies*,

no. 6 (Centre for Contemporary Cultural Studies, Birmingham, 1974); 'Re-Thinking the "Base-and-Superstructure" Metaphor', in Jon Bloomfield (ed.), *Class, Hegemony and Party* (Lawrence & Wishart, London, 1977) pp. 43–72; 'The "Political" and the "Economic" in Marx's Theory of Classes', in Alan Hunt (ed.), *Class and Class Structure* (Lawrence & Wishart, London, 1977) pp. 15–60; and 'The Problem of Ideology – Marxism without guarantees', in Betty Matthews (ed.), *Marx: A Hundred Years On* (Lawrence & Wishart, London, 1983) pp. 57–85; Barry Hindess and Paul Hirst, *Mode of Production and Social Formation* (Macmillan Press, London, 1977); Paul Hirst, 'Althusser and the Theory of Ideology', in *On Law and Ideology* (Macmillan Press, London, 1979) pp. 40–74; Ernesto Laclau and Chantal Mouffe, *Hegemony and Socialist Strategy: Towards a Radical Democratic Politics* (Verso, London, 1985) especially Chapter 3, ' Beyond the Positivity of the Social: Antagonisms and Hegemony', pp. 93–148; Gayatri Chakravorty Spivak, 'Scattered Speculations on the Question of Value', in *In Other Worlds: Essays in Cultural Politics* (Methuen, New York and London, 1987) pp. 154–75.

26. Cf. Hall, 'The "Political" and the "Economic" in Marx's Theory of Classes'; Paul Hirst, 'Economic Classes and Politics', in A. Hunt, op. cit., pp. 125–54; and Tagg, 'Introduction' to *The Burden of Representation*.

27. Cf. Hirst, 'Althusser and the Theory of Ideology'; and Tagg, ibid.

28. Laclau and Mouffe, op. cit., p. 111.

29. Ibid., p. 112.

8

Postmodernism and the Born-Again Avant-Garde

My point of departure is one of the most tenacious narratives of contemporary art history and theory. Easy target for more than a decade, it seems now that news of its death has been greatly exaggerated. With variously motivated attempts to salvage something from the centreless art practices of the late 1970s and early 1980s, debate has turned again on the concept of modernism, seen now in relation to what is increasingly called 'postmodernism'. The term has been invoked in a confusing variety of contexts and has a number of conflicting currencies. I do not want, however, to spend much time on its cruder apologists. There are, of course, those who, adapting the prescriptions of Clement Greenberg, have tried to prolong what he divined as the project of a fleeting American avant-garde by means of an even severer selectivity. To avoid having to notice the loss of an earlier modernism's ethical and political mission and the presence of more embarrassing things, their critical gaze has fixed on the fetishism of formal innovation, whose subtleties define monolithic periods and movements named

The material for this chapter grew out of a televised debate on 'Art After Modernism', chaired by Laura Mulvey for *Voices* and broadcast on Channel Four in April 1984. First presented as a lecture at Newcastle Polytechnic in October 1984, the text of this chapter was later published in *Block* (no. 11, 1985/86), and reprinted as an introduction to J. Tagg (ed.), *The Cultural Politics of 'Postmodernism'*, (Current Debates in Art History: One, SUNY Binghamton, Binghamton, 1989).

according to their place in a linear or cyclical temporality, in which they are always before something and after something else: impressionism or postimpressionism, early cubism or late, painterly abstraction or postpainterly abstraction, modernism or post-modernism. Against the advocates of such stoic disavowal stand the more knowing celebrants of novelty for whom the renewal of art is more readily equatable with the renewal of the market for art. They cheerfully admit to the waning of heroic rhetoric and the decline of the high moral tone but welcome hectic diversity and the penetration of the art world by the values and practices of consumer production as more fitting to the mood and structure of post-industrial and postmodern society. Some go further and see eclecticism and self-referential play (now made respectable under the borrowed name of intertextuality) as representing a new content and direction – 'The New Spirit in Painting' giving unified expression to a 'Zeitgeist' in which all the old beliefs and antagon-isms are outmoded and talent and technology are all. Poor old Hegel. He has been back as tragedy and as farce and is down to a big prize TV game.

But I do not want to be delayed by this from turning my real attention to a body of analyses critical of this celebratory commerc-ialism whose various modes of address to the notion of postmod-ernism still appear to return us to the structures of a familiar cultural theory and historiography. I turn first to the French philosopher Jean-François Lyotard whose writings from the past decade and a half are enjoying a new currency if not a vogue in Britain and the USA now. Lyotard rejects one form of capitalist postmodernism as commercial eclecticism – 'the degree zero of contemporary general culture' – which evades the challenge of authentic research and in which the only criterion is profit.[1] Yet he welcomes the splintering of social life and the destructuring of individual experience which he connects to a general crisis in representation in science and art. For Lyotard, ideas of the unified subject, the transparency of the sign to its referent, socio-cultural unity and the unitary end to history are dangerous fictions of Hegelian inspiration which can only be maintained by one sort of terror or another. Modern means of image transmission and information storage have vastly multiplied such realist fantasies of an organically unified society, transparent to itself, free from doubt, and evolving along a controlled and predictable line. Offered as visions of efficiency or liberation, they are always fantasies of order,

authority and control, pressed, at a time of crisis of all legitimations, with ever-increasing violence. Whether made in the name of profit or the name of social policy, calls for unity, order, identity, security, unmediated communications and stabilised meanings come only from the voice of authoritarian conservatism and are always linked to the liquidation of experimental avant-gardes. The link is justified because avant-gardes, by questioning the rules of art, have called into doubt the very notions of 'reality' and 'identity' which dominate Party solutions and mass communications. Avant-garde artists know that modernity cannot exist without the shattering of every kind of belief and the invention of other realities. True postmodernism is the challenging of all that has been received.

What is extraordinary, however, is that from the shards of this shattered whole, Lyotard retrieves his own unity. Postmodern thought and postmodern art have thrown aside the security blankets of belief, the consoling myths and legitimising narratives of the past, and have called into question the adequacy of every discourse in order to present the sublime fact that the unpresentable exists. On this level, the analysis of postmodern aesthetics may be transferred to the concurrent crisis of scientific knowledge. There is a single line of questioning and a single compulsion: the urge to make new. Art interrogates itself to the end of intelligibility, challenging all forms of presentation in its drive to impart a sense of the unpresentable. Postmodern science, working without the consolation of truth or the legitimising myth of human liberation, challenges all established statements and narratives as it continually generates more work and infuses the repressive systems with new and unknown desires. The diversity of experimentation and dissent is gathered up in the unity of the mission of the avant-garde to challenge the very structures of meaning of society. Like John Wayne, out of the smoke and dust of the postmodernist explosion, we begin to see the familiar chunky outlines of a rough but redeeming modernism. There is the singleness of purpose, the showdown on the frontier of the possible, the fearless interrogation, the high-noon drama on which hangs the fate of social, psychological and epistemological renewal, the restless need for change, now stripped of any illusions of progress, but with its eyes fixed on a horizon which is endlessly different yet somehow always the same. If this is postmodern, it is evidently not a radical break with modernism but a moment of the same structure opening on the production of ever new modernisms. As Lyotard insists:

Postmodernism thus understood is not modernism at its end but
in the nascent state, and this state is constant.[2]

The difficulty with this reassertion of the modernist idea that art
has the crucial if feared ability to transform meaning and value for
the surrounding society is that it assumes too much in the continuity
of context and fails to explain the changing relation of avant-garde
practices to capitalist production, dominant cultures and state
apparatuses. How, in his rush to embrace every excessive act of
postmodernity, can Lyotard avoid being caught in a compromising
position with the eclectic cultural commodities he scorns? Artists
like the New York video-maker, Martha Rosler, have become well
aware of the problem. Her work has been focused by a situation in
which it has become difficult to distinguish between the turn-over of
styles of the newly successful art and that of other commodities,
especially those produced by an 'entertainments industry' which
'has become the prime source of cultural goods and self-images for
a Western world now well on its way to cultural hegemonisation'.[3]
Rosler also has less nostalgia for a cultural modernism which
conservative critics may blame for the ungovernability of western
societies, but which has also operated a mechanism of exclusion,
marginalising black, gay, Third World and female artists, and
securing a position of privilege for the exemplary white, Eur-
opean-oriented, male. If there has recently been any wavering in
this, it has only been to 'supply the necessary transfusion of energy
and style' to the system and to conjure away social conflict by a
'symbolic acceptance of the socially dispossessed'. The problem
remains the high density of corporate culture and its endlessly
adaptable capacity for incorporation. It has to be fought not by
the tactics of the vanguard but by a post-Cuba-style guerrilla war.

> It is only through a 'guerrilla' strategy which resists a deadly
> universalisation of meaning by retaining a position of marginal-
> ity, that the production of critical meanings still remains possible.
> It is only on the margins that one can still call attention to what
> the 'universal' system leaves out.[4]

It may be noticed that the struggle of marginals imagined here
bears a distinct resemblance to Lyotard's formulation and, as with
Lyotard, the idea belongs with a cluster of others whose persistence
in Rosler's arguments returns her perilously close in certain respects
to the theories she seeks to oppose. The unqualified antipathy to

mass culture, for example, and the determination to open up a rift between it and authentic art has a history going back, through the influential arguments of *Partisan Review* in the 1940s in which Greenberg's ideas were formed, to nineteenth-century conservative cultural theory and evaluative aesthetics. It depends from a view of culture as the production of key values or the expression of significant human meanings allowing insight into society as a whole. It is also linked to a privileging of the artist as maker of these meanings, as socially or spiritually empowered to adjudicate on abiding human values. This notion of the artist as specially endowed persists in and, indeed, has been very much attached to the view of the artist as outsider, heroine on the margins, or guerrilla in the cultural ghetto. The idea is still that the future of significant culture lies in the hands of the embattled few.

This exclusive mission is, however, only an élitist or utopian fantasy. Marginality guarantees nothing. Culture is not expressive of an experience to be had on the margins or anywhere else and, contrary to what is suggested, belligerent independence is not the artist's natural or necessary state. What is rather the case is that formations which represent themselves as heroically isolated – that is, avant-gardes – only emerge under special historical conditions. Avant-gardism is not an inescapable artistic fate or a process inherent in the history of art. It is a social strategy by which artists both engage with and differentiate themselves from the contemporary field of cultural politics. The role, function and representation this strategy gives to artists belong to a particular historical pattern which has been important only in certain conjunctures – Paris in the 1850s and 1870s, for example, or New York in the 1940s. Such avant-gardes, however, were never outside the social order in the ways that they represented themselves as being. Indeed, the form of their dislocation both from the dominant national culture and from any popular base cannot be understood outside the particular cultural, political and economic conditions which made it possible. Avant-gardism and modernist ideals developed only within certain metropolitan intellectual formations at particular stages in the history of not-yet-stabilised capitalist states. These formations depended on metropolitan centres for their arenas of intervention, for their institutional bases, for their access to publicity and communications, and for the professional and leisure-class audiences which could support their activities. Their particular conditions of existence cannot, therefore, be generalised as giving access

to an enduring predicament of artists, culture, or humanity. More-over, the meaning and value of the avant-garde stance changed with changing conditions. A strategy which opened up certain sets of possibilities in one moment was overtaken by the growth of corporate monopolies, by the restructuring of the relations of capital and the state, by the remobilisation of nationalism, by the break-up of traditional cultural formations, and by processes of professionalisation, suburbanisation, and redeployment, all of which affected cultural activities in First World countries in the postwar period. Such processes transformed avant-garde forma-tions in complex ways and gave them new meanings. But the transformations cannot be adequately described by the hold-all term postmodernism; they cannot be understood as a simple process of incorporation; and they cannot be challenged by yet tighter definitions of outsiderness or newer forms of avant-gardism. The point to be made about American Abstract Expressionism, for example, is that it constituted the appropriation and reassertion of a European cultural practice at a time in the USA when the relations of artists, art institutions, corporate structures and the state had changed. The point is not that it expressed the aspirations of corporate capitalism or that the artists who practised it were either unwitting dupes of some grand conspiracy or discredited hacks who sold out, who stopped being avant-garde enough. What is wrong is the avant-gardist analysis and the stance itself. What is needed is an alternative way of understanding culture and cultural conflict, very different from the one inherent in avant-gardism.

Perhaps this is the moment to turn to Fredric Jameson whose recent, lengthy meditation on the subject argues, as I have done, that the unrealisable utopianism of modernist movements emerged in a definite socio-economic context.[5] From this, Jameson goes on to draw the conclusion that significant modifications in the role and dynamic of cultural practice must always be matched to the emergence of new social and economic relations. Just as the dominance of the realist mode was bound up with the formation of market capitalism, and the arrival of modernism with the development of monopoly and imperialism, so the eclipse of the authoritarian, moralist stance of high modernism and the waning of its monumental emotional import has been coincident with the spread of industrialisation not only to all sectors of the economy but also to the sphere of circulation and the domain of culture.

Postmodernism is therefore an historical not an aesthetic category which constitutes not a stylistic option but the cultural dominant of late capitalism.

For Jameson, postmodernism may offer a strategy for surviving and producing new desires within the structural limits of capitalism, but it is not a revolution. He rejects the idea of the continuous, self-propelling generation of newness. Perpetual change must be seen as the rhythm of the capitalist mode of production itself and exhilaration with this rhythm as the reward and lure by which the social reproduction of capitalism is accomplished. In this sense, postmodernist innovation is a function of the late capitalist system, not a subversion of it, and the fundamentally anarchist approach to science and art that it fosters is simply unable to confront the challenge of an international cultural commodity market and a global monopoly of information systems. Such monopolies, like the rest of the private property system, cannot be expected to be transformed from within, but can be challenged 'only by a genuinely political (and not symbolic or protopolitical) action'.[6]

It is a telling point against those taken with the idea of a 'guerrilla rhetoric'. But let us pause to consider the theoretical structure – and especially the concept of culture and the place of the political – which generates such an analysis. What seems to underlie Jameson's virtuoso polemic and his notion of dominant cultural norms is a return to something like the Lukácsian notion of culture as the reflex or expression of a homogeneous structure whose character and history are ultimately determined by economic processes.[7] From the point of view of the total structure, he sees late capitalism as expressing itself in the fragmentation and heterogeneity of postmodern cultural production. From the perspective of the particular cultural product, by an equation of function and meaning, he comes to a view of the work of postmodernist art as an expression of its newly developed function within a system of cultural commodities. The price of historicising and setting a limit to the cultural seems to have been the obliteration of its specificity and effectivity.

Beyond the wealth of reference, the extreme abstraction of Jameson's underlying analysis and the ultimate obscurity of the strategy he proposes for an acceptable practice, which will somehow express the global system, correspond to the level of generalisation at which he sets the problem: how to posit a connection between

culture in general and the socio-economic structure as a whole. Yet, we can reject this level of abstraction without falling back, as he thinks we must, into a particularist atomism in which everything is just different from everything else; just as we can reject both Jameson's concept of the structure of the social and his analysis of meaning without being committed to a historical relativism of random and repressive difference, either as an apologist for consumer society or as advocate of an anarchic avant-gardism. From the point of view of structure, there are clearly ways of theorising totalities and the temporalities of historical change which do not invoke the holism and evolutionism of what Althusser called the expressive model. This is what Marx argued out across the pages of the *Grundrisse* notebooks in which he broke with Hegel's teleological notion of the social complex as an essential identity giving expression to a particular stage of a process of concentration described by the unfolding contradictions of the simple, unique, internal principle: the Idea. What Marx arrived at instead was a theory of articulation or representation on the basis of which the economic structure and, by extension, the social totality – always at a definite stage of historical development – could be conceived as a complex, conflictual and interactive totality – 'a rich totality of many determinations and relations', as he put it – in which the dominant moment was production.[8] The idea of an inner structure or essence was effectively displaced. Similarly, from the point of view of the theory of meaning, following semiotic analyses, one can think cultural practices as having definite conditions of existence which they do not determine without imagining that these are what they express. Cultural meanings are neither the reflection or reflex of a referent in an anterior reality, nor the expression of a primal experience which may be abstracted from its articulation in discourse. They are rather produced by determinate practices and their social consequences are always heterogeneous and open to dispute. Certainly, their production, circulation and consumption take place under given, though changeable, conditions in which their effects may be more or less constrained. But they are in no way the expression of these conditions.

How does this theoretical dispute about the nature of the social totality and the production of cultural meanings turn on the problems of modernism and postmodernism at which we have been looking? Perhaps the first stumbling-block is the idea of

modernity itself. This is what proponents of modernism and postmodernism presuppose: a unity of experience prior to discourse and corresponding to a set of identifiable conditions; a global response to the global processes of socio-economic modernisation; a continually renewed experience which issues somehow in an ever-renewing series of expressions whose formal innovations testify to their modernness of content. The mechanism by which all this takes place is never certain but, given the panoramic reaches of space and time across which it must act, it can never be anything but grand and absolute. The 'signs in the street' must all signify the same thing: the global signified – modernity.[9]

The problems of this theory lie both on the plane of synchronic relations and along the axis of historical change it implies. In the first place, that modernity which is affirmed in modernism is not a unified state of affairs evenly imposed in a uniformly postindustrial world. In the second place, as I have insisted earlier, historical transformations – including the development of modernism – do not take place by a continuous replacement of one moment by another in a sequential series which is endlessly different but always the same. Both spatially and temporally, historical change is not even and continuous but complex and differential and internally heterogeneous. The rhythm of development and dispersal of industrial capitalism was neither smooth nor uninterrupted, and it was never evenly distributed across the globe. As Perry Anderson has argued, its irregular expansion and geographical unevenness give rise to a complex temporality woven of different and discontinuous strands.[10] The pattern is one of high complexity in which diverse and internally divided societies are seen to have engaged with industrialisation under very different climatic, historical, political and cultural conditions, and with very different relationships to the emergence of an increasingly international system of capital. The idea of a general, definable modernity is in retreat and with it the idea of a universalised modernism which is its alleged expression. Cultural production must necessarily exhibit a real, integral diversity which universalising and homogenising theories can only obliterate.

Even if we narrow our focus to those cultural groupings which were self-consciously modernist, we shall see only a diversity of formations and practices with different relations to capitalist development, national traditions, residual and dominant cultures

and emergent social forces, and therefore with different meanings and effects. What is structurally similar in the confluences of conditions which determined the sporadic emergence of such modernisms cannot be assayed without first grasping this historical particularity. Only then will we be in a position to gauge whether certain combinations of factors were necessary to the existence of modernist and postmodernist formations and practices, whether and how these conditions and practices changed, how they interacted, and under what conditions they tended to disintegrate. Even then, we must not make the mistake of seeing the various modernisms as reflections or expressions either of their conditions of existence or of some experience which these conditions allegedly determine. Modernist discourses are not simply media through which inner and socially-determined experiences find outward expression and thereby recognition in the answering experience of others. The materiality of discursive practices, the impossibility of referring them back to some primal anterior reality, and the impossibility of abstracting experience from the discursive structures which articulate it, disrupt any simple notion of the determination of discourses by a sociality of which they are, in any case, a part.[11] The cultural value of modernisms cannot, therefore, be established by however patient a reconstruction of their social conditions. They can be evaluated only by tracing their structures and effects under changing circumstances in the societies in which they emerged, and by interrogating the relationship of these effects to their conditions of production and reception, their means of representation, and the practices through which these means were set to work. There can be no general answer to the question of the value of modernism. We cannot circumvent the task of historical analysis of the national cultural complexes and systems of international exchange across which modernisms claimed to have constructed a transcendent culture.

What then of the hopes for a radical interventionist culture that the theories of modernism and avant-gardism seemed to hold out? We must be specific again. Such hopes have a history. It makes sense to talk of cultural intervention and struggle only in relation to societies which have developed certain forms of the state and elaborated a range of cultural institutions, and in which governmentality rests, at least in part, on the action of these institutions in securing the social relations which constitute the functioning social

order. Cultural products and practices have significance precisely because of their place in that non-unitary complex of social practices and systems of representation which construct, invoke, maintain, or subvert the relations of domination and subordination in which social position and identity are produced. Such practices and representations must therefore affect and in turn be affected by political and economic conditions and conflicts, though they cannot be seen as their expression. Nor can they be evaluated by reference back to their origins or sources. Their only measure is the calculation of their specific social consequences – which is not to say that they determine their own conditions of existence or that these do not have effects. Cultural practices always involve the mobilisation of determinate means and relations of representation within an institutional framework whose organisation takes a particular historical form – marked in the West today, no doubt, by what Stuart Davis called 'cultural monopoly'.[12] There is no meaning outside this framework but it is not monolithic. The institutions which compose it offer multiple points of entry and spaces for contestation – and not just on the margins. The nature of the resistance will depend on the nature of the site. But the spaces are never isolated. Their relations and hierarchies also constitute a specific level of intervention, demanding its own specific forms of struggle.

It must be clear, therefore, that the variety and complexity of these spaces and hierarchies mean that no one strategy can be adequate to all confrontations. Lyotard is right to insist that we cannot repair the fragmentary character of culture and should not try. We are free of the burden of masterpieces. In Terry Atkinson's words, 'You can't have socialism in one work of art.' But an equally pressing conclusion is that no one kind of person can do the job. The specialness of the artist, point of honour of the avant-garde and held fast even by practitioners like Rosler, can no longer serve even as a mobilising myth. Cultural institutions require a whole range of functionaries and technicians who contribute their skills or service cultural production in a whole range of ways. A painting is as much a collective work as a film and only takes on the currency of social meaning through the application of multiple levels of expertise. It follows, then, that any adequate cultural intervention must be collective – as collective as advertising, television or architecture; as collective as the accumulated skills, the layers of habit, the

practices and codes, production values, rituals of procedure, technical rules of thumb, professionalised knowledges, distinctions of rank, and so on, which make up the institutional base.

Success in such a strategy will be a matter for continual calculation and not a moral question settled once and for all at the imaginary threshold between incorporation and independence. It will be measured partially and locally, in the absence of generalised rules, from an always questionable internal perspective, caught in the totalising system, seeking to link up with other localised eruptions of dissent, but without the security of the great narratives of legitimation which bolstered belief in change in the past. In this, Lyotard is right. But we shall also have to do without that story first told as a vision of utopian progress at the dawn of industrialisation by followers of Saint Simon: I mean the fable of the avant-garde.[13]

Notes

1. Jean-François Lyotard, 'Answering the Question: What Is Post-modernism?' in *The Postmodern Condition: A Report on Knowledge*, trans. G. Bennington and B. Massumi (University of Minnesota Press, Minneapolis, 1984) p. 76.
2. Ibid., p. 79.
3. Martha Rosler, unpublished notes for a televised discussion of 'Art After Modernism', *Voices*, 11 April 1984.
4. Ibid.
5. Fredric Jameson, 'Postmodernism, Or the Cultural Logic of Late Capitalism', *New Left Review*, no. 146, July–August 1984, pp. 53–92.
6. Fredric Jameson, 'Foreword', to Lyotard, *The Postmodern Condition*, op. cit., p. xxi.
7. In 'Postmodernism, Or the Cultural Logic of Late Capitalism', Jameson argues that 'postmodern culture is the internal and super-structural expression of a whole new wave of American military and economic domination throughout the world': op. cit., p. 57.
8. Karl Marx, *Grundrisse: Foundations of the Critique of Political Economy (Rough Draft)*, trans. Martin Nicolaus (Penguin, Harmondsworth, 1973) p. 100.
9. Cf. Marshall Berman, 'The Signs in the Street: A Response to Perry Anderson', *New Left Review*, no. 144, March–April 1984, pp. 114–23.
10. Perry Anderson, 'Modernity and Revolution', *New Left Review*, no. 144, March–April 1984, pp. 96–113.

11. Cf. Gareth Stedman-Jones, *Languages of Class. Studies in English Working-Class History 1832–1982* (Cambridge University Press, Cambridge, 1983) pp. 20–2.

12. Stuart Davis, 'Abstract Painting Today', in Francis V. O'Connor (ed.), *Art For the Millions* (New York Graphic Society, Greenwich, Conn., 1973) p. 122.

13. Cf. Nicos Hadjinicolaou, 'Sur L'Idéologie de L'Avant-Gardisme', *Histoire et critique des arts*, no. 6, July 1978, pp. 49–76.

9

Globalisation, Totalisation and the Logic of Discourse

everything became discourse – provided we can agree on this word – that is to say, a system in which the central signified, the original or transcendental signified, is never absolutely present outside a system of differences.

Jacques Derrida[1]

I have been asked to say something about the proliferation of photographies in the context of this debate on 'Culture, Globalisation and the World-System'. The problem is that I have also been asked to be brief and this may impose on what I want to say a certain negative tone: a refusal of a place in the debate and of its mode of theorising, without being able to go on to construct in detail the beginnings of other kinds of account. The difficulty is partly the present context, not only this conference, but also the present state of the field of research which has hardly begun to provide adequate materials for extensive accounts of the world-wide dissemination of photography. It is, indeed, one of the great merits

This text was first delivered as a response to papers by Immanuel Wallerstein, Roland Robertson and Ulf Hannertz, in *Current Debates in Art History: Three* on 'Culture, Globalisation and the World System: Contemporary Conditions for the Representation of Identity', organised by Anthony King at the State University of New York at Binghamton, in April 1989.

of today's debate that it directs our attention so forcefully to this need. And yet, I would still be resistant to the view that it is only empirical research that stands between us and a comprehensive account. Quite bluntly, I would suggest that the very desire for such an account is tied to notions of social totality and historiographical representation that are untenable. If we are to talk of global systems, then we shall have to ask whether concepts of globalisation can be separated from theoretical totalisations.

Here, it would seem that I am in agreement with Roland Robertson that it would be difficult to see as anything but reductive and economistic Immanuel Wallerstein's injunction to work against the 'very logical consequence' of 'the process of masking the true existential situation', and 'trace the actual development of the "culture" . . . over time within the historical system which has given birth to this extensive and confusing use of the concept of culture, the modern world-system which is a capitalist world-economy'.[2] Such 'logic' seems to put us back, once more, in the primitive architecture of the base and superstructure model of the social whole. No matter how many staircases and landings are inserted, we still find ourselves trudging up and down the same metaphorical tenement, from the ground-floor shopfronts and workshops to the garrets in the roof, where the painters and photographers of *Bohème* always have their studios. The communards have not yet pierced the walls and floors of this dwelling. The only difference seems to be that the local storefront now opens on a great global thoroughfare, beyond even Haussmann's imagination. The vista is expansive but, like Daguerre's diorama, its illusion of realism depends on our identifying with the imposed convention of its single, fixed perspective. As a representation of a social totality, it claims both too little and too much for what it wishes to see as a determinant space: evacuating from the 'economic', cultural practices that have been increasingly structural to it, and collapsing the political effectivity of material modes of production of meaning through a reflectionist concept of representation.

By contrast, I might agree with Roland Robertson that, far from being economically fixed and culturally masked, concepts of globalism have no status outside the fields of discourse and practice that constitute them. But here, too, I would have to depart from the way the construction of a range of representations of globality seems to be thought of by Robertson as the effect or expression of a

real process of globalisation, and even a 'global-human condition', lying behind its 'images' and knowable, somehow, outside the processes of representation.[3] Closely related to this is Robertson's claim for his own position that 'globalization theory contains the seed of *an account as to why* there are current intellectual fashions of deconstruction, on the one hand, and postmodernist views concerning the "confluence of everything with everything else", on the other'.[4] For all his conviction that he is also opposed to 'what poststructuralists and postmodernists now call a "grand narrative"',[5] Robertson would still seem to be privileging some sort of master knowledge: a metatheory that can, like Wallerstein's or Jameson's reading of Marxism, account for all other types of theoretical production. For the so-called deconstructionists and postmodernists, one might reply that Robertson's notion of the world-as-a-single-place would seem to be caught in precisely what the Derridians might think of as a 'metaphysics of presence', or the Lacanians as a projection on to the isolated image of the planet of an Imaginary wholeness that represses the multiple and heterogeneous positioning effects of language. Put briefly, the world that is systematic or one place can never be a world of discourse: this world is never present to itself; it never constitutes an accomplished totality.

Before I am indicted of idealism, let me begin to trace out something of what this might mean in relation to my designated 'area' of photographies.[6] Perversely, perhaps, I can begin by conceding immediately the importance of the perspectives opened by an understanding of the geographical expansion and increasing structural integration of capitalist production. This might have to be qualified to the extent that a neglect of specific local factors, such as national frameworks of patent and copyright law, would leave one unable to explain the different patterns of exploitation of the early daguerreotype and calotype processes or, indeed, the uneven constraints on the later development of national photographic and, subsequently, film industries. However, it is equally clear that a narrowly national focus would not allow one even to pose the question of the extraordinarily rapid proliferation of photographic practices in the nineteenth century, from the dissemination of daguerreotypes in the 1840s, through the entrepreneurial phase of mass-produced portraiture, to the fully corporate stage of dry-plate, camera and photofinishing industries of the 1880s and 1890s.

It is also true that this latter development created crucial conditions not only for the vast expansion of the photographic economy, but also for the transformation of its institutional structures, in part as a reaction to the emergence of a broadly based, economically significant and aesthetically troubling sphere of amateur practice. To acknowledge this is not, however, to grant that we could ever derive the categories, constraints and motivations, or the cultural subordination, of amateur photographies from the technological and economic shifts themselves. To talk about the emergence of amateur photographies is to talk of the tracing out of new levels of meaning and practice, new hierarchies of cultural institutions, and new structures and codes of subjectivity: processes unquestionably bound up with technological innovation and the restructuring of production and marketing, but equally part of the momentum of a reconstitution of the family, sexuality, consumption and leisure that plots a new economy of desire and domination. And if we can follow this overdetermined development across a radiating cultural geography, it is never as a simple unrolling, economically and technologically driven process. The formation of amateur photographies had always to be negotiated in and across the fields of specific national structures, cultural conventions, languages, practices, constructed traditions and institutions. So far from expressing the necessity of a purely economic or even ideological process, amateur practices constituted a *discursive formation* in the fullest sense, saturated with relations of power, structuring new effects of pleasure, and generating new forms of subjectivity that have then to be seen as determinant conditions of capitalist growth in themselves.

We might take as another example the widespread emergence of instrumental photography, drawing on older practices of cartography and mechanical drawing and closely allied to the development of social statistics and specialised forms of writing. Its very function implied a universal and objective technique that would transcend the limits of all existing notational languages. Yet, for it to work, what had to be set in place were local discursive structures whose power and effectivity were never given in the technology, but had to be produced and negotiated across a constellation of new apparatuses that reconstituted the social as object of new disciplinary practices and technical discourses whose political character was elided. The institutionalisation of record photography was not,

therefore, just a matter of overcoming conservative resistance to a new technology, but a struggle over new languages and techniques and the agencies that claimed to control them. The notion of evidentiality, on which instrumental photographs depended, was not already and unproblematically in place: it had to be produced and institutionally sanctioned. And if, more generally, photography was taken to hold out the promise of an immediate and transparent means of representation, a universal and democratic language, and a tool for a universal science, then these claims, too, have to be treated as the specific, historical stakes of a politico-discursive struggle.

What I am arguing, against any totalising or teleological view, is that the meaning and value of photographic practices cannot be adjudicated outside specific language games. Nor can a single range of technical devices guarantee the unity of the field of photographic meanings. A technology has no inherent value outside its mobilisations in specific discourses, practices, institutions and relations of power. Import and status have to be produced and effectively institutionalised and such institutionalisations do not describe a unified field or the working out of some essential causality. Even as they interlink in more or less extended chains, they are negotiated locally and discontinuously and are productive of value and meaning. And it is on this same ground that they would have to be challenged.

It is beyond my brief – and my time – to pursue the consequences of this discursive analysis for notions of a world or global culture. Returning to the models with which I began, I might, however, underline the following awkward points. In the first place, once one allows any effectivity to discursive practices in constituting meaning and identity and generating effects of power, then there is no longer any way of invoking another, determinant and exterior tier of 'social' explanation. But, beyond this, once one confronts the openness and indeterminacy of the relational and differential logic of the discursive field, then notions of social totality have to be radically displaced. As Ernesto Laclau and Chantal Mouffe have argued:

> The incomplete character of every totality necessarily leads us to abandon, as a terrain of analysis, the premise of 'society' as a sutured and self-defined totality. 'Society' is not a valid object of

discourse. There is no single underlying principle fixing – and hence constituting – the whole field of differences.[7]

If the 'social' exists – and here we might usefully substitute the 'global' – it is only 'as an effort to construct that impossible object',[8] by a temporary and unstable domination of the field of discursivity, imposing a partial fixity that will be overflowed by the articulation of new differences. There is no end to this history. 'Wholeness' cannot throw down its 'crutches' and walk, restored.[9] We have lost the guarantees of an immanent objective process, but that very lack opens the way to the multiplication of forms of subversion and the imagination of new identities, in which cultural strategies can no longer be contained in a secondary role.

Notes

1. Jacques Derrida, *Writing and Difference*, trans. Alan Bass (University of Chicago Press, Chicago, 1978) p. 280.
2. Immanuel Wallerstein, 'Culture as the Ideological Battleground of the Modern World-System', unpublished paper, p. 6.
3. Roland Robertson, 'Globality, Global Culture and Images of World Order', in Hans Haferkamp and Neil Smelser (eds), *Social Change and Modernity* (University of California Press, Berkeley) (forthcoming).
4. Roland Robertson, 'Globalisation Theory and Civilisational Analysis', *Comparative Civilisations Review*, No 17, Fall 1987, p. 22.
5. Robertson, 'Globality, Global Culture and Images of World Order', p. 4.
6. For a more argued treatment of some of the themes sketched here, see: John Tagg, *The Burden of Representation. Essays on Photographies and Histories* (Macmillan, London, and University of Massachusetts Press, Amherst, 1988).
7. Ernesto Laclau and Chantal Mouffe, *Hegemony and Socialist Strategy. Towards a Radical Democratic Politics* (Verso, London, 1985) p. 111.
8. Ibid, p. 112.
9. See, Immanuel Wallerstein, 'The Universal and the National. Can There Be Such a Thing as a World Culture?' in Anthony King (ed.), *Culture, Globalisation and the World-System: Contemporary Conditions for the Representation of Identity*, Current Debates in Art History: Three (SUNY Binghamton and Macmillan, London, 1991).

10

Occupied Territories: Tracking the Work of Rudolf Baranik

Critics are a professionally ungrateful lot. They habitually accept invitations and then insult their host. It is almost standard form, for example, to deride and deconstruct the title under which one has been invited to speak. At a recent symposium I organised, all that was left of the title, after the panel had spoken, were the quotation marks, like fishbones on the side of the plate. Learning nothing from that experience, however, I intend to do the same and begin with David Craven's title: *Where Art and Society Meet.*

The phrase marks out a particular place: a place at which we are invited to encounter Rudolf Baranik's work, compelled by conscience to its own rendezvous. The place is a heavily patrolled border, the frontier of two distinct and counterposed realms – Art and Society: a place to take a stand and declare, '*Ich bin ein Künstler*'; or else pronounce ourselves for 'Society', knowing that to be a cold-war code for socialism. Our choices are limited. The

This chapter is the text of my contribution to a debate with Donald Kuspit, which took place as part of a symposium, *Where Art and Society Meet*, organised by David Craven and Janet Steck to coincide with 'To See, To Hear', an exhibition of the work of Rudolf Baranik at the Dowd Fine Arts Gallery, SUNY College at Cortland, in March 1988. It was subsequently published in *Block* (no. 14, 1988).

sentence has us in a turnstile. To escape, we must move this way or that, symmetrically, to the Right or the Left. On the one hand, Art; on the other, Society. Along their imaginary border the forces of a certain kind of conservatism and a certain kind of Marxism line up like mirror images. Art is external to Society because it is autonomous or determined: a transcendental realm or a superstructural expression. When we start, however, to think about the conditions of meaning, in Art or more generally, this separation and its concomitant, mutually dependent political choices break down.

To function as means of communication and exchange, systems of meaning must already contain social relations. Without shared conventions, patterns of usage and a community of speakers, we would not say we were dealing with a language at all. Languages, moreover, not only presuppose and contain social relations, but have a constitutive role in relation to their speakers, as their systems of differentiation and structures of address cut out the spaces of social identities that are produced, defined and fixed in relations of difference, which are also relations of power. We may deduce, therefore, not only that language systems are inherently social, but that sociality is, at least in part, an effect of systems of meaning.

I say 'in part' because, following Michel Foucault, we might say that a society – a social formation – is produced unevenly and discontinuously across three overlapping and mutually investing levels. At one level, the technological and organisational capacities of production, transformation, use and consumption, which themselves imply relations of communication, structures of obligation and subordination, and a division of labour; at another, the means and relations of communication, which also constitute a type of production and necessarily inflect relations of knowledge and power between individuals; and at a third, the specific techniques and modalities of power which fix social relations between individuals by structuring the field of their possible actions, but thereby also organise both the productivity of bodies and their place within a field of knowledge and truth. The effectivity of this model, in contrast to the traditional Marxist topography of base and superstructure, lies in the fact that it does not require practices to be divided up in advance and allotted to separate spaces, according to some predetermined function – economic, political, or ideological. It does not invoke a notion of totality in which practices already have a place; nor does it suggest a hierarchy of determination

between the three levels. Moreover, its conception of an irreducible play of power relations goes far beyond the limits of legitimation and coercion, of law and the state, or of the political in the narrowly defined sense of the term.

I trace out the terms of this analysis only in order to change the ground on which we think the problem and to leave behind the dualism of Art and Society. We are dealing now, around these terms, not with given and discrete domains, but rather with the specific ways in which relations of production, signification and power have been historically colonised and condensed in regulated institutional systems that constitute Art and Society as the objects of specific disciplines, in the fullest sense of the word. As the outcome of a specific system of inducements and exclusions, valorisations and constraints, the discipline of Art has a relatively recent history. It dates from the same period of the eighteenth century in which 'Society' emerged as an object of knowledge for human sciences similarly bound up with the negotiation of a new division of manual and intellectual labour, new disciplinary techniques and a new privilege of knowledge. What we have, therefore, is not a cusp of space between the two, where the skins of Art and Society meet and touch, like the fingers of God and Adam. We have specific historical sites, fields of knowledge, arenas of action, spaces marked out by incitements and constraints of production, meaning and power. It is these we must analyse rather than just inhabit, if we would calculate the possibilities of intervention and change. It is not then a question of the artist reaching out, intending to touch and move a social world that is somehow elsewhere. There is no externality. We are always already there: the structures with which we must struggle are in my voice, they are on this platform, they demarcate this space, they are the condition of our meaning, they divide and individuate us, they make us subject.

Does this, then, collapse the special space in which we have been invited to see and hear Rudolf Baranik's work? In the intended sense, it does; but as the price, perhaps, of opening other contexts of reading. Yet, there will be costs. For example, what the work will have to be seen as confronting is not an elementary existential plight or the abyss of the human condition.[1] The universalised categories of subject, experience and essence have been radically displaced by concepts which open on an analysis of historical régimes of production, meaning, power and subjection, across which divided

social identities are fixed and curtailed. The universalisation of the subject (wounded or not), like the universalisation of Art, is caught in the strategy of power it claims to transcend. By the same token, reverence for the status of the artist as 'the authentic voice of suffering and despair', 'the exemplary survivor', has also to be cut away. Seen as a specific kind of intellectual operating in specific, if overdetermined, institutional structures, it is the defeated artist who becomes the exemplar, the fixed signifier, the phallic monument to freedom and pain, the one who silences us by speaking for 'us' – and 'them'. A better model might be what Michael Herr in his book on Vietnam calls the 'moving-target-survivor subscriber': the grunt who susses out the war-machine, keeps on the move, and gets back home; the one who knows the ground and the rules of the game and whose resistance cannot be appropriated; rather than the self-immolating hero.[2]

If these are criticisms of what I take to be Rudolf Baranik's conception of his own project, as well as Donald Kuspit's reading of it, there may be other ways to pursue his diverse practices and welcome the way they will not cohere into an *oeuvre*. The notion of an interventionist practice, engaging the specificities of its own institutional entrapment, might bring to mind a specific kind or style of work: Barbara Kruger's undoing of forms of positioning in her disturbingly recaptioned images, perhaps; Victor Burgin's psychoanalytically interrogated photo-texts; or even Art & Language's polemical bludgeoning to death of the ontology of art. But these are not necessarily, or paradigmatically, what is implied.

The project of the New York avant-garde of the late 1940s, out of which features of Baranik's work emerged, can equally be read as an assault on language and logic as trenchant (and as regrettably abstracted and globalised) as any in contemporary works of Deconstruction. To the radically displaced metropolitan intellectuals of the 1940s, in the aftermath of Hiroshima, it seemed that the outcome of Western intellectual, industrial and scientific progress had been a culminating horror, beyond which the terms democracy, freedom and progress had ceased to have meaning. In the shadow of such negation, any attempt to document or speak the effects of the encompassing horror could only be complicit in it, by reducing its dimensions to the consumable. What had to be rejected was the very structure of Western representation which, as Dwight McDonald wrote in 1945, was 'no longer adequate, either aesthetically or

morally, to cope with the modern horrors'.[3] In a whole range of ways, therefore, painters of the New York avant-garde felt compelled to repudiate the Western Logos, with its traditions of rationalism, geometry and representation, to paint out the traces of a discredited system, and to arrive at a painting without image, a language without signs: to speak the unspeakable without representing it.

Such an enterprise, pointedly located at the level of language, had the potential to lead to a new politics of representation and an effective assault on the institutional régimes of sense of developed capitalist societies. Conceived as a transcendent moral and ethical mission, however, it led elsewhere. The void of representation was to be filled again by a search for redemptive mythologies, disclosing in turn the supposed primitive, irreducible and universal legibility of authentic human Art. By a parallel process of elision, the cultural and political dislocation of the avant-garde was seen not as a specific and local historical outcome, but as a universal condition and a necessary basis for heroism and creativity. Caught in the net of its own mythologising, the avant-garde was left without an effective grasp of its conditions of practice and without the means, theoretical or practical, to control the meaning of its own statements or prevent their appropriation by institutions and discourses the artists did not anticipate or even condone.

Yet the question of the tyranny of language, its institutional closures and régimes of meaning kept returning as the object of critical practice. It returned in a diversity of feminist practices which, from the 1960s, challenged the division of personal and political relations, the hierarchy of Art and craft, the dualism of a masculinised public and feminised private voice, the sexual division of labour in art, and the investment of all these in gendered relations of power and meaning. It returned in the theoretical critiques and counter-practices of conceptual and postconceptual art. And it returned in the collective, organisational activism of the 1970s which, going beyond the immediate issues to which it responded, broke down both an entrenched professional division of labour and constraining definitions of the object and mode of political action. What is striking about the continued engagement of Rudolf Baranik across this period is that, at each return, the issues were reimposed on and inflected by his many-levelled and heterogeneous body of work; from the 'Dark Silence' and 'Edge Manifesto' paintings, to

the meditations on the father's relation to the death of his son, to
the *24th Century Dictionary of the English Language*, to the Artists'
Meeting for Cultural Change. Here is someone compelled to
become a 'moving-target-survivor' and leave a trail of damage
across the institutional field.

I do not want to end in the imaginary position of dominance of
the commentator. Some of that damage reaches me, as I speak from
the privilege of criticism. In 1976, Rudolf was a member of a group
of artists, critics, historians and theoreticians who intervened
against the Whitney Museum's sleight-of-hand presentation of a
highly selective Rockefeller collection of American pictures as a
bicentennial celebration of the Great Narrative of National Art.
The group was excluded from the museum, just as non-white, non-
male, non-nationalistic work was excluded from historical status in
the narrative of the show. But the institution could not guarantee
the stability or affectivity of its own discourse: nothing is uncondi-
tional and the publication and street sale of an *anti-catalogue* by the
group stole the work for other meanings, even while it continued to
hang on the Whitney's walls.[4] Was this interventionist art or art
history? Was that secure division itself being shaken? This is the
place to end: with the challenge thrown out to art history and
criticism to grasp their own conditionality as practices implicated in
dominant institutions of meaning, professionalised structures of
knowledge and the networks of a cultural economy; to calculate
the effectivity of their own interventions; and to develop the
collaborative strategies necessary to resistance. But this is an
invitation that critics will no doubt be grateful to avoid.

Notes

1. Consider, for example, these two comments by Donald Kuspit on
 Rudolf Baranik's *Napalm Elegy* paintings. From 'Rudolf Baranik's
 Uncanny Awakening from the Nightmare of History', *Arts Magazine*,
 vol. 50, no. 6, February 1976, p. 71:

 > In a sense, for Baranik, the historical world, which destroys our
 > faces, exists only to trigger consciousness of fate – to induce the
 > abstract state of anxiety.

And eleven years later, from 'Elegy: Existential Prose and Polemical Poetry', in *Rudolf Baranik: Elegies, Sleep, Napalm, Sky* (Ohio State University Gallery of Fine Art, Columbus, Ohio, 1987) p. 18:

> The napalm did not make the wound; it was created in the process of the self's formation. The napalm – symbolic of political horror and inhumanity – is the occasion for the wounded self's display, not the cause of its wound. The social disintegration symbolised by napalm bombing strips the social camouflage from the narcissistically injured self and lets it display its wound with artistic grandiosity.

2. Michael Herr, *Dispatches* (Avon, New York, 1978) p. 7. The notions of the 'exemplary survivor' and 'the authentic voice of suffering and despair' are taken from Kuspit, 'Elegy: Existential Prose and Polemical Poetry', op. cit., pp. 13, 14.
3. Dwight Macdonald in the September 1945 issue of *Politics*; quoted in Serge Guilbaut, *How New York Stole the Idea of Modern Art*, trans. Arthur Goldhammer (University of Chicago Press, Chicago and London, 1983) p. 108.
4. The Catalogue Committee, *an anti-catalogue* (New York, 1977).

11

The Pachuco's Flayed Hide: Mobility, Identity and *Buenas Garras*

(with Marcos Sanchez-Tranquilino)

Founded on the disciplines of archaeology and natural history, both inherited from the classical age, the museum was a discredited institution from its very inception. And the history of museology is a history of all the various attempts to deny the heterogeneity of the museum, to reduce it to a homogeneous system or series.

Through reproductive technology postmodernist art dispenses with the aura. The fiction of the creating subject gives way to the frank confiscation, quotation, excerptation, accumulation and repetition of already existing images. Notions of originality, authenticity and presence, essential to the ordered discourse of the museum, are undermined.

Douglas Crimp[1]

This chapter was written as an intervention in the catalogue for the major retrospective of *Chicano Art: Resistance and Affirmation* that opened at the Wight Art Gallery, UCLA, in September 1990. An extensively illustrated version was also presented at the conference on *Cultural Studies Now and In the Future*, organised by Larry Grossberg, Cary Nelson and Paula Treichler, at the University of Illinois, Urbana-Champaign, in April 1990.

There is an irony here – if you are in a position to enjoy it: those who never made it till now arrive to find the Museum in ruins (though not before ASCO have signed it with their *placas*). But it gets worse. They arrive to find their Identity already gone, their Culture in fragments, their Nationhood dispersed, and their Monuments reduced to canonical rubble. The site they were to occupy is nothing but a razed discursive plane. Welcome to the New Art History. There is room for everyone and a place for none.

A victory like this might invite cynicism. At the very moment that the counter-mobilisations of dominated cultures come to challenge their exclusion from the privileged representations and institutions of the National Cultural Heritage, there ceases to be an occupiable space in which to celebrate their 'coming of age'. It is not just that the precious, airless vaults of Serious Art have *exploded*, as the differences and particularities that once were obstacles to inclusion have been transformed into the means of new and more flexible forms of accumulation. Nor is it just that, in the process, museums have willingly relativised themselves, eagerly colonising the market opportunities of diversity and enthusiastically embracing a new division of labour: social history for museums of daily life or folk and 'ethnic' art; vivid dioramic displays for museums of ethnography; and a wealth of spectacle, contextualisation and exhaustive cataloguing for the international circuit of major metropolitan museums of Art. This much might be dismissed as the 'spectacular reification'[2] of a service economy culture and stoically resisted in the name of an authentic presence and expression. The problem is that the grounds of this resistance have also *imploded* and the consequences for history, theory and practice have not been welcome.

As long as the Museum could be conceived as an Ideological State Apparatus[3] and art history as an ideological expression, then it was possible to imagine another place, another consciousness, the expression of another centre: an excluded but emergent and oppositional culture. The Universal Survey Museum[4] and a complicit conception of art history as the narrative unfolding of a universal cultural expression could be counterposed to oppositional art histories, as counter-narratives of the coming to consciousness of dominated but defiant peoples. The effectivity of this opposition depended, however, on preserving intact a conception of the

constitutive subject and a logic of representation as expression or reflection that compelled such oppositional art histories to cling to the imaginary body of their Other, even as they struggled to turn it on its head. Now, with the undermining of these categories and logics, both sides seem to have been flung out or sucked into a gravityless space – a space without familiar coordinates.

In such a space, art history can no longer be stabilised around that familiar strategic mixture of connoisseurship, iconography, artistic biography, and the study of periods and movements; but this is not because of the exposure of their functional implication in the power of the state or because of the revelation, beneath the 'one-sided, immediate unity' of their analyses, of a denied but determinant social basis. Such forms of sociological explanation have themselves been caught in the internal collapse of the discipline they claim to critique, as a new impetus in critical theory and cultural practice has invaded art history's structural categories, its narrative voice, its institutional security, and even its object of study. To see this itself as symptomatic of a 'cultural logic' of 'Late Capitalist' commodification would merely be circular: what is at issue is the 'logic' of symptomatic expression and the privileged knowledge on which it depends.[5] Appeals to experience or determinant interests similarly beg the question, but such appeals are no more a precondition of action than is a map of the imagined totality.[6] What is unravelling now is the discursive formation of a discipline – the conjunctural effects of its practices, institutions, technologies and strategies of explanation. It is precisely this unravelling that opens up spaces for new kinds of questioning and intervention so that, if the deconstruction of art-historical narratives of expression and identity conflicts with ideas of the cultural self-assertion of dominated groups previously excluded from the space of the active subject of culture and heritage, then what we need to ask is whether this conflict need be disabling or defeating. Are there other models of identity and cultural struggle?

It is time to return to cases. What is left of 'resistance and affirmation' for the subjects of *el Movimiento*, the Chicano civil rights movement, or of its cultural wing? At the end of this dry road stands a familiar figure. *Ese*, Louie: 'un vato de atolle', posing in Bogart-tough role, with his own imaginary music, in his dark topcoat and tailor-made drapes: 'his smile as deadly as his vaisas!'

'Legs Louie Diamond': switching the codes of fetishism on the street.[7]

> *Coats cannot be exchanged for coats . . .*
> 						Karl Marx[8]

> *Xipe Totec, Our Lord of the Flayed Hide, changes his skin.*
> 						Carlos Fuentes[9]

It should be explained that 'Louie' is the protagonist of a historically pivotal poem by José Montoya, to whom we shall have cause to return later. Louie is a small town *pachuco*: a stylish Mexican-American youth from the margins, who began to assert his ambivalent place in Californian society in the years following the end of the Second World War. Most significantly for us, he did this in part by wearing a Zoot Suit, and it is the effects of this suit's meanings that we are going to pursue. For, while Marx has told us that 'coats cannot be exchanged for coats', Louie changed his coat and, like the great Aztec God *Xipe Totec*, Our Lord of the Flayed Hide, in putting on a new skin, he put on a new identity. But this identity has a strange history in the challenge it posed, not only to the codes of respectable American and Mexican society, but also – subsequently – to the codes of cultural history.

In 1973, Arturo Madrid-Barela, finding that literary portraits of the *pachuco* paradoxically 'shed more light on his interpreters than on the subject', called on scholars 'to begin the long, laborious process of peeling back the layers of falsehood and fantasy that obscure [the *pachuco*'s] true history'.[10] The problem, Madrid-Barela knew, was one of visibility: the visibility for which *pachuco* and *pachuca* dressed, and were beaten and imprisoned. The question is whether this can be grasped in terms of paring, illuminating, clarifying or exposing a 'true history', free of the mythmakers' 'distortions',[11] outside the conditions of historical narration. As Bruce-Novoa has written in the context of the debate on representations of Chicano history and cultural production:

As more and more emphasis is placed on the discursive process of the creation of a text of cultural past, the possibility of returning to a belief in a monological history invested with the status of truth fades. [12]

The peeling of history implies the trace of the knife and the hand. Whose *vaisa* holds the *fila*? What is the arc of the cut? As Bruce-Novoa has argued, it was the continued closure of institutions of national culture to Chicanos that provoked a shift in the 1960s to a strategy of cultural nationalism, constructed out of the totalisation of 'communal memory and tradition' as a new truth with which to challenge 'dominant history' as false or, at best, partial and distorted. [13] The mythologising and the coupled demythologising of *pachuco* culture were outgrowths of attempts to fix such truth in narrative historiographical forms that assimilated themselves to the expressive structure of cultural nationalism. At the same time, this logic of cultural nationalism fixed the identity of writer and written – historian and object – in a cultural affinity that, paradoxically, had to transcend historicity. What was suppressed, whether tactically or not, was the play of difference that was the very field of emergence of the *pachuco*'s game. The *pachuco* could then be 'recovered' as the proto-subject of national regeneration, in a nationalist narration grounded on the notion of an essential ethnic identity that *expresses* itself in cultural form.

Yet a troubling residuum remained: the enigmatic problem of the *pachuco*'s Mexicanness or Americanness, bequeathed by Octavio Paz to all subsequent commentators. It has been, however, the essentialising narrative itself that has made this trouble and produced the enigma of the *pachuco*. Desertion from both Mexican and American cultures and insubordinate difference were, for wartime superpatriots, the marks of the *pachuco*'s treason. Seven years later, Paz looked back with lofty patrician disdain at the scowling, self-destructive 'sinister clown' as existential casualty:

> His whole being is sheer negative impulse, a tangle of contradictions, an enigma. Even his very name is enigmatic: *pachuco*, a word of uncertain derivation, saying nothing and saying everything. [14]

The puzzle of the *pachuco* as failure of identity was premised on a conception of subjectivity as given, unitary and constitutive, and on

a logic of culture as the expression of this constitutive subject. But these are the same assumptions that we encounter in later sub-cultural studies, which see in the Zoot Suit 'the product of a particular social context'[15] and 'a shared set of experiences':[16] a ritual form through which 'resistance can find natural and uncon-scious expression'.[17] The structure of explanation is the same, which may account for why, as late as 1984, Stuart Cosgrove could still believe that Paz's description of the *pachuco*'s delinquency and ambivalence could provide 'a framework in which the Zoot Suit can be understood'.[18]

And what of the notion of *pachuco* and *pachuca* culture as a *sub*culture – *sub*ordinated yet again? How could this be compatible with the recognition that it had no 'parent'; it was neither the child of North America, nor the orphan of Mexico. Derivation and dominance, as Paz vaguely sensed, were what it put at issue. And just as it spoke a double offence to both institutionally solidified national cultures and their violent securities of identity, so it has gone on offending the protocols of cultural histories – dominant or alternative – because they do not speak its *language*.

By contrast, *el pachuco* and *la pachuca* insisted on the textures of language – on *el Caló, el tacuche, los plaqueazos*; on their intransi-gence to monolingual readings – even while they insolently appro-priated the 'stinking badges' of the cultures through which they moved. To Paz's apparent annoyance, they refused to 'return to the dress of [their] forebears';[19] and what a bizarre imagining that conjures up. Instead, they got into the dress codes of white male status and normality, playing with the images of an Anglo popular culture's own masculine 'outsiders' – the southern dandy, the Western gambler, the *modern* urban gangster. They did not there-fore negate 'the very principles' of North American fashion, as Paz tells us,[20] but subsumed them in their own rhythms, arenas and exchanges, thereby exposing the limits of Paz's presumed subject of modernity, comfort, practicality and convenience. Such a strategy repudiated *sub*ordination in a hierarchy of national cultures. It was neither 'inside' nor 'outside': it ruptured their structures of Other-ness, at least for a moment, at least for the best times of the week.

Pachuco culture was an assemblage, built from machines for which they never read the manuals. It was a cultural *affirmation* not by nostalgic return to an imaginary original wholeness and past, but by appropriation, transgression, reassemblage – breaking and

restructuring the laws of language: in the speech of *Caló* and *pochismos*;[21] but also in the languages of the body, gesture, hair, tattoos, dress, and dance; and in the languages of space, the city, the *barrio*, the street. Paz was offended and saw only negativity: a grotesque and anarchic language that said nothing and everything: a failure of memory or assimilation. The refusal to choose made no sense. The aggressive visibility only exacerbated the lack of cultural presence. The *pachuco* was an indecipherable mythology. (The *pachuca* – the Black Widow – could not even be thought.) And so it goes on. Tragic, heroic, delinquent or grotesque, without a clear identity and location, the *pachuco* is a scandal of civilised meaning. In the name of national dignity, for Madrid-Barela in 1973 as for the white uniformed servicemen in the streets of East Los Angeles exactly thirty years earlier, he must be stripped, peeled, skinned, down to a raw and naked truth.[22]

Why do they want the *pachuco* naked? Why do they want his clothes? The *pachuco's tacuche*: the padded, finger-length coat with wide lapels; the narrow-brimmed lid or hat; the draped pants with reat-pleats, ballooning to the knee then narrowing tightly at the ankle; the looping chain; the double-soled shoes, good for dancing 'El Pachuco' and 'La Pachuquilla' to Lalo Guerrero and his Trio Imperial.[23] And the *pachuca* – different from but not Other to the male – in the same drape coat, straight black skirt or narrow slacks, flat black shoes or 'zombie slippers', and beehive hairdo, piled high and decorated, often with razor blades.[24] They knew what they were putting on, like the Filipinos in Los Angeles and the black youth of Georgia and Harlem, with whom *pachucos* and *pachucas* exchanged style cues,[25] and beyond this, without necessary connection, like those other fascinating delinquents of the 'Africas' and 'jungles' of great, industrialised cities: the 'flash' costermongers of Mayhew's London;[26] the Northern Scuttlers and their Molls;[27] the Bowery Boys and Gals of mid-nineteenth-century New York City;[28] or the *sapeurs* and *sapeuses* of present-day Kinshasa, with their immodest flashing of labels and their exuberant chanting-songs of French, Italian and Japanese designers' names.[29]

The clothes made meanings with their bodies. They made them hateful and desirable. They made them visible. But, worse than that, they made them readable in a way that had to be denied. This is not to suggest that there was ever a fixed and final reading attached to the clothes, outside a specific moment, framework and intervention,

or that the space of identity they described was ever homogeneous or resolved. (Transgressive or not, the suit of clothes torn from the back of the Zoot Suiter by rioters in Harlem and East Los Angeles in 1943 could appear again on the backs of the working-class, London Teds who fomented the 'Race Riots' of Notting Hill in 1958.) The point is that the meanings were *not* unreadable to the cultures they inflamed. You could not miss a Zoot Suit or a Pompadour in the street. But not only there. They stood out in a discursive space the *pachuco* and *pachuca* extended around them: a third space, between the dualities of rural and urban, Eastside and Westside, Mexican and American, and, arguably, feminine and masculine. Not pure negation. Not *mestizo* – half and half – but an even greater *mestizaje*.[30] A new space: a new field of identity.

On either side of this refusal of Otherness and 'this stubborn desire to be different',[31] the dominant Anglo and estranged Mexican cultures each refused to recognise this new space and continued to blame the *pachuco*'s corruption on the contamination of the other. Displaced from both, *pachucos* and *pachucas* sought to make an identity as mobile as the space of the street they inhabited; mobile, yet legible, at least to those who shared the code and could read the *placas* emblazoned throughout the *barrio*. As a space of mobility without guarantees, the street articulated a new economy of identity and power. It was a polity marked out, but also made legible, in emphatic and constantly overpainted *plaqueazos* that served as a check on the local abuse of power in the street by their public declaration of an always shifting pattern of relations, as territories, cohorts, friends and lovers were gained and lost. Yet this writing was always on others' walls. The space of the streets was always staked out in advance: the routes and boundaries laid down by city planners and patrolled by city police, social workers and ethno-linguists; the fixed grid for regulating movement and dissent; the commercial strips for commodity display and consumption; the passages and barriers to and from the *colonia* or *barrio*: never an equal space for the housed and the homeless, or for men and women, even when, in prurient indignation, the Los Angeles newspapers crowed that 'Zooter Girls' were fighting with knives and brass knuckles alongside the men.[32]

The field was one they neither owned nor controlled. And if the path they cut across it was a path of resistance, what they made was not a track to something lost or excluded, but a path of interference:

a resistance to reading – for which they paid a heavy price. And the resistance has not stopped. It frustrates Madrid-Barela's call for 'social and economic documentation' that will dispel the *pachuco*'s 'mythic dimensions' and expose the 'construct of fact and fiction'.[33] Madrid-Barela will have no truck with 'the empty posturings of brown power or the middle-class accommodations of ethnic politics',[34] but what he offers in their place is a reduction to a duality that insists on a choice *pachucos* and *pachucas* had already subverted.

This is not to deny that *pachucas* and *pachucos* operated on historical and political grounds: that they negotiated changing conditions of urban working-class life, family structure and employment; or that they found their opportunity in the emerging patterns of a new cross-national and inter-cultural economy, as war work brought a relative affluence and changed patterns of labour and consumption. It is not to deny that they were touched by the desire for the beyond of an impossible integration, by that sad optimism and nostalgia for the future which is the pathos of modernism. It is to suggest that their interlingual strategy of identity and resistance was a strategy of the border and will not accommodate to the old homilies and historiographies, and that the consequences of this have not been engaged. Octavio Romano, for example, decides that: '*The Pachuco movement was one of the few truly separatist movements in American History*'. Yet, undoing his own assertion, he goes on:

> Even then, it was singularly unique among separatist movements in that it did not seek or even attempt a return to roots and origins. The Pachuco indulged in a self-separation from history, created his own reality as he went along even to the extent of creating his own language.[35]

For those who wore the Zoot Suit, it was not a question of discovering beneath the structures of domination an innate individual and collective identity that could be safeguarded and cultivated until the political moment destined for its emergence. *Pachuco* culture was a survival strategy not of purity, of saying *less*, but rather of saying *more*, of saying too much, with the wrong accent and intonation, of mixing the metaphors, making illegal crossings, and continually transforming language so that its effects might never be wholly assimilable to an essential ethnicity, to a 'social

ecology' of delinquency, or to the spectacle of multiculturalism and commodified diversity.[36]

> *It is the secret fantasy of every* bato *in or out of the* Chicanada *to put on a Zoot Suit and play the Myth* más chucote que la chingada.
>
> Luis Valdez[37]

In 1970, José Montoya buried El Louie. In 1977, he dug him up again to take his pulse. His aim was to combat a loss of cultural memory at a time when *el Movimiento,* the Chicano civil rights movement, seemed to be entering a less militant phase. In his documentary exhibition and publication, *Pachuco Art: A Historical Update*, which grew out of the Royal Chicano Air Force's *Barrio Art Program* in Sacramento, Montoya sought to do this through collective remembering, infusing the imagery and symbolism of the *pachuco* into contemporary Chicano art and *barrio* life, inverting the stereotype of negation and marginalisation, and instilling pride in a new generation of *Chicanitos*. Against the embarrassed forgetfulness of conservatives and the moralising denial of leftists, Montoya ensured that the *pachuco* would push his defiant foot forward and fix his stare again, reinvented and reinvested as the prototype of Chicano cultural resistance: 'the first Chicano freedom-fighters of the Chicano movement'.[38]

The paradox, however, was that the *pachuco*, who never looked back or stood still, should be absorbed into a mythology of the past as a means of making sense of present grounds of struggle in terms of an assertion of an essential national identity and cultural expression. The effect was to be underlined in the following year by the popular success of Luis Valdez's play *Zoot Suit* and the image of Ignacio Gómez's poster, with its monumental and phallicised figure, legs triumphantly astride the diminutive projection of *El Lay*'s City Hall. The 'enigma' had taken on a new and unambiguous dignity of presence, though Montoya seemed to know the *pachuco* remained a troubling if necessary space of absence in this discourse. (El Louie was always already gone; buried from the start: 'Hoy enterraron al Louie'.[39] Buried in a textuality, one might

say, with which he had known how to play. In all events, gone – as the very spur to his resurrection in words of remembering.)[40]

What is at issue in this resurrection of the *pachuco* in the late 1970s is not the displacement of militancy by nostalgia. It is the representation of that militancy through the articulation of the *pachuco* into the politics of identity of a *nationalist* movement. The problems here are the problems of all nationalisms through which, as Tom Nairn has put it:

> societies try to propel themselves forward to certain kinds of goal (industrialization, prosperity, equality with other peoples, etc.) *by a certain sort of regression* – by looking inwards, drawing more deeply upon their indigenous resources, resurrecting past folk-heroes and myths about themselves and so on'.[41]

Nationalisms work through such *differentiae* because they have to, caught as they are in the conflicts of *modernity* and *modernisation*, in conditions of uneven development that, within the spaces of colonialist domination, may yield no resources but the geographical, ethnological and cultural peculiarities of a region which, in the rhetorics of nationalism, become the indices of origins, roots, hidden histories and shared heritages. Yet, however successful it may be in articulating a populist culture of identity, 'all nationalism', Nairn says, 'is both healthy and morbid'.[42]

Whatever momentum of reidentification and reterritorialisation nationalisms make possible, they always turn on their own strategy of terror: their own interiorisation of a centre, their own essentialising of a dominant frame of differentiation, their own pogroms and expulsions. Whatever the tactical value of their reactive inversions, nationalist discourses remain prisoner to the very terms and structures they seek to reverse, mirroring their fixities and exclusions. But the attachment is also deeper and its effects more pervasive and unconscious, as nationalisms are fractured by the drive of a desire for the very Other they constitute, denigrate and expel, yet to which they continue to attribute enormous powers.

The crisis of coherence and the instability of such nationalist formations are not, then, only a function of accelerating multinational exchange or globalised communications and travel. They mark an internal crisis, and a crisis, we have been arguing, that the *pachuco* and *pachuca* knowingly provoked. There is a deep contradiction, therefore, in their assimilation, alongside the *conquistador*

and Aztec noble, to the discourse of essential identity and expressive culture; just as there is something highly significant in the fact that this assimilation was primarily negotiated around the monumentalised figure of the male, largely to the exclusion of the *pachuca*.[43] The transgressive nature of their mutual practice could not be recognised.

Yet, we should be careful ourselves not to be reductive here. The Chicano nationalist movement that began in the 1960s was centrally an antiracist, civil rights movement that rejected all previous identities and defined Mexican Americans as a regionally diversified, multicultural and mixed race people from whom would arise *La Nueva Raza*.[44] Nevertheless, its attempt to shape a politics of unification and nationhood on the basis of the 'reclamation' of an indigenous, non-white, family-based identity and culture – 'a Bronze People with a Bronze Culture'[45] – suppressed differences and conflicts in the historically antagonistic elements it sought to merge and remained haunted by a duality of assimilation and secession beyond which the *pachuca* and *pachuco* had already gone.

There is another sense, however, in which the rediscovery of *pachuco* culture was rightfully central. If the term 'Chicano', itself taken over from *pachuco* vocabulary,[46] can be understood as an assertion not of a lost origin but of a simultaneity and multiplicity of identities, then the question of cultural retrieval may be posed as one of engaging not the *imagery*, but the *strategy* of the *pachuco* and *pachuca*; a strategy, that is, not of fixed difference, but of the transformation of languages and spaces of operation to evade both invisibility and assimilation. From this point of view, the re-engagement of the past might lead not to a litany and iconography of masculinist heroics, but to the mode of operation of a group such as ASCO, founded in 1972 by *'veteranos'* of the 1960s' car clubs and 'blowouts' of East Los Angeles's Garfield High: Harry Gamboa Jr., Gronk, Willie Herrón, and Patssi Valdez.[47]

ASCO: nausea, disgust, repulsion: their audience's response, but also their own reaction to themselves, to an American social environment of poverty, racism, sexism and militarism, and to what Gamboa has described as 'the frenzied fiasco of depersonalised survival in the urban environment'.[48] Like the *pachuco* and *pachuca*, ASCO did not depend on establishing a continuist historical tradition through which the imaginary securities of the past might guarantee the resistance of the present. Nor did they seek

to avoid what Kobena Mercer has called 'skirmishes of appropriation and commodification played out around the semiotic economy of the ethnic signifier'.[49] ASCO risked the streets and found in the accelerating commodity theatre and political battleground of Whittier Boulevard the material and characteristic exaggerations from which they could make their performance work.

Their response to Chicano displacement, denial and subjugation did not, however, stay in the *barrio*. It spilled over into the Anglo Westside and its prospering network of institutions for marketing and promoting a quasi-official 'modern' art culture. In 1972, ASCO 'signed' or vandalised the Los Angeles County Museum of Art with their *plaqueazos*, claiming the building, the entire eclectic collection, its *mainstreams* and organising historiographical narratives for their 'art'. The 'work' lasted a day before it disappeared, like Siquieros's mural in Olvera Street, behind a coat of official whitewash. But a significant territory had been breached. As Jean Baudrillard has argued, in the absence of any transcendent system from which works of art may be said to derive, it is the signature – sign of the subject-creator in name – that secures authenticity and the code on which the integrity of meaning of the oeuvre and the system of consumption founded upon it both depend:

> the slightest attack upon this sign which is both authentic and accepted, unmotivated and codified, is felt as a profound attack upon the cultural system itself . . .[50]

But ASCO's was a calligraphic gesture that, at the same time, mocked itself: marking, in the gap between *signature* and *placa*, its own impossibility, at the site of an institution that had already marked their work and that of contemporary Chicano artists as Other, 'outside'.

ASCO marked, resigned, but refused to occupy the spaces, genres, and languages disposed in advance 'for Chicanos'. Gronk and Herrón might work, on and off, for years on the *Black and White Mural* in the Estrada Courts Housing Project, but on another occasion – as on Christmas Eve 1974 – it would be enough for Gronk to tape Patssi Valdez and Humberto Sandoval to a liquor-store wall to constitute an *Instant Mural*. Yet the tapes could never hold them. Like the *pachucos y pachucas*, ASCO saw the spaces of cultural barrioisation as spaces of transformation and borders as lines to be erased.[51] They seemed at odds, therefore, not only with

the agencies of a dominant Anglo culture, but also with those Chicano artists and historians whose sense of cultural identity sprang from the fountainhead of nationalist cultural metaphors – pre-Columbian themes, the iconography of the Mexican Revolution, and the relics of the imagery of an adapted Roman Catholicism – rather than from the exhilaration of cultural cross-dressing. For ASCO, the space of this nationalist strategy and its attendant historiography were in ruins; but this was not disabling.

As Stuart Hall has remarked:

> The past is not waiting for us back there to recoup our identities against. It is always retold, rediscovered, reinvented. It has to be narrativized. We go to our own pasts through history, through memory, through desire, not as a literal fact.[52]

What we begin to make out is another narration of identity, another resistance. One that asserts a difference, yet cannot be absorbed into the pleasures of a global marketing culture. One that locates its different voice, yet will not take a stand on the unmoving ground of a defensive fundamentalism. One that speaks its location as more than local, yet makes no claim to universality for its viewpoint or language. One that knows the border and crosses the line.

This is not a new story. It is not one that had to wait for the theorisation of the 'global postmodern'. As we began to hear it, it drifted into *El Lay* with the *pachucos* from El Paso, Texas. Not from Utopia or from Paris, but from 'ol' EPT' and the border with Juárez. A voice from the borderlands; though the border, as we know, was not always there. Should we find this a surprise: that this uncertain, in-between space should be the arena of a new formation of identity? Gloria Anzaldúa would remind us:

> Borders are set up to define the places that are safe and unsafe, to distinguish *us* from *them*. A border is a dividing line, a narrow strip along a steep edge. A borderland is a vague and undetermined place created by the emotional residue of an unnatural boundary. It is in a constant state of transition. The prohibited and forbidden are its inhabitants. *Los atravesados* live here: the squint-eyed, the perverse, the queer, the troublesome, the mongrel, the mulato, the half-breed, the half dead; in short, those who cross over, pass over, or go through the confines of the 'normal'.[53]

Notes

1. Douglas Crimp, 'On the Museum's Ruins', in Hal Foster (ed.), *The Anti-Aesthetic: Essays on Postmodern Culture* (Bay Press, Port Townsend, WA, 1983) pp. 49, 53.
 It should be understood from what follows that the ruining of the Museum can only be understood as a rhetorical inflation of a specific and conditional crisis, comparable to Baudrillard's equally hyperbolic, and only apparently opposite, assertion that: 'The museum, instead of being circumscribed in a geometrical location, is now everywhere, like a dimension of life itself' (Jean Baudrillard, 'The Precession of Simulacra', in *Simulations*, trans. Paul Foss and Paul Patton (Semiotext(e), Foreign Agents Series, New York, 1983) pp. 15–16.)
2. The term comes from Hal Foster, 'Wild Signs: The Breakup of the Sign in Seventies' Art', in John Tagg (ed.), *The Cultural Politics of 'Postmodernism'*, Current Debates in Art History: One (SUNY at Binghamton, Binghamton, 1989) pp. 69–85.
3. See Louis Althusser, 'Ideology and Ideological State Apparatuses (Notes towards an Investigation)', in *Lenin and Philosophy and other essays*, trans. Ben Brewster (New Left Books, London, 1971) pp. 121–73.
4. See Carol Duncan and Allan Wallach, 'The Universal Survey Museum', *Art History*, vol. 3, no. 4, 1980.
5. Cf. Fredric Jameson, 'Postmodernism, Or the Cultural Logic of Late Capitalism', *New Left Review*, no. 146, July/August 1984, pp. 53–92.
6. Ibid, pp. 89–92. Cf. also: Fredric Jameson, 'Cognitive Mapping', in Cary Nelson and Lawrence Grossberg (eds), *Marxism and the Interpretation of Culture* (University of Illinois Press, Urbana and Chicago, 1988) pp. 347–57; and Anders Stephanson, 'Regarding Postmodernism – A Conversation with Fredric Jameson', *Social Text*, no. 17, Fall 1987, pp. 29–54.
7. José Montoya, 'El Louie', *Rascatripas*, vol II (Oakland, CA, 1970); republished in Luis Valdez and Stan Steiner (eds), *Aztlán, An Anthology of Mexican American Literature* (Random House, New York, 1972) pp. 333–37.
8. Karl Marx, *Capital: A Critique of Political Economy*, vol. 1, trans. Ben Fowkes (Vintage Books, New York, 1977) p. 132.
9. Carlos Fuentes, *A Change of Skin*, trans. Sam Hileman (Farrar, Straus & Giroux, New York, 1968) p. 371.
10. Arturo Madrid-Barela, 'In Search of the Authentic Pachuco: An Interpretive Essay', *Aztlán*, vol. 4, no. 1, Spring 1973, p. 57 and p. 31.
11. Ibid., p. 32.
12. Bruce-Novoa, 'History as Content, History as Act: The Chicano Novel', *Aztlán*, vol. 18, no. 1, 1987, p. 42.
13. Ibid., pp. 41–42.
14. Octavio Paz, 'The Pachuco and Other Extremes', in *The Labyrinth of Solitude*, trans. Lysander Kemp, Yara Milos and Rachel Phillips Belash (Grove Press, New York, 1961) p. 14. For a more extended

analysis of this essay, see: Marcos Sanchez-Tranquilino, 'Mano A Mano: An Essay on the Representation of the Zoot Suit and Its Misrepresentation by Octavio Paz', *Journal*, The Los Angeles Institute of Contemporary Art, Winter 1987, pp. 34–42.

15. Stuart Cosgrove, 'The Zoot Suit and Style Warfare', in Angela McRobbie (ed.), *Zoot Suits and Second-Hand Dresses: An Anthology of Fashion and Music* (Unwin Hyman, Boston, 1988) p. 5. The article is reprinted from *History Workshop Journal*, no. 18, 1984.

16. Ibid., p. 8.

17. Ibid., p. 20.

18. Ibid., pp. 5–6.

19. Paz, op. cit. p. 16.

20. Ibid., p. 15.

21. *Pochismos* or *Anglicismos* are translated and Hispanised English words taken over into south-western interlingual slang. *Caló* draws on south-western Spanish, regional dialect, Mexican slang, and words that have changed little in form and meaning from Spanish Gypsy slang of the fifteenth century; but it is also a language of constant innovation, kept in restrictive usage by frequent and rapid changes of content through the invention of new terms. See: George Carpenter Barker, *Pachuco: An American-Spanish Argot and Its Social Functions in Tucson, Arizona*, Social Science Bulletin no. 18, University of Arizona Bulletin, vol. 21, no. 1, January 1950. See also, Raphael Jesús Gonzales, 'Pachuco: the Birth of a Creole Language', *Arizona Quarterly*, vol. 23, no. 4, Winter 1967.

22. Cf., Mauricio Mazón, *The Zoot-Suit Riots. The Psychology of Symbolic Annihilation* (University of Texas Press, Austin, 1984).

23. Barker, op. cit., p. 39.

24. See, for example, Beatrice Griffith, *American Me* (Houghton Mifflin Company, Boston, 1948) p. 47.

25. Cf., Cosgrove, op. cit.; Ralph H. Turner and Samuel J. Surace, 'Zoot-Suiters and Mexicans', in Roger Daniels and Spencer C. Olm (eds), *Racism in California. A Reader in the History of Oppression* (The Macmillan Co., New York, 1972) pp. 210–19; Steve Chibnall, 'Whistle and Zoot: The Changing Meaning of a Suit of Clothes', *History Workshop Journal*, no. 20, 1985; and Kobena Mercer, 'Black Hair/Style Politics', *New Formations*, no. 3, Winter 1987, pp. 33–54.

26. See, Henry Mayhew, *London Labour and the London Poor*, vol. 1, *The London Street Folk* (Frank Cass & Co., London, 1851) pp. 4–61, especially 'Language of Costermongers', pp. 23–4, and 'Of the Dress of Costermongers', pp. 51–2. See also, Dick Hebdige, 'Hiding in the Light: Youth Surveillance and Display', in *Hiding in the Light: On Images and Things* (Comedia/Routledge, London & New York, 1988) pp. 17–36.

27. See, R. Roberts, *The Classic Slum* (Manchester University Press, Manchester, 1971).

28. See, Christine Stansell, *City of Women: Sex and Class in New York, 1789–1860* (University of Illinois Press, Urbana and Chicago, 1987)

pp. 89–101. See also: Alvin F. Harlow, *Old Bowery Days: The Chronicles of a Famous Street* (D. Appleton & Co., New York, 1931); and Lloyd Morris, *Incredible New York: High Life and Low Life of the Last Hundred Years* (Random House, New York, 1951). Contemporary accounts and journalism include: George C. Foster, *New York by Gas-Light* (Dewitt & Davenport, New York, 1850); Abram C. Dayton, *Last Days of Knickerbocker Life in New York* (G. W. Harlan, New York, 1882); and George Ellington, *The Women of New York, Or the Underworld of the Great City* (Arno Press, New York, 1869).

29. Michael Macintyre, 'Hot Couture', *The Face*, vol. 2, no. 14, November 1989, pp. 84–89.

30. Cf. Gloria Anzaldúa, *Borderlands/La Frontera. The New Mestiza* (spinsters/aunt lute, San Fransisco, 1987) p. 5.

31. Paz, op. cit., p. 15.

32. See, José Montoya, *Pachuco Art: A Historical Update* (RCAF, Sacramento, 1977).

33. Madrid-Barela, op. cit., p. 58 and p. 31.

34. Ibid., p. 57.

35. Octavio Romano, 'The Historical and Intellectual Presence of Mexican-Americans', *El Grito*, vol. II, no. 2, Winter 1969; quoted in Bruce-Novoa, *Chicano Poetry. A Response to Chaos* (University of Texas Press, Austin, 1982) p. 219.

36. The emergence of 'youth' as a psycho-social category linked to the notion that the city was divided and organised into distinct 'ecological' areas, each with its own 'world', was developed by the Chicago School of Social Ecology from the late 1920s on: see, R. E. Park and R. D. McKenzie (eds), *The City* (University of Chicago Press, Chicago, 1967); and R. E. Faris, *Chicago Sociology: 1920–1932* (University of Chicago Press, Chicago, 1967). For an application of this model to research on Chicano youth gang members and *pintos* (prison inmates), see Joan W. Moore, *Homeboys: Gangs, Drugs, and Prison in the Barrios of Los Angeles* (Temple University Press, Philadelphia, 1978).

On the question of cultural innovation and the diversification of commodity production and marketing, see, e.g., Mercer, op. cit. Nevertheless, even if, as Mercer argues, the Zoot Suit was absorbed into the 'Bold Look' of mainstream 1949 'menswear', what was repressed in this incorporation? And what repressed meanings returned to weigh 'like a nightmare' on the backs of the wearers?

In other respects, and aside from his continued attachment to subcultural theory, our analysis comes close to Mercer's notion of the 'creolisation' of inter-cultural forms and his analysis of black dress and hair styles in the 1940s as encoding 'a refusal of passivity by way of a creolising accentuation and subtle inflection of given elements, codes and conventions'. (Mercer, op. cit. p. 47.)

37. Luis Valdez, *Zoot Suit: An American Play*, 1978. Although Valdez's historic play has never been published, this line is often quoted in discussions: see Jorge A. Huerta, 'The Ultimate Pachuco: Zoot Suit',

in *Chicano Theater: Themes and Forms* (Bilingual Press/Editorial Bilingue, Ypsilanti, Michigan, 1982) pp. 174–85. For timely Chicana feminist analyses of *Zoot Suit* and Chicano theatre, see Yolanda Broyles Gonzáles, 'Toward a Re-Vision of Chicano Theatre History: The Women of El Teatro Campesino', in *Making A Spectacle: Feminist Essays on Contemporary Women's Theatre* (The University of Michigan Press, Ann Arbor, Michigan, 1989) pp. 209–39; and Yvonne Yarbro-Bejarano, 'The Female Subject in Chicano Theatre: Sexuality, "Race", and Class', *Theatre Journal*, vol. 38, no. 4, December 1986, pp. 389–407.

38. Montoya, *Pachuco Art: A Historical Update*, p. 1.

39. The opening line of Montoya, 'El Louie', op. cit.

40. In George Barker's classic study of *pachuco* argot, for example, 'Luey' is one of Barker's informants and *dramatis personae* in the imaginary *pachuco* dialogue in which, as in Montoya's poem, 'Luey' stages a fight with 'Goat': Barker, op. cit., pp. 34–5. Montoya insisted that La Chiva actually existed, though reminded by Bruce-Novoa that *la chiva* is slang for heroin and an occasional euphemism for La Chingada: The Fucked One – Death. Cf. Bruce-Novoa, *Chicano Poetry*, pp. 14–25.

41. Tom Nairn, 'The Modern Janus', in *The Break-Up of Britain: Crisis and Neo-Nationalism*, second enlarged edition (Verso, London, 1981) p. 348.

42. Ibid., p. 347.

43. There are important exceptions, however, in the work of Judy Baca and Isabel Castro and, indeed, of José Montoya himself.

44. Cf. Carlos Muñoz Jr., *Youth, Identity, Power: The Chicano Movement* (Verso, London & New York, 1989) pp. 15–16.

45. *El Plan Espiritual de Aztlán*, National Chicano Youth Liberation Conference, Denver, Colorado, 1969. Perhaps the tensions of this nationalism are most poignantly gathered in the notion of 'our *Mestizo* Nation'. See Rudolfo A. Anaya and Francisco Lomeli (eds), *Aztlán: Essays on the Chicano Homeland* (Academia/El Norte Publications, Albuquerque, New Mexico, 1989) pp. 1–5.

46. Barker, op. cit., p. 41. The simultaneity of identities signified by the term 'Chicano' is what characterises 'American' identity when that identity is not reduced to a mythical Anglo-European paradigm: see Marcos Sanchez-Tranquilino, '*Murales del Movimiento*: Chicano Murals and the Discourses of Art and Americanization', in Eva Sperling Cockroft and Holly Barnet-Sanchez (eds), *Signs from the Heart: California Chicano Murals* (Social and Public Art Resource Center, Venice, CA, 1990) pp. 85–101.

47. Members of the group had earlier distinguished themselves as 'jetters': Chicano high school students who differentiated themselves from contemporary *cholos* and Anglos through a fashion code based not on exaggeration, but on sardonic and elegant understatement. The 'blowouts' were the 1968 walkouts of students from the high schools of East Los Angeles, protesting both the Viet Nam War and the

discriminatory conditions and lack of resources of their segregated education.

48. Harry Gamboa Jr., 'The Chicano/a Artist Inside and Outside the Mainstream', *Journal*, The Los Angeles Institute of Contemporary Art, Winter 1987, p. 22.
49. Mercer, op. cit., p. 49.
50. Jean Baudrillard, 'Gesture and Signature: Semiurgy in Contemporary Art', in *For A Critique of the Political Economy of the Sign*, trans. Charles Levin (Telos Press, St Louis, MO, 1981) p. 106.
51. Gronk announced that he would be erasing the border in 1980. See: Harry Gamboa Jr., 'Gronk: Off-The-Wall Artist', *Neworld Magazine*, vol. 6, no. 4, July 1980, pp. 33–43.
52. Stuart Hall, 'Old and New Ethnicities', unedited transcription of the second of two lectures given in conjunction with the Third Annual Symposium on 'Current Debates in Art History', *Culture, Globalisation and the World-System: Contemporary Conditions for the Representation of Identity*, organised by Anthony King, Department of Art and Art History, SUNY Binghamton, 14 March 1989, p. 28.
53. Anzaldúa, op. cit., p. 3.

Glossary

atravesados	those who cross over or are crossed over.
barrio	Chicano urban neighbourhood.
Caló	argot of the Mexican underworld and *pachucos*, which can be traced back to the Gypsies of Spain who referred to their language as *Caló;* thought to have been brought to Mexico by bullfighters.
chucote	abbreviation of *pachucote*.
colonia	Chicano rural neighbourhood.
ese	say, hey; guy; him; you.
fila	a type of knife (*pachuco*; from *filero*: colloquial Mexican).
garras	clothes (*pachuco*; from New Mexican dialect: rags), e.g. 'buenas garras': fine clothes.
pachuco, pachuca	(originally) man, woman from El Paso (*El Pachuco*).
placa	Chicano 'graffiti' signature or emblem.
plaqueazo	Chicano public 'graffiti' badge or emblem.
pochismos	or 'Anglicismos' are of two main types: English words that have been made into Spanish nouns or verbs through Hispanisation or changes in spelling or pronunciation (e.g. *birria* – beer); and English or American slang expressions that have been translated into Spanish (e.g. *pegarle* – to beat it).

tacuche suit (*pachuco*: Zoot Suit).

vaisa hand (*pachuco*; from 'vice', as in 'grip like a vice').

vato de atolle a man of high integrity and strong character.

veterano *pachuco* or veteran of the so-called Los Angeles 'Zoot-Suit Riots' of 1943; more generally, a veteran youth gang member, a long-time *barrio* resident, or a Chicano elder.

Bibliography

Althusser, Louis, *For Marx*, trans. Ben Brewster (Allen Lane, The Penguin Press, Harmondsworth, 1969).

——, *Lenin and Philosophy and other essays*, trans. Ben Brewster (New Left Books, London, 1971).

Althusser, Louis and Etienne Balibar, *Reading Capital*, trans. Ben Brewster (New Left Books, London, 1970).

Anderson, Perry, 'Modernity and Revolution', *New Left Review*, no. 144, March–April 1984, pp. 96–113.

Anzaldúa, Gloria, *Borderlands/La Frontera. The New Mestiza* (spinsters/aunt lute, San Fransisco, 1987).

Appignanesi, Lisa (ed.) *Postmodernism* (ICA Documents, 4 & 5, Institute of Contemporary Arts, London, 1986).

Appignanesi, Lisa (ed.) *The Real Me: Postmodernism and the Question of Identity* (ICA Documents, 6, Institute of Contemporary Arts, London, 1987).

Barthes, Roland, *Mythologies*, trans. Annette Lavers (Paladin, London, 1973).

——, *Elements of Semiology*, trans. Annette Lavers and Colin Smith (Jonathan Cape, London, 1967).

——, *Image-Music-Text*, ed. S. Heath (Fontana/Collins, Glasgow 1977).

——, *Camera Lucida*, trans. Richard Howard (Jonathan Cape, London, 1982).

Batchen, Gregory, 'Photography, Power, and Representation', *Afterimage*, vol. 16, no. 4, November 1988, pp. 7–9.

Baudrillard, Jean, *The Mirror of Production*, trans. Mark Poster (Telos Press, St Louis, MO, 1975).

——, *For A Critique of the Political Economy of the Sign*, trans. Charles Levin (Telos Press, St Louis, MO, 1981).

——, 'The Precession of Simulacra', in Brian Wallis (ed.), *Art After Modernism. Rethinking Representation*, (Godine, New York, 1984).

——, *The Ecstasy of Communication*, trans. Bernard and Caroline Schutze, ed. Sylvère Lotringer (Semiotext(e), Foreign Agents Series, New York, 1988).

——, *Selected Writings*, ed. Mark Poster (Stanford University Press, Stanford, 1988).

Baudry, Jean-Louis, 'Ideological Effects of the Basic Cinematographic Apparatus', *Film Quarterly*, vol. 28, no. 2, Winter 1974–75.

——, 'The Apparatus: Metapsychological Approaches to the Impression of Reality in the Cinema', *camera obscura*, no. 1, Autumn 1976, pp. 104–28.

Baxandall, Michael, *Patterns of Intention. On the Historical Explanation of Pictures* (Yale University Press, New Haven, 1985).

Benjamin, Walter, *Illuminations*, trans. Harry Zohn, ed. Hannah Arendt (Fontana/Collins, London, 1973).

——, 'The Author as Producer', in Victor Burgin (ed.), *Thinking Photography* (Macmillan, London, 1982).

Bennett, Tony, 'The Exhibitionary Complex', *New Formations*, no. 4, Spring 1988, pp. 73–102.

Bennett, T., G. Martin, C. Mercer and J. Woollacott (eds), *Culture, Ideology and Social Process* (Batsford, London, 1981).

Berman, Marshall, *All That Is Solid Melts Into Air: The Experience of Modernity* (Simon & Schuster, New York, 1982).

Bernheimer, Richard, *The Nature of Representation: A Phenomenological Inquiry* (New York University Press, New York, 1961).

Bhabha, Homi K., '"The Other Question" - The Stereotype and Colonial Discourse', *Screen*, vol. 24, no. 6, Nov.–Dec. 1983.

Blackburn, Robin (ed.), *Ideology in Social Science: Readings in Critical Social Theory* (Fontana/Collins, Glasgow, 1972).

Bloomfield, Jon (ed.), *Class, Hegemony and Party* (Lawrence & Wishart, London, 1977).

Blonsky, Marshall (ed.), *On Signs* (The Johns Hopkins University Press, Baltimore, MD, 1985).

Brewster, Ben, 'Fetishism in *Capital* and *Reading Capital*', *Economy and Society*, vol. 5, no. 3, August 1976, pp. 344–51.

Bryson, Norman, *Vision and Painting: The Logic of the Gaze* (Macmillan, London, 1983).

Bryson, Norman (ed.), *Calligram. Essays in New Art History from France* (Cambridge University Press, London and New York, 1988).

Bürger, Peter, *Theory of the Avant-Garde*, trans. Michael Shaw (University of Minnesota Press, Minneapolis, 1984).

Burgin, Victor (ed.), *Thinking Photography* (Macmillan, London, 1982).

——, *The End of Art Theory: Criticism and Postmodernity* (Macmillan, London, 1986).

Certeau, Michel de, *The Practice of Everyday Life*, trans. Steven F. Rendall (The University of California Press, Berkeley, Los Angeles and London, 1984).

——, *Heterologies: Discourse on the Other*, trans. Brian Massumi (University of Minnesota Press, Minneapolis, 1986).

Churchill, Ward (ed.), *Marxism and Native Americans* (South End Press, Boston, n.d.).

Clark, T. J., *Image of the People: Gustave Courbet and the 1848 Revolution* (Thames & Hudson, London, 1973).

——, 'The Conditions of Artistic Creation', *Times Literary Supplement*, no. 3768, 24 May 1974, pp. 561–2.

——, *The Painting of Modern Life: Paris in the Art of Manet and His Followers* (Alfred A. Knopf, New York, 1984).

Clarke, J., S. Hall, T. Jefferson, and B. Roberts (eds), *Resistance Through Rituals*, Working Papers in Cultural Studies, nos 7 and 8 (Centre for Contemporary Cultural Studies, Birmingham, 1975).

Clifford, James, *The Predicament of Culture: Twentieth Century Ethnography, Literature and Art* (Harvard University Press, Cambridge, Mass., 1988).

Clifford, James and Vivek Dhareshwar (eds), *Travelling Theories, Travelling Theorists*, vol. 5 of *Inscriptions* (University of California at Santa Cruz, Santa Cruz, 1989).

Coward, Rosalind, 'Class, "Culture" and the Social Formation', *Screen*, vol. 18, no. 1, 1977.

——, *Female Desires: How They are Sought, Bought and Packaged* (Grove Press, New York, 1984).

Coward, Rosalind, and Ellis, John, *Language and Materialism. Developments in Semiology and the Theory of the Subject* (Routledge & Kegan Paul, London, 1977).

Coward, R., S. Lipshitz and E. Cowie, 'Psychoanalysis and Patriarchal Structures', *Papers on Patriarchy* (Women's Publishing Collective, Brighton, 1976) pp. 6–20.

Cowie, Elizabeth, 'Woman as Sign', *m/f*, no. 1, 1978, pp. 49–63.

Crimp, Douglas, 'On the Museum's Ruins', *October*, no. 13, Summer 1980.

——, 'The Photographic Activity of Post-modernism', *October*, no. 15, Winter, 1980–81.

Crow, Thomas, 'Modernism and Mass Culture in the Visual Arts', in Benjamin Buchloh, Serge Guilbaut, and David Solkin (eds), *Modernism and Modernity* (The Press of the Nova Scotia College of Art and Design, Halifax, Nova Scotia, 1983) pp. 215–64.

Culler, Jonathan, 'Jacques Derrida', in John Sturrock (ed.), *Structuralism and Since: From Lévi-Strauss to Derrida* (Oxford University Press, Oxford, 1979).

Debord, Guy, *Society of the Spectacle* (Black and Red, Detroit, 1970).

Debray, Régis, *Teachers, Writers, Celebrities: The Intellectuals of Modern France*, trans. David Macey (New Left Books, London, 1981).

Deleuze, Gilles, *Foucault*, trans. Seán Hand (University of Minnesota Press, Minneapolis, 1988).

Dennett, T., D. Evans, S. Gohl and J. Spence (eds), *Photography/Politics: One* (Photography Workshop, London, 1979).

Derrida, Jacques, *Speech and Phenomena*, trans. David Allison (Northwestern University Press, Evanston, 1973).

——, *Writing and Difference*, trans. Alan Bass (University of Chicago Press, Chicago, 1978).

——, *Positions*, trans. Alan Bass (University of Chicago Press, Chicago, 1981).

——, *Dissemination*, trans. Barbara Johnson (University of Chicago Press, Chicago, 1981).

——, *Margins of Philosophy*, trans. Alan Bass (University of Chicago Press, Chicago, 1982).

——, *The Truth in Painting*, trans. Geoff Bennington and Ian McLeod (University of Chicago Press, Chicago and London, 1987).

——, *The Post Card: From Socrates to Freud and Beyond*, trans. Alan Bass (University of Chicago Press, Chicago and London, 1987).

Doane, Mary Ann, 'Film and the Masquerade: Theorising the Female Spectator', *Screen*, vol. 23, nos. 3–4, September/October 1982.

Duncan, Carol and Alan Wallach, 'The Universal Survey Museum', *Art History*, vol. 3, no. 4, 1980.

Eagleton, Terry, *Literary Theory* (Blackwell, Oxford, 1983).

Foster, Hal (ed.), *The Anti-Aesthetic: Essays on Postmodern Culture* (Bay Press, Port Townsend, WA, 1983).

——, *Recodings: Art, Spectacle, Cultural Politics* (Bay Press, Port Townsend, WA, 1985).

—— (ed.), *Discussions in Contemporary Culture*, no. 1 (DIA Art Foundation, Bay Press, Seattle, 1987).

—— (ed.), *Vision and Visuality, Discussions in Contemporary Culture*, no. 2 (DIA Art Foundation, Bay Press, Seattle, 1988).

——, 'Wild Signs (The Break-Up of the Sign in Seventies' Art)', in John Tagg (ed.), *The Cultural Politics of 'Postmodernism'*, Current Debates in Art History, One (State University of New York at Binghamton, Binghamton, 1989).

Foucault, Michel, *The Archaeology of Knowledge* trans. A. M. Sheridan Smith (Pantheon, New York, 1972).

——, *Discipline and Punish: The Birth of the Prison*, trans. Alan Sheridan (Allen Lane, The Penguin Press, Harmondsworth, 1977).

——, *Language, Counter-Memory, Practice: Selected Essays and Interviews*, ed. and trans. D. F. Bouchard (Basil Blackwell, Oxford, 1977).

——, *Power, Truth, Strategy*, ed. Meaghan Morris and Paul Patton (Feral Publications, Sydney, 1979).

——, *Power/Knowledge*, ed. Colin Gordon (Harvester Press, Brighton, 1980).

——, *Foucault Live (Interviews, 1966–84)*, ed. Sylvère Lotringer, trans. John Johnston (Semiotext(e) Foreign Agents Series, New York, 1989).

Frascina, F. (ed.), *Pollock and After: The Critical Debate* (Harper & Row, New York, 1985).

Freud, Sigmund, 'Fetishism', *Standard Edition*, vol. XXI (Hogarth Press, London).

Gates, Henry Lewis (ed.), *'Race', Writing, and Difference* (University of Chicago Press, Chicago and London, 1986).

Geras, Norman, 'Marx and the Critique of Political Economy', in Robin Blackburn (ed.), *Ideology in Social Science: Readings in Critical Social Theory* (Fontana/Collins, Glasgow, 1972) pp. 284–305.

Gilbert-Rolfe, Jeremy, *Immanence and Contradiction: Recent Essays on the Artistic Device* (Out Of London Press, New York, 1985).

Godfrey, Tony, 'Sex, Text, Politics: An Interview with Victor Burgin', *Block*, no. 7, 1982.

Green, N. and F. Mort, 'Visual Representation and Cultural Politics', *Block*, no. 7, 1982, pp. 59–68.

Habermas, Jürgen, *Legitimation Crisis*, trans. Thomas McCarthy (Beacon Press, Boston, 1975).

Hadjinicolaou, Nicos, *Art History and Class Struggle*, trans. Louise Asmal (Pluto Press, London, 1978).

Hall, Stuart, 'The Determinations of Newsphotographs', *Working Papers in Cultural Studies*, no. 3 (Centre for Contemporary Cultural Studies, Birmingham, 1972).

——, 'Marx's Notes on Method: A Reading of the 1857 Introduction', *Working Papers in Cultural Studies*, no. 6 (Centre for Contemporary Cultural Studies, Birmingham, 1974).

——, 'Re-Thinking the "Base-and-Superstructure" Metaphor', in Jon Bloomfield (ed.), *Class, Hegemony and Party* (Lawrence & Wishart, London, 1977) pp. 43–72.

——, 'The "Political" and the "Economic" in Marx's Theory of Classes', in Alan Hunt (ed.), *Class and Class Structure* (Lawrence & Wishart, London, 1977) pp. 15–60.

——, 'Cultural Studies: Two Paradigms', *Media, Culture and Society*, vol. 2, no. 1, 1980.

——, 'The Problem of Ideology - Marxism without guarantees', in Betty Matthews (ed.), *Marx: A Hundred Years On* (Lawrence & Wishart, London, 1983) pp. 57–85.

Harris, Jonathan, 'The Chic of the New', *The Oxford Art Journal*, vol. 10, no. 1, 1987, pp. 116–122.

Harvey, David, 'The Representation of Urban Life', *Journal of Historical Geography*, vol. 13, no. 3, 1987, pp. 317–321.

Heath, Stephen, 'Difference', *Screen*, vol. 19, no. 3, Autumn 1978.

Hebdige, Dick, *Subculture: The Meaning of Style* (Methuen, London and New York, 1979).

——, *Hiding in the Light: On Images and Things* (Comedia/Routledge, London and New York, 1988).

Hindess, Barry and Paul Hirst, *Mode of Production and Social Formation* (Macmillan, London, 1977).

Hirst, Paul, *On Law and Ideology* (Macmillan, London, 1979).

Hoggart, Richard, *The Uses of Literacy: Aspects of Working-Class Life with Special Reference to Publications and Entertainments* (Chatto & Windus, London, 1957).

Hunt, Alan (ed.), *Class and Class Structure* (Lawrence & Wishart, London, 1977).

Irigaray, Luce, *Speculum of the Other Woman* (Cornell University Press, Ithaca, 1985).

Jameson, Fredric, 'Postmodernism, or the Cultural Logic of Late Capitalism', *New Left Review*, no. 146, July/August 1984, pp. 53–92.

Joselit, David (ed.), *Utopia Post Utopia: Configurations of Nature and Culture in Recent Sculpture and Photography* (The Institute of Contemporary Art, Boston/The MIT Press, Cambridge, MA, 1988).

Krauss, Rosalind, 'Photography's Discursive Spaces: Landscape/View', *Art Journal*, vol. 42, no. 4, Winter 1982.

Kristeva, Julia, 'Signifying Practice and Mode of Production', *Edinburgh Magazine*, no. 1, 1976.

Kuhn, Annette, *Women's Pictures: Feminism and Cinema* (Routledge & Kegan Paul, London and New York, 1982).

Laclau, Ernesto, 'Building a New Left: An Interview with Ernesto Laclau', *Strategies: A Journal of Theory, Culture and Politics*, no. 1, Fall 1988, pp. 10–28.

Laclau, Ernesto and Chantal Mouffe, *Hegemony and Socialist Strategy: Towards a Radical Democratic Politics* (Verso, London, 1985).

Linker, Kate, 'Representation and Sexuality', in B. Wallis (ed.), *Art After Modernism. Rethinking Representation* (Godine, New York, 1984).

——, *Difference: On Representation and Sexuality* (The New Museum of Contemporary Art, New York, 1984).

Lyotard, Jean-François, *The Postmodern Condition: A Report on Knowledge*, trans. Geoff Bennington and Brian Massumi (University of Minnesota Press, Minneapolis, 1984).

——, *Driftworks*, ed. Roger McKeon, (Semiotext(e), Foreign Agents Series, New York, 1984).

——, *Peregrinations: Law, Form, Event* (Columbia University Press, New York, 1988).

——, *The Differend: Phrases in Dispute*, trans. Georges Van Den Abbeele (University of Minnesota Press, Minneapolis, 1988).

Lyotard, Jean-François with Jean-Loup Thébaud, *Just Gaming*, trans. Wlad Godzich (University of Minnesota Press, Minneapolis, 1985).

MacCabe, Colin, *Tracking the Signifier. Theoretical Essays: Film, Linguistics, Literature* (University of Minnesota Press, Minneapolis, 1985).

Macherey, Pierre, *A Theory of Literary Production*, trans. Geoffrey Wall (Routledge & Kegan Paul, London, 1978).

Marin, Louis, *Utopics: Spatial Play*, trans. Robert A. Vollrath (Humanities Press, New Jersey and Macmillan, London, 1984).

Marx, Karl, *Grundrisse: Foundations of the Critique of Political Economy (Rough Draft)*, trans. Martin Nicolaus (Penguin Books, Harmondsworth, 1973).

——, *Capital*, Vol. 1, trans. Ben Fowkes (Vintage Books, New York, 1977).

——, 'The Eighteenth Brumaire of Louis Bonaparte', in Karl Marx and Frederick Engels, *Collected Works*, vol. 11 (Lawrence & Wishart, London, 1979) pp. 99–197.

McRobbie, Angela (ed.), *Zoot Suits and Second-Hand Dresses: An Anthology of Fashion and Music* (Macmillan, London, 1988).

Mercer, Kobena, 'Black Hair/Style Politics', *New Formations*, no. 3, Winter 1987, pp. 33–54.

Metz, Christian, *Psychoanalysis and the Cinema: The Imaginary Signifier*, trans. C. Britton, A. Williams, B. Brewster and A. Guzzetti (Macmillan, London, 1982).

Mitchell, W. J. T. (ed.), *The Politics of Interpretation* (University of Chicago Press, Chicago and London, 1983).

Moi, Toril, *Sexual/Textual Politics: Feminist Literary Theory* (Methuen, London and New York, 1985).

Mulhern, Francis, 'Notes on Culture and Cultural Struggle', *Screen Education*, no. 34, Spring 1980.

Mulvey, Laura, 'Visual Pleasure and Narrative Cinema', *Screen*, vol. 16, no. 3, Autumn 1975.

Muñoz, Carlos Jr., *Youth, Identity, Power: The Chicano Movement* (Verso, London and New York, 1989).

Nelson, Cary and Lawrence Grossberg (eds), *Marxism and the Interpretation of Culture* (University of Illinois Press, Urbana and Chicago, 1988).

Nicolaus, Martin, 'The Unknown Marx', in R. Blackburn (ed.), *Ideology in Social Science* (Fontana, Glasgow, 1972).

Nochlin, Linda, *Women, Art and Power: And Other Essays* (Harper & Row, New York, 1988).

Pollock, Griselda, 'What's Wrong With Images of Women?' *Screen Education*, no. 24, Autumn 1977.

——, 'Vision, Voice and Power. Feminist Art History and Marxism', *Block*, no. 6, 1982, pp. 2–21.

——, 'Art, Art School, Culture: Individualism After the Death of the Artist', *Block*, no. 11, Winter 1985/6, pp. 8–18.

——, *Vision and Difference: Femininity, Feminism and Histories of Art* (Routledge, London, 1988).

Popper, Karl, *The Poverty of Historicism* (Routledge & Kegan Paul, London, 1957).

Poster, Mark, *Foucault, Marxism and History: Mode of Production vs. Mode of Information* (Polity Press, Cambridge, 1984).

Preziosi, Donald, *Rethinking Art History: Meditations on a Coy Science* (Yale University Press, New Haven & London, 1989).

Rees, A. L. and Francis Borzello, *The New Art History* (Camden Press, London, 1986).

Risatti, Howard (ed.), *Postmodern Perspectives: Issues in Contemporary Art* (Prentice-Hall, Englewood Cliffs, N.J., 1990).

Rose, Jacqueline, *Sexuality in the Field of Vision* (Verso, London, 1986).

Ross, Kristin, *The Emergence of Social Space: Rimbaud and the Paris Commune* (University of Minnesota Press, Minneapolis, 1988).

Rouillé, André, *L'Empire de la photographie: Photographie et pouvoir bourgeois 1839–1870* (Le Sycomore, Paris, 1982).

Said, Edward, *The World, The Text, and The Critic* (Harvard University Press, Cambridge, Massachusetts, 1983).

Sekula, Allan, *Photography Against the Grain* (The Press of the Nova Scotia College of Art and Design, Halifax, Nova Scotia, 1984).

——, 'The Body and the Archive', *October*, no. 39, Winter 1986, pp. 3–64.

Silverman, Kaja, *The Subject of Semiotics* (Oxford University Press, New York, 1983).

——, 'Fassbinder and Lacan: A Reconsideration of Gaze, Look and Image', *camera obscura*, no. 19, January 1989, pp. 55–84.

——, *The Acoustic Mirror: The Female Voice in Psychoanalysis and Cinema* (Indiana University Press, Bloomington and Indianopolis, 1988).

Soja, Edward W., *Postmodern Geographies. The Reassertion of Space in Critical Social Theory* (Verso, London and New York, 1989).

Solomon-Godeau, Abigail, 'Photography After Art Photography', in Brian Wallis (ed.), *Art After Modernism. Rethinking Representation* (Godine, New York, 1984).

——, 'Reconstructing Documentary: Connie Hatch's Representational Resistance', *camera obscura*, nos. 13–14, Spring–Summer 1985.

——, 'The Legs of the Countess', *October*, no. 39, Winter 1986, pp. 65–108.

Spivak, Gayatri Chakravorty, *In Other Worlds: Essays in Cultural Politics* (Methuen, London and New York, 1987).

Stansell, Christine, *City of Women: Sex and Class in New York, 1789–1860* (University of Illinois Press, Urbana and Chicago, 1987).

Stedman Jones, Gareth, *Languages of Class: Studies in English Working-Class History 1832–1982* (Cambridge University Press, Cambridge, 1983).

Stephanson, Anders, 'Regarding Postmodernism - A Conversation with Fredric Jameson', *Social Text*, no. 17, Fall 1987, pp. 29–54.

Sturrock, John (ed.), *Structuralism and Since: From Lévi-Strauss to Derrida* (Oxford University Press, Oxford, 1979).

Tagg, John, *The Burden of Representation: Essays on Photographies and Histories* (Macmillan, London, 1988).

—— (ed.), *The Cultural Politics of 'Postmodernism'*, Current Debates in Art History, One (State University of New York at Binghamton, Binghamton, 1989).

Taylor, Ronald (ed.), *Aesthetics and Politics* (New Left Books, London, 1977).

Waites, B., T. Bennett and G. Martin (eds), *Popular Culture: Past and Present* (Croom Helm/The Open University Press, London, 1982).

Wallis, Brian (ed.), *Art After Modernism: Rethinking Representation* (Godine, New York, 1984).

White, Hayden, *Tropics of Discourse: Essays in Cultural Criticism* (The Johns Hopkins University Press, Baltimore and London, 1978).

Williams, Gareth, '18 Brumaire: Karl Marx and Defeat', in B. Matthews (ed.), *Marx: A Hundred Years On* (Lawrence & Wishart, London, 1983).

Williams, Raymond, *Problems of Materialism and Culture* (Verso, London, 1981).

——, 'Marxism, Structuralism and Literary Analysis', *New Left Review*, no. 129, Sept.–Oct. 1981, pp. 51–66.

——, *The Sociology of Culture* (Schocken Books, New York, 1982).

——, *Keywords: A Vocabulary of Culture and Society* (Oxford University Press, New York, 1985).

Wittgenstein, Ludwig, *Philosophical Investigations*, trans. G. E. M. Anscombe (Basil Blackwell, Oxford, 1958).

——, *Lectures and Conversations on Aesthetics, Psychology and Religious Belief*, ed. Cyril Barrett (Basil Blackwell, Oxford, 1966).

Wollen, Peter, *Readings and Writings: Semiotic Counter-Strategies* (Verso and New Left Books, London, 1982).

Wolff, Janet, 'The Invisible Flâneuse: Women and the Literature of Modernity', *Theory, Culture & Society*, vol. 2, no. 3, 1985, pp. 37–48.

Wright, Elizabeth, *Psychoanalytical Criticism: Theory in Practice* (Methuen, London and New York, 1984).

Index

Abstract Expressionism, 162, 179–80
Adorno, Theodor, 49
Agee, James, 94
Alberti, Leon Battista, 12
Althusser, Louis, 4–6, 55, 79–82, 86, 101, 135, 164; *Reading Capital*, 4
Amber Films, 70
Anderson, Perry, 44, 165
Antal, Frederick, 135
anti-catalogue, 52, 63, 64, 68, 92, 181
Anzaldúa, Gloria, 196
Aperture, 103
Arago, François, 122–3
Archaeology: of knowledge, 9–11, 35, 46
Archive, 10, 76, 100–3, 140–1; archival records, 83–5, 90, 103–4; 'ignoble archives', 103. *See also* Photography; Representation

Art: and 'Society', 148–9, 176–8; concept and institution of, 22, 33, 42–3, 51, 59–60, 67, 69, 98–100, 116–18, 125–7, 129–30, 145, 147, 179–80, 184; criticism of, 116–18. *See also* Canon
Art & Language, 69, 179
Art history: and the canon, 42, 51; and cultural politics, 46, 55, 185; and deconstruction, 31–3, 54, 185; and the economy of art, 50, 60; and education, 44–5, 53, 62–4, 68–70, 86–7; and institutions, 43–6, 49, 50, 52; and

practice, 43–6, 52, 62–4; and taste, 49; discursive formation of, 148–9, 185; methods of, 41–2, 46, 53, 63, 135, 185; narratives of, 50, 54, 157, 181, 184, 195–6; object of knowledge of, 42–3, 51, 103. *See also* Social history of art
Art Monthly, 71
Art schools, 62–4, 68–9
Artist: status of, 67–8, 69, 92–3, 99, 129, 130, 137–8, 145, 147, 160–1, 167–8, 179, 195
Artists' International Association, 74
Artists' Meeting for Cultural Change, 181
Artists' Union, 68, 92
Arts Council of Great Britain, 70, 74, 88–9, 91–2
Arts funding, 65, 67, 70–1, 87–9, 92
Asco, 184, 194–6; *Black and White Mural*, 195; *Instant Mural*, 195; signing of Los Angeles County Museum of Art, 195
Atget, Eugène, 98
Atkinson, Conrad, 72
Atkinson, Terry, 167
Atlantic Monthly, 124
Authorship, 2, 18, 69, 92–5, 108, 111, 117, 129, 145, 167, 195
Avant-garde, 45, 65–6, 157, 159–62, 166–8, 180

Baca, Judy, 22 fn 43
Baranik, Rudolf, 116, 176, 178–81
Barker, George, 22 fn 40

211